# THE ART OF THE
# LITERARY POSTER

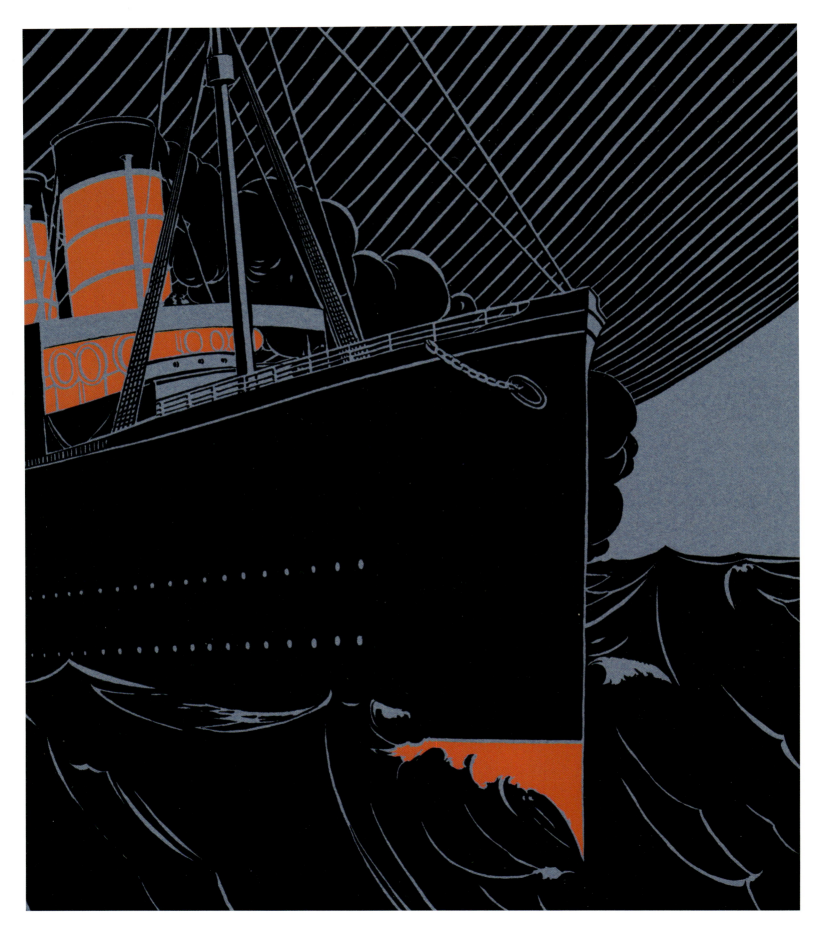

# THE ART OF THE LITERARY POSTER

## THE LEONARD A. LAUDER COLLECTION

ALLISON RUDNICK

WITH ESSAYS BY JENNIFER A. GREENHILL,
RACHEL MUSTALISH, AND SHANNON VITTORIA

THE METROPOLITAN MUSEUM OF ART, NEW YORK
DISTRIBUTED BY YALE UNIVERSITY PRESS, NEW HAVEN AND LONDON

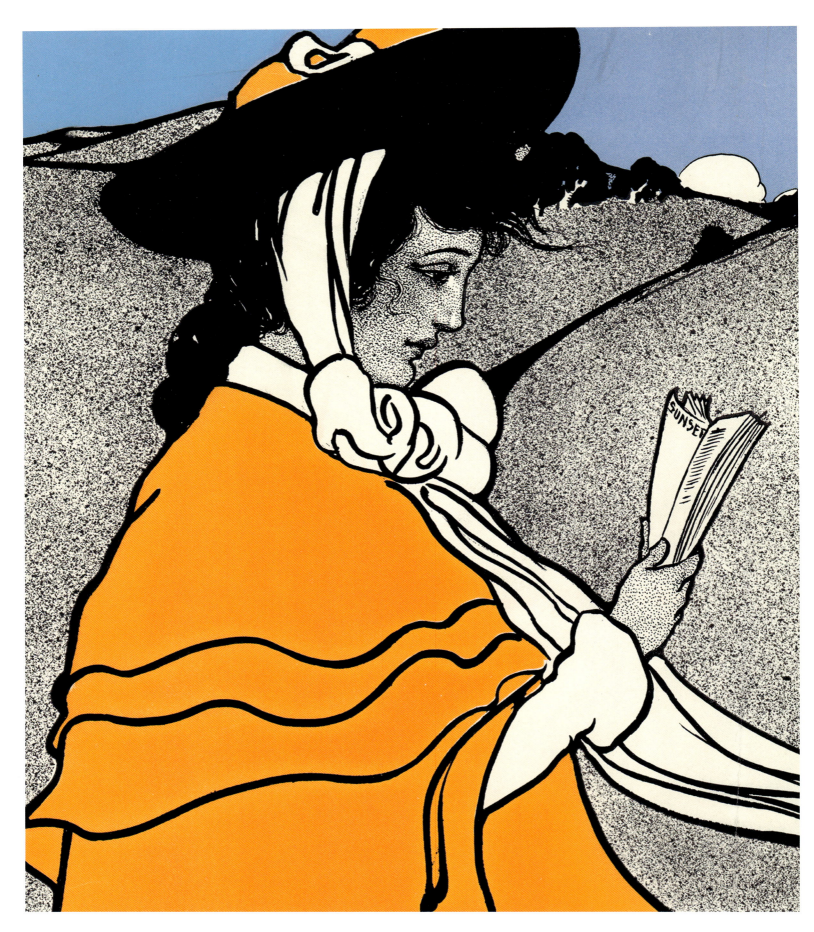

# CONTENTS

7 *Director's Foreword*

9 *Acknowledgments*

11 **Preface**
LEONARD A. LAUDER

15 **The Literary Poster: A Beacon of Modernity**
ALLISON RUDNICK

25 **By Women, for Women: American Art Posters of the 1890s**
SHANNON VITTORIA

47 **Poster Pyrotechnics: Advertising Psychology and the Foundations of Modern Marketing**
JENNIFER A. GREENHILL

71 **A Complex Art: Techniques for a New Poster Aesthetic**
RACHEL MUSTALISH

85 **PLATES**

229 *List of Plates*

237 *Notes*

243 *Selected Bibliography*

244 *Index*

248 *Photograph Credits*

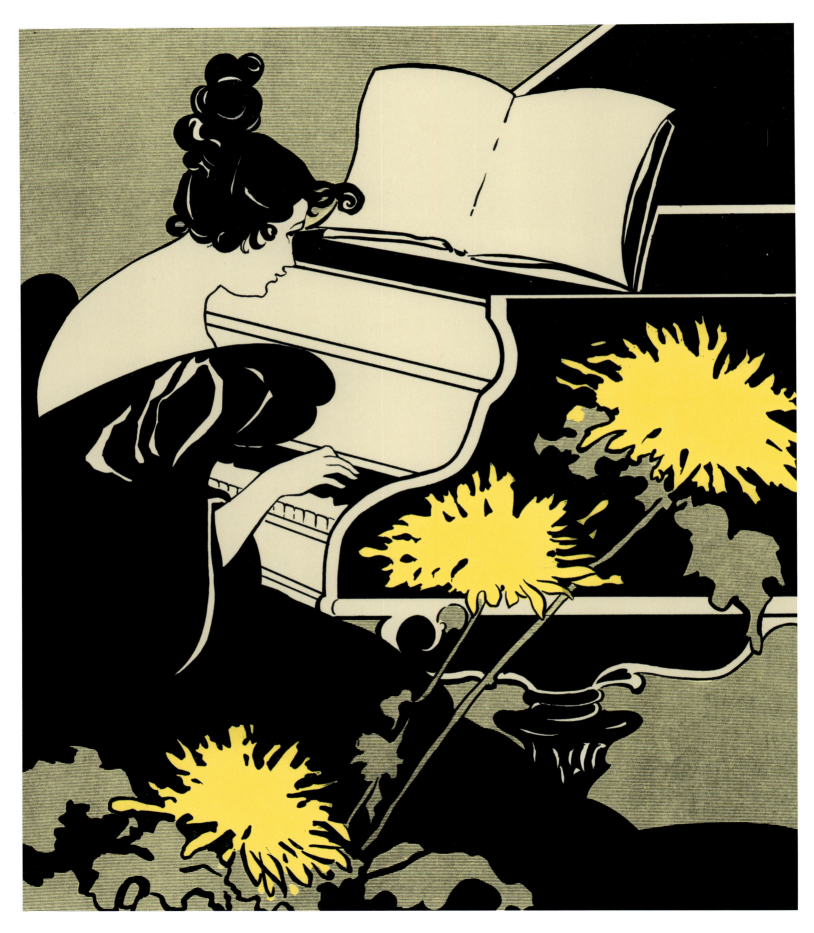

# DIRECTOR'S FOREWORD

DURING THE 1890S, a new type of poster emerged in the United States, one that more closely resembled a work of art than an advertisement. Thanks to recent innovations in printing techniques, artists could create colorful, inventive compositions that seamlessly integrated text and images. Recognizing the broad appeal of this novel art form, the publishing industry began commissioning sophisticated placards to advertise magazines, journals, books, and other types of literature. Though short-lived, the so-called literary poster had a lasting impact on illustration, graphic design, and marketing in this country.

Leonard A. Lauder — one of the great collectors and philanthropists of our time — has long championed American literary posters of the 1890s, appreciating their historical value and sheer beauty. Since making his first donation of such posters to The Met, in 1984, he has devoted time, energy, and expertise to supporting the development of the Museum's collection of more than five hundred works in this genre. With an eye toward condition and quality, Mr. Lauder has singled out impressions in pristine condition — a feat when it comes to objects that were once tacked to shop windows and building facades — enabling today's museum visitors to view the best examples of the form as they would have looked over one hundred years ago.

In 1987, The Met published David W. Kiehl's *American Art Posters of the 1890s in The Metropolitan Museum of Art*. Including fascinating essays and a full catalogue of the Museum's then-current holdings in this area, it is still considered to be the go-to text on the subject. Since its publication, with Mr. Lauder's support, the Museum's collection of these posters has more than doubled in size. In *The Art of the Literary Poster* and its accompanying exhibition, Allison Rudnick, Associate Curator in the Department of Drawings and Prints, presents key works by the leading American poster artists of the day — including Will H. Bradley, Joseph Christian Leyendecker, Edward Penfield, and Ethel Reed — several of which were acquired after 1987. The catalogue also features a series of astute essays that shed new light on the subject, approaching literary posters from the perspectives of visual culture, feminist art, marketing psychology, and technique. A complementary page on the Museum's website is devoted to showcasing the entire collection.

Leonard A. Lauder has made this project possible through his remarkable vision and generosity. For steering The Met to build this extraordinary collection, I thank him as well as his longtime curator, Emily Braun.

MAX HOLLEIN
*Marina Kellen French Director and CEO*
*The Metropolitan Museum of Art, New York*

# ACKNOWLEDGMENTS

THE MET'S SUPERB COLLECTION of American literary posters and this beautiful publication would not exist without the vision, determination, expertise, and generosity of Leonard A. Lauder. Several decades ago, he astutely recognized that posters of this type belonged in a great public institution, and since then he has developed and shaped the collection into what it is today. I extend my profound gratitude to Mr. Lauder for raising awareness of the historical value of the posters, ensuring that the best examples of the genre are made accessible to the public, and for contributing an insightful preface to the catalogue. I am indebted to Emily Braun, Distinguished Professor at Hunter College and the Graduate Center, City University of New York, and the curator of Mr. Lauder's collection, for sharing her deep knowledge of the works and providing sage guidance throughout the process of planning this catalogue, which has benefited significantly from her incisive and discerning feedback.

At The Met, I am grateful to Max Hollein, Marina Kellen French Director and CEO, who provided steadfast support of this publication from the start, and to Andrea Bayer, Deputy Director for Collections and Administration, who offered valuable counsel. Nadine M. Orenstein, Drue Heinz Curator in Charge of the Department of Drawings and Prints, worked on the poster collection early in her decades-spanning career at the Museum. Her enthusiasm for the material and spirited encouragement of the project have guided me throughout. Thank you to my colleagues in the Department of Drawings and Prints, particularly Marissa Acey, Casey Davignon, David del Gaizo, Clara Goldman, Jasmine Kuylenstierna, Ricky Luna, and Liz Zanis, who contributed substantially to the realization of the publication and related exhibition.

Profound thanks are due to the contributors to this catalogue: Jennifer A. Greenhill, Endowed Professor of American Art, University of Arkansas; Rachel Mustalish, Sherman Fairchild Conservator in Charge, Department of Paper Conservation; and Shannon Vittoria, Assistant Curator, the American Wing. Each of their essays shifts our understanding of American posters in pivotal ways. I am appreciative of my colleagues in The Met's Publications and Editorial Department, led by Mark Polizzotti, Peter Antony, and Michael Sittenfeld. Special thanks go to Elisa Urbanelli, Senior Editor, and Paul Booth, Senior Production Manager, whose contributions shaped the publication in ways that cannot be measured. In addition, Jenn Sherman provided vital assistance in image acquisitions and rights clearance. Susan Marsh brought the posters to life through her stellar book design.

Several colleagues at the Museum went to great lengths to ensure that this catalogue reproduces the posters with images of the highest possible quality. I am indebted to the Imaging Department, led by Scott Geffert, for devoting years to planning, acquiring, and erecting a new camera and stand for photographing works in the Lauder collection, and especially to Love Ablan for her photography efforts. I also thank Chris Heins, Isaac Jonas, Anna-Marie Kellen, Nancy Rutledge, and Juan Trujillo. Conservators Rachel Mustalish and Rebecca Capua worked tirelessly to untangle the complex technical processes behind the production of the posters and to treat them when needed.

*The Art of the Literary Poster* catalogue and the related exhibition and webpage were also made possible by Quincy Houghton, Deputy Director, Aileen Marcantonio, and Marci King in Exhibitions; Inka Drögemüller,

Deputy Director for Digital, Education, Publications, Imaging, Library, and Live Arts, and Tricia Robson in the Director's Office; Whitney W. Donhauser, Jason Herrick, and, in particular, Katherine Lester Thompson in Development; Neil Cox, Head of the Leonard A. Lauder Research Center for Modern Art; Alicia Cheng, Chelsea Garunay, Patrick Herron, Alexandre Viault, and Greta Skagerlind in Design; Sharon Cott, Sujin Kim, James Moske, and Caroline Chang in the Counsel's Office; Douglas Hegley, Christopher Alessandrini, and Isabella Garces in Digital; Jennifer Isakowitz in Communications; and Indira Mokeeva in Finance. I also thank Mark Resnick for his guidance and encouragement.

Finally, I am privileged to be continuing the legacy of Elliot Bostwick Davis, David W. Kiehl, Samantha Rippner, and Freyda Spira, former curators in the Department of Drawings and Prints. Each has been vital to the development of the Lauder poster collection at The Met, and each has, in different ways, passed down their considerable knowledge.

ALLISON RUDNICK
*Associate Curator*
*Department of Drawings and Prints*

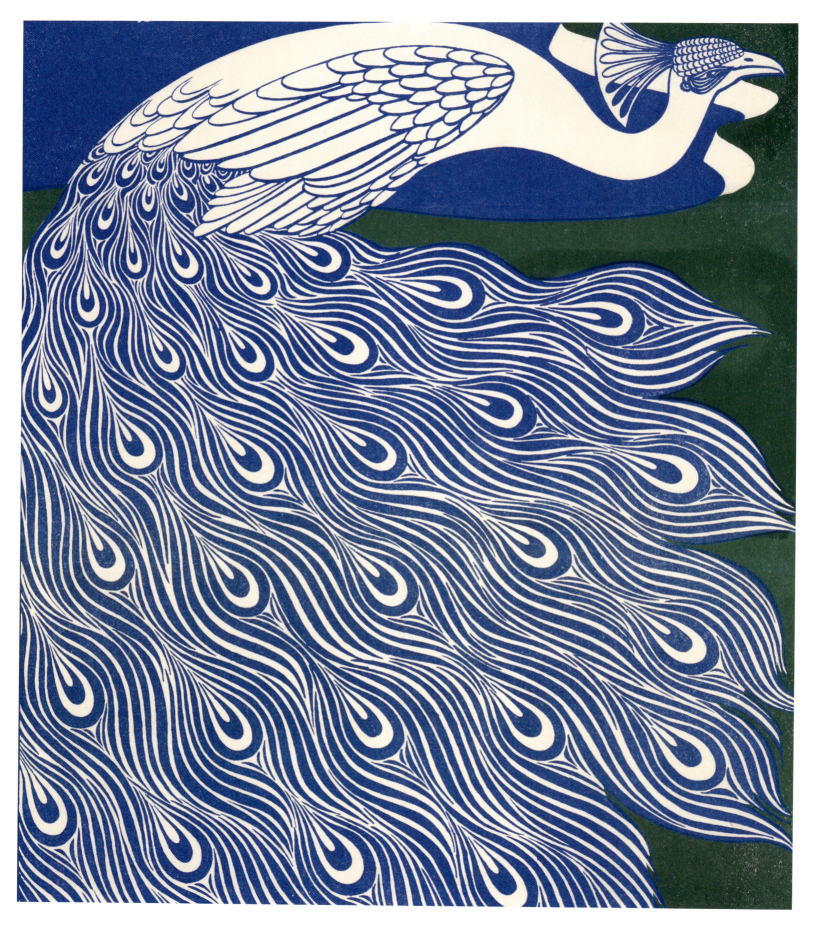

# PREFACE | LEONARD A. LAUDER

ASK ANY COLLECTOR how it all began, and you may hear wonderful stories about childhood collections ranging from bottle caps to baseball cards. I started to collect in earnest at the age of ten. It was in 1943, during World War II, that I acquired my first American poster. The Office of War Information (OWI) issued a series of patriotic posters. "Loose Lips Sink Ships," "Remember Pearl Harbor," and other slogans were incorporated into beautiful, vibrant images that captured my imagination. My goal was to collect every war poster published by the OWI. Riding subways and buses often for hours to the outlying boroughs, I trudged to every OWI office in New York City in search of the missing numbers in the series. Even at that age, I had the compulsion to collect. Over the years my interests and tastes have changed, but the drive to collect and the thrill of forming a collection have stayed with me.

My childhood fascination with posters lay dormant until 1977. That year, the Whitney Museum of American Art mounted the exhibition *Turn-of-the-Century America*, brilliantly curated by Patricia Hills. Tucked away in a corner was a group of art posters from the 1890s. Conveying the freshness, innocence, and excitement of the period, they reflected a self-confident, seemingly problem-free America. The spirit of these lively images captivated me, as it had done for others when they were first produced and sought after. Once again, my enthusiasm for the American poster was sparked, but this time I wanted to understand what innovations in printing and marketing led to this burst of creativity in the United States. I asked myself, "Why the poster?" How was it that these bold and colorful designs gave birth to modern advertising and were also the first flowering of modernism in this country?

Before embarking on my search, I had a lot to learn. I read endlessly on the subject. It was with this knowledge that I began to outline how the collection would look. The works would be chosen for their quality, composition, and historical value. I identified the images that I felt were essential, as well as the overall "feel" I wanted to achieve in the completed collection. I am often asked which was the first poster to enter the collection. It is impossible to remember. By the time I bought the first one, I had already shaped the collection so carefully in my mind that each addition was like fitting a piece into a jigsaw puzzle. I was keen to acquire poster art by unsung women artists and was especially determined to gather as many images as possible by the enormously talented Ethel Reed. (*Is Polite Society Polite* [pl. 113] remains one of my all-time favorites.) Over the years, Jack Banning, Susan Reinhold, and Bob Brown of the Reinhold Brown Gallery, my "French connection" Deborah Glusker-Lebrave, and especially Jack Rennert, the premier poster expert, made sure that I saw every work that became available. Each acquisition gave me great pleasure, as it filled an already identified gap.

Most of the posters in the collection are not advertising posters as we know them today. Certainly, during this period, there were numerous examples of quite ordinary posters, hawking circuses, theatrical productions, and patent medicines. Often lackluster in their design and printed by apprentices rather than skilled lithographers, these works are weak in both composition and color. In contrast, the posters I have chosen, such as Will H. Bradley's *Modern Poster* (pl. 10), exhibit an aesthetic sophistication that elevates them beyond the realm of mere commercial art.

According to Edward Penfield, "A design that needs study is not a poster no matter how well it is executed."[1] I have taken these words to heart. The most successful poster is one that elicits an immediate response. The concise wording, bold typeface, flat areas of color, and simplified forms work together to create a strong narrative. Though the posters in the collection may have originally advertised magazines, books, and bicycles, it is their supreme artistry that sold me.

That these posters have survived at all is a small miracle. Although coveted as collectibles in their day, they were nonetheless considered ephemera and did not receive the care afforded to fine art. Not surprisingly, many were found badly damaged, having been folded, tacked up on walls, taped, or trimmed. In the course of my search, I had to pass up key images due to their poor condition. With time, a pristine example would emerge. In the context of my collection, I could ensure that these high-quality examples would be preserved indefinitely.

I had always intended the collection to be donated to a museum. I worked with Bonnie Clearwater, my curator at the time, and her successor, Julia Blaut, to find the right home. Since I am a New Yorker and the city has nurtured my cultural interests, a New York institution seemed desirable. The Metropolitan Museum of Art proved to be the ideal place. It already had a significant number of American turn-of-the-century posters. Happily, my collection was abundant in the areas where its was lacking. I came to know Colta Ives, then curator in the Department of Prints and Photographs, and David Kiehl, then associate curator, whose enthusiasm for American graphic art was infectious. Just a decade after I started my quest, the exhibition *American Art Posters of the 1890s* opened at The Met in 1987, marking the gift of my collection, which had been formalized three years earlier. Thanks to Kiehl's impeccable scholarship, the catalogue became the standard reference on the subject for researchers and curators and dealers and auction houses. It made me immensely proud. But I did not stop there: after all, I learned from that book that some 1,500 American posters had been issued by publishing houses around the turn of the century. I could not wait to find more.

Even though it belongs to The Met, in my mind, it is still "my" collection. Since my original gift, I have continued to acquire American literary posters for the Museum, assisted by my curator of more than thirty-five years, Emily Braun, who shares my enthusiasm for these distinctive and often witty images. She is constantly on the lookout for the rare find. I filled in the remaining Penfield designs for *Harper's* with the poster for the April 1894 issue and recently added Louis John Rhead's marvelous *C. Bechstein Pianos* (pls. 78, 128). As the collection continued to grow, many wonderful surprises came to light. Nearly two dozen posters by George Reiter Brill for the *Philadelphia Sunday Press* filled a major gap. There was nothing more exciting than finding a previously undocumented or unique poster — Alice Cordelia Morse's *Kate Carnegie by Ian Maclaren* (pl. 68), to name just one. My biggest joy came with the discovery of Lafayette Maynard Dixon's starkly beautiful posters for the California periodicals *Overland Monthly* and *Sunset Magazine* (pls. 23–27). During this time, I had the pleasure of working with curators Samantha Rippner, Elliot Bostwick Davis, and Freyda Spira in the Department of Drawings and Prints.

Over three decades the collection has more than doubled in size, so it was much to my delight when Mark Polizzotti, Publisher and Editor in Chief, and Allison Rudnick, Associate Curator in the Department of Drawings and Prints, agreed that it was time to do a new book with updated research and implement a comprehensive online catalogue. I am grateful to Rachel Mustalish, Sherman Fairchild Conservator in Charge, Department of Paper Conservation, for her efforts in caring for these posters and expertly studying the print technologies of the period, and to Nadine Orenstein, Drue Heinz Curator in Charge, Department of Drawings and Prints, for her continued support. My deepest gratitude, however, is to my family. They remained patient while living with piles of posters in the closets and under the bed. The forming of a collection is not a one-person job, and it is to all of these people that I am grateful.

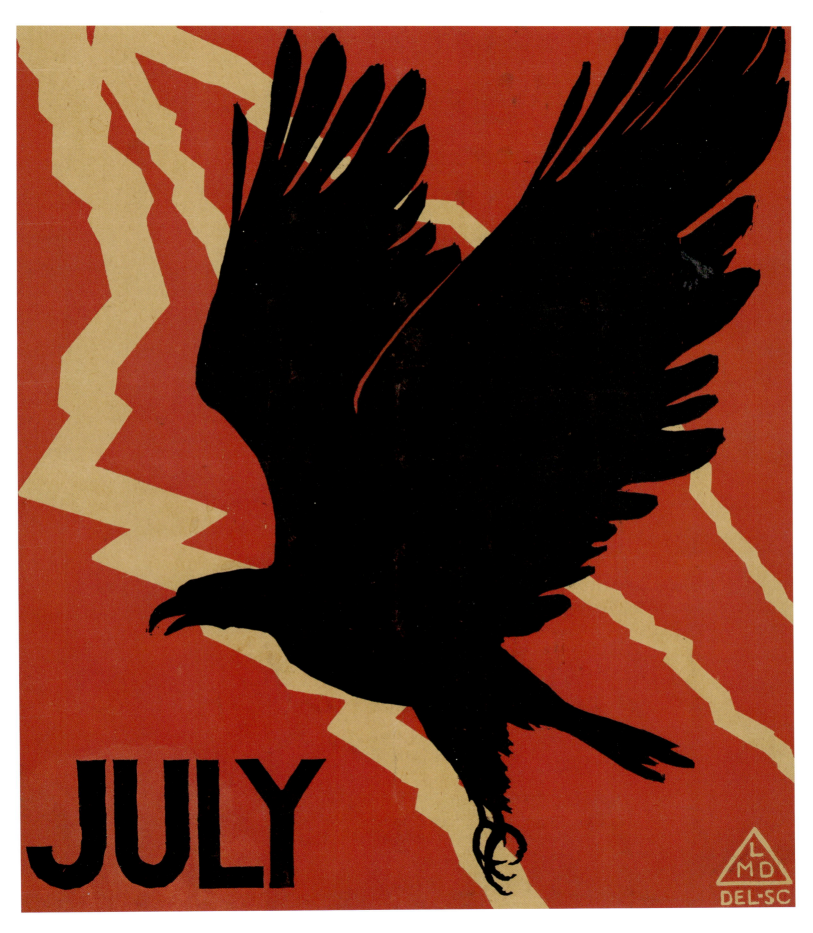

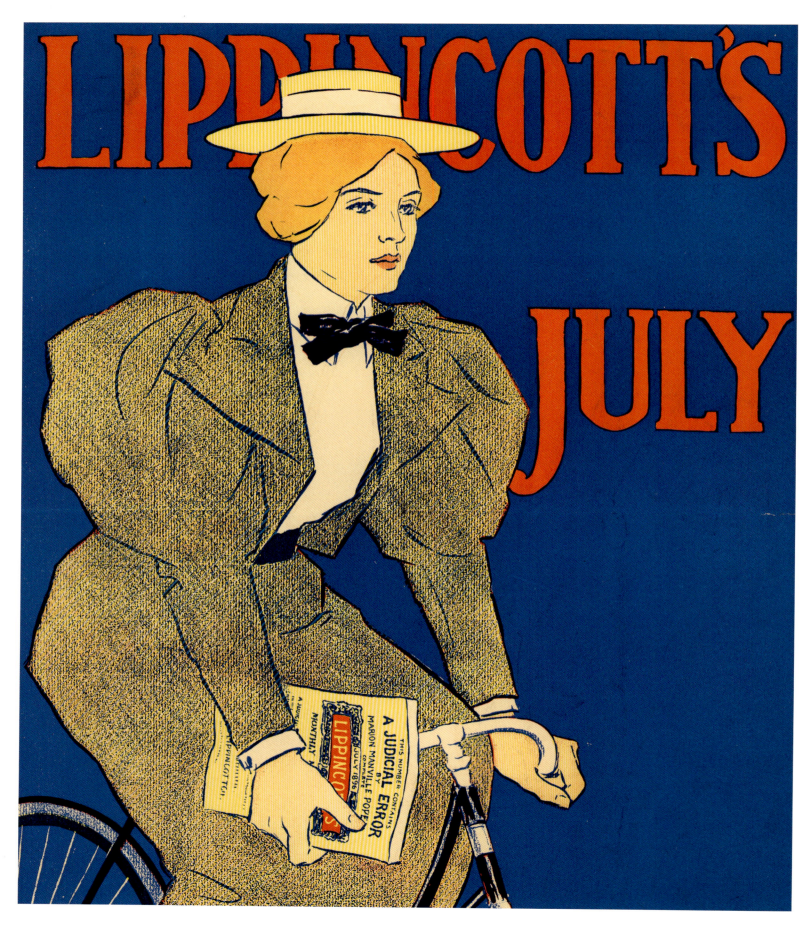

# THE LITERARY POSTER
## A BEACON OF MODERNITY

ALLISON RUDNICK

**D**URING THE SUMMER OF 1896, a poster of a redheaded woman riding a bicycle appeared in bookshop windows and newsstands in cities across the United States (pl. 36). Sporting a fashionable outfit, the cyclist gazes blankly beyond the viewer, seeming to exert little effort. Though her body occupies most of the composition, she is off-center, her bicycle wheels cropped by the bottom edge of the frame. These compositional strategies create the impression that she is cycling into the viewer's space; it is as if we are experiencing a fleeting encounter on a busy city street, despite the lack of contextual clues. The flatness of the unmodulated blue background is augmented by the words "LIPPINCOTT'S JULY" emblazoned in large red letters across the top half of the composition, partially obscured by the woman's flat-brimmed hat.

The poster, an advertisement by Joseph J. Gould Jr. for the July 1896 issue of *Lippincott's Monthly Magazine*, is thoroughly modern on several fronts. Stylistically, it draws on the aesthetic elements of Japanese woodcut prints, which inspired a generation of artists in the United States and Europe to abandon the Western tradition of using three-point perspective to convey depth in favor of emphasizing the two-dimensionality of the picture plane. The poster's subject matter, too, is emphatically of the moment. Its stylish protagonist, who projects an air of independence and cool detachment, has all the trappings of the so-called New Woman of the Progressive Era.[1] The bicycle suggests that she has the time and resources to enjoy activities such as cycling, a form of leisure popular among the middle and upper classes during the late nineteenth century, while the issue of *Lippincott's* magazine that she clutches against the handlebars signals her educated status. Tall and lean, with light skin,

FIG. 1 | Edward Penfield (American, 1866–1925), *Harper's, April*, 1893. Lithograph, 18⅝ x 12⅞ in. (47.3 x 32.7 cm). Private collection

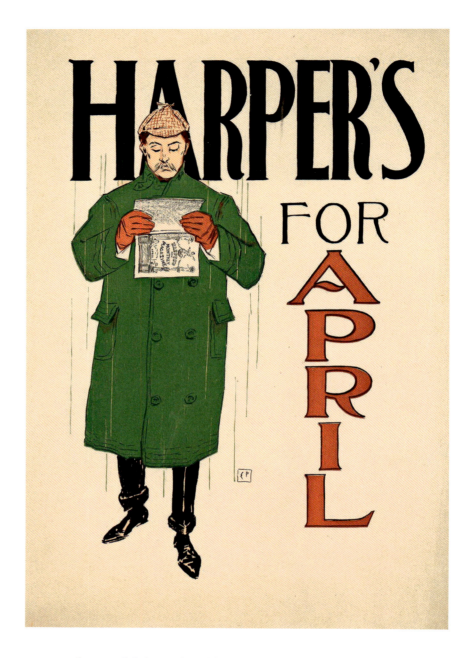

upswept hair, and delicate facial features, she manifests the period's standards of idealized beauty, as embodied in the popular character of the Gibson Girl created by the illustrator Charles Dana Gibson.[2]

Beyond the bold aesthetic and contemporary subject of Gould's *Lippincott's, July*, the poster itself represented something new: an advertisement that looks and functions like a work of art, an image made for public consumption in which commercialism and culture coalesce. Emerging in the early 1890s, advertising posters devoted to magazines,

FIG. 2 | Strobridge Lithographing Company (American), *P. T. Barnum's Greatest Show on Earth and The Great London Circus: A Supernatural Equipoise and Balancing Exhibition by a Troupe of Japanese Equilibrists of Extraordinary Agility and Strength*, 1882. Lithograph, 30 3/16 x 39 13/16 in. (76.6 x 101.1 cm). Cincinnati Art Museum, Gift of the Strobridge Lithographing Company (1965.686.70)

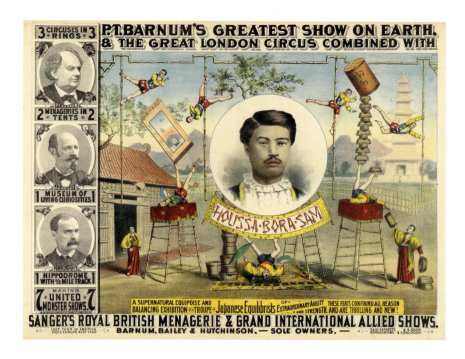

journals, newspapers, books, and other forms of literature were targeted to appeal to an audience of well-read, affluent Americans. Although the heyday of this inventive genre was relatively brief, lasting barely a decade, literary posters had a significant influence on graphic design that surpassed and outlasted their practical purpose. By reflecting the hallmarks of modernity in their style, subject matter, and technique, they ushered in an era of sophisticated, high-quality advertisements that marked a shift in the history of American visual culture.

Gould illustrated a poster for each monthly issue of *Lippincott's* from late 1895 to mid-1897. His designs closely resemble those of Edward Penfield, the art director at Harper and Brothers, whose sleek, minimalist placard for the April 1893 issue of *Harper's* is widely considered to be the first-ever literary poster (fig. 1). In the striking composition, a man in a green overcoat is so immersed in reading an issue of *Harper's* that he is oblivious to the fact that it is raining — a witty meteorological reference to "April showers." Its stark simplicity and seamless integration of image and type stand in contrast to the busy compositions of the theater and circus posters that had become a mainstay of the visual landscape in urban centers across the country (fig. 2). Penfield's elegant design also demonstrated the artist's understanding that simple forms make for a poster that effectively communicates a clear, direct message to the viewer.[3] The widespread positive reception of Penfield's poster inspired

competing publishers around the country to commission distinctive advertisements promoting their products, thus launching a veritable "poster craze" that lasted until the end of the decade.[4]

Contemporary critics were attuned to the difference in the quality of design between the literary posters and what came before them. One critic wrote that Penfield's poster was "unlike anything seen in the land before. It was a poster which forced itself upon one: in design and colour it was striking, and yet it was supremely simple throughout. . . . The poster was distinctly successful; it was theoretically as well as practically good. The artist had attained his ends by the suppression of details: there were no unnecessary lines."[5] Another critic remarked, "The theaters have done little or nothing to encourage artistic advertising. Our bill-boards are generally an unwieldy mass of letters interspersed with crude and thoughtlessly-placed figures," whereas "publishing companies first gave the impetus to this work and developed the poster phase in art in our country."[6] More so than other types of advertising, the literary poster epitomized the vanguard in graphic design of the period.

This new type of poster shared characteristics with fine-art prints that its precursors lacked. Unlike most large-scale advertisements, which were produced by lithography firms, literary posters were frequently printed by the publishing houses that issued them, sometimes on the very presses used to print magazines, newspapers, and books. Art department staff at the houses were able to oversee the printing process, resulting in products of higher quality. Often designers signed their work — another break from the past that further aligned the new poster with fine art; it was a strategy that catered to a burgeoning market of poster enthusiasts.[7] And unlike large theater and circus posters, which plastered building facades and billboard surfaces, most posters advertising literary products were relatively small and displayed tastefully in bookstores and newsstands. As their artistic status grew, the demand for posters became so acute that some booksellers sold them directly to collectors without displaying them at all.[8] As a critic for *The Publishers' Weekly* astutely observed in 1894, "the advertising poster is fast becoming a work of art."[9]

American designers of literary posters were influenced, directly or indirectly, by the innovations of the French artist Jules Chéret. Trained in printmaking, Chéret spearheaded technical advances in color lithography that enabled the mass production of large, colorful compositions merging text and imagery.[10] Works by Chéret and his French followers were featured in the first major poster exhibition in the United States,

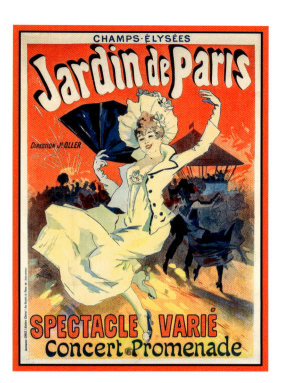

FIG. 3 | Jules Chéret (French, 1836–1932), *Jardin de Paris* poster, 1897. Lithograph, approx. 48 x 34 1/8 in. (121.9 x 86.7 cm). Milwaukee Art Museum, The James and Susee Wiechmann Collection

which opened in 1890 at the Grolier Club in New York. Though Penfield denied having seen a French poster until after he began producing advertisements for *Harper's*, Chéret no doubt paved the way for the modern American poster by elevating what had previously been considered a crude marketing tool into a highly collectible work of art.[11]

Chéret's posters commissioned by Parisian theaters are populated by ebullient women, many of them celebrities of cabaret, opera, and other popular forms of entertainment, whose lively energy is complemented by a bright color palette and playful typefaces (fig. 3). The joie de vivre and blatant sex appeal of these performers stand in sharp contrast to the respectability and reserve conveyed by Gould's cyclist and other aloof female figures featured in advertisements for magazines such as *Lippincott's, Harper's,* and *Collier's*. Whereas Chéret's posters sought to attract the male gaze, those by his American counterparts were designed to appeal to the sophisticated tastes of the magazines' readership, which was composed of both men and women. Gould's cosmopolitan "New Woman" might have sparked the desires of male viewers, but she also induced a degree of envy on the part of female viewers, who received the aspirational message that they could be like her if only they, too, read *Lippincott's*.[12]

The cover of the issue of *Lippincott's* that the cyclist clutches in her hand bears the magazine's logotype, which includes the title rendered in yellow against a red background and surrounded by an ornate frame. The typography is echoed in the large red letters that spell out the title across the poster's top edge. Faithful to the real magazine, the depicted cover announces that contained within its pages is "A Judicial Error," a short essay by the popular writer Marion Manville Pope. It is treated with more detail than any other part of the poster's composition, thus calling attention to itself. Gould used this tactic repeatedly in his series of posters for *Lippincott's*, in which a reader holds a copy of the current issue being advertised (pls. 35–42). As an attribute, the magazine signals cultivated erudition and identification with the affluent leisure class. Periodicals were relatively expensive, and their readers would have had both the means to purchase them and the time to read them.[13]

The ubiquity of literary posters that feature figures reading, clutching, and carrying magazines serves to locate the genre in the tradition of the portrait of the intellectual. For millennia, a portrait subject's intellect has been communicated through the presence of a printed text. This motif dates to at least the second millennium BCE, when an Egyptian

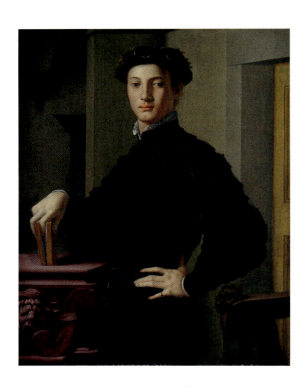

FIG. 4 | Bronzino (Agnolo di Cosimo di Mariano) (Italian, 1503–1572), *Portrait of a Young Man*, 1530s. Oil on wood, 37⅝ x 29½ in. (95.6 x 74.9 cm). The Metropolitan Museum of Art, New York, H. O. Havemeyer Collection, Bequest of Mrs. H. O. Havemeyer, 1929 (29.100.16)

artist created *The Seated Scribe,* a sculpture of a man holding a piece of papyrus in his lap. Books abounded in sixteenth-century portraits of Florence's elite literati. An example is Bronzino's *Portrait of a Young Man*, in which the subject has slipped his finger between two pages of a book resting on a table, as if he had been interrupted while reading and is marking where he left off (fig. 4). According to the scholar Julia Siemon, "A young man shown in the act of reading in a Florentine portrait of the 1530s implies a literary consciousness linking him to an intellectual community."[14] An image of a person holding a magazine in an American poster of the 1890s operates in a similar way.

In the example of Penfield's advertisement for the April 1894 issue of *Harper's*, a cosmopolitan woman in a long, red overcoat clutches an umbrella by her side and tucks a *Harper's* under her arm (pl. 78). The artist composed a cartoon — which the printer used as a prototype when translating his design into a printed poster — in ink and wash with hand-cut paper applied to the head, hands, and umbrella as a means of making corrections (fig. 5). The only element of the composition that was not done by hand is the photomechanically printed cutout of the magazine cover, which was likely excised from a printed *Harper's* ad. The miniature reproduction of the cover offered Penfield a practical tool in working out the design. As a mass-produced object, it also serves as a reminder that the presence of magazines in literary posters was as much the result of a marketing technique as a desire to locate the posters within a long art-historical lineage linking reading to intellect and refinement.

Poster artists' knowledge of printmaking techniques varied widely. Some simply submitted drawings to the printer to be reproduced using photomechanical methods. Others were required to carefully consider the printing process when conceiving their designs. For example, when *The Century* magazine announced a contest for a poster advertising the 1896 midsummer issue, the participants were asked to account for "the ease and cheapness with which [the posters] can be reproduced," for the submissions would be judged on that basis.[15] Maxfield Parrish allegedly received the second prize rather than the first because his poster would have necessitated printing in four colors rather than three, as stipulated in the competition rules.[16] In contests like that sponsored by *The Century*, artists were expected to both excel in draftsmanship and demonstrate an understanding of the working methods of the printers.

Will H. Bradley was the rare poster designer who also trained as a printmaker, and the style, subjects, and palettes that distinguish his work

FIG. 5 | Edward Penfield, Study for *Harper's, April*, 1894. Cut-and-pasted painted paper, watercolor, ink, and gouache on paper, 15 ⅞ x 11 ¾ in. (40 x 30 cm). The Metropolitan Museum of Art, New York, Leonard A. Lauder Collection of American Posters, Gift of Leonard A. Lauder, 2023 (2023.421)

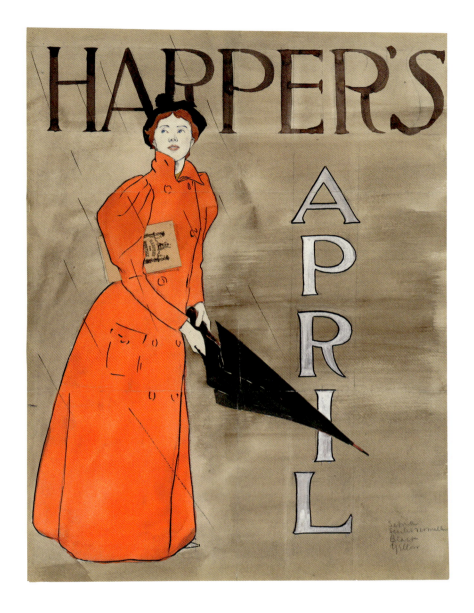

bear the evidence of a printer's approach to the medium. Like Penfield, he gained a loyal following of artists and collectors, initially through his placards for the avant-garde "little magazine" *The Chap-Book*.[17] He later established his own press, producing the printers' trade magazine *Bradley: His Book*.[18] Bradley designed his posters with efficiency and cost in mind, notably by limiting the number of color plates needed in their production. As the scholar Roberta Wong explains, "Bradley's clearly separated color areas and large, flat, simple shapes facilitated the job of the technician who printed the poster. In addition, Bradley would carefully select a few colors that could produce a variety of tones."[19]

FIG. 6 | Will H. Bradley (American, 1868–1962), *The Chap-Book [The Blue Lady]*, 1894. Lithograph, 19 15/16 x 13 15/16 in. (50.6 x 35.4 cm). The Metropolitan Museum of Art, New York, Gift of David Silve, 1936 (36.23.20)

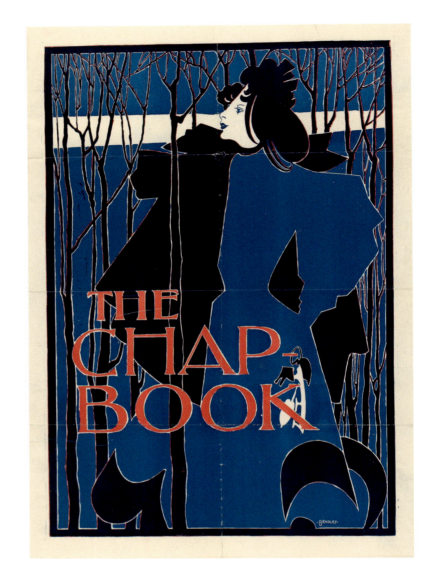

A placard for *The Chap-Book* titled *The Blue Lady* was printed using only two color plates, one red and one blue (fig. 6). In certain areas of the composition the two colors are layered to create a dark, purple-blue tone, while passages that are void of ink harness the white of the paper support.

Several of Bradley's works allude to the art of printmaking in their subject matter. For example, *The Chap-Book, November, Thanksgiving Number* features two figures, one standing in front of the other, rendered with the sinuous, curving lines that are emblematic of Art Nouveau (pl. 5). The figures are identical except for their size — a nod, perhaps, to the newfound ease of reducing and enlarging an image using up-to-date

printing technologies. Bradley's repetition, mirroring, and scaling of forms demonstrate a clever play on printmaking tropes that calls the viewer's attention to how his works were made. The artist stressed the importance of conceiving a design with the intended audience in mind, stating that, in contrast to an advertisement in a fishmonger's store, "if the poster is to attract buyers for a periodical or book, there must be an appeal to different impulses and sensibilities."[20] The sophisticated interplay between a literary poster's allusion to the printing process itself and its subject matter — a printed book or magazine — would have undoubtedly resonated with its audience of readers.

By the late 1890s, the poster craze began to wane. As one critic wrote in *Brush and Pencil* in 1899:

> *We see no longer in the shop windows the vivid things which used to herald loudly in color and design a new magazine or book for the coming month. Not that a new arrival from the land of literature at the present time is not announced by some pictured advertisement — the windows are still crowded — but its advertising is of a more literal and quiet character, as often the book-cover design is enlarged and used for this purpose, or the magazines give us simple character sketches of new-famed officers or politicians.*[21]

What she observed was an interesting, if not altogether unsurprising, phenomenon. The posters were ultimately more successful as collectors' items than they were as advertisements. In response, publishers shifted focus and directed resources toward compelling covers for publications, in some cases commissioning the same poster artists and designers, who adapted their modern illustrative aesthetic to the book-cover format. Though the posters did not have the selling power that publishers had hoped for, the sleek designs and witty messaging found in advertisements over the course of the twentieth and twenty-first centuries stand as proof of their enduring impact on the marketing industry. By fully embracing — and reflecting — the modern world, poster designers opened up the possibilities for what graphics with the intent to sell something could look like.

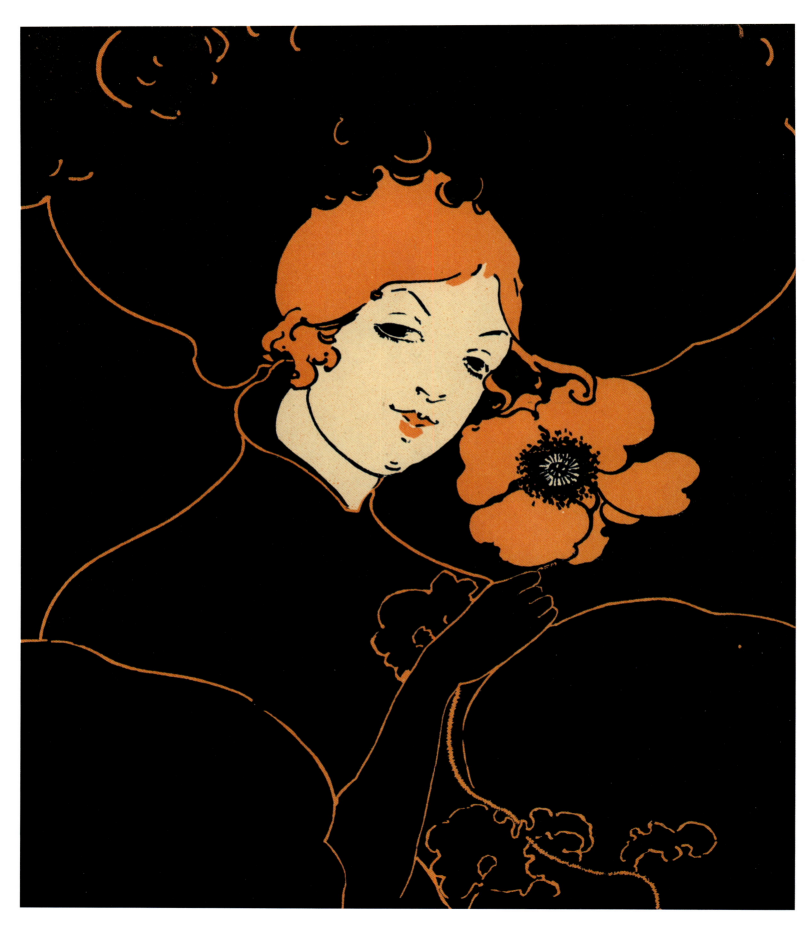

# BY WOMEN, FOR WOMEN
## AMERICAN ART POSTERS OF THE 1890S

SHANNON VITTORIA

IN NOVEMBER 1898 the London-based periodical *The Poster* published its first and only article to focus on the work of a woman artist.[1] Written by the French critic S. C. de Soissons, "Ethel Reed and Her Art" opened with the following assessment of the progress American women had made in their quest to "conquer" the art world: "I am not sure whether the movement of the emancipation of woman was started in America, but I am positive that there is no other country where the tendency to shake off the fetters put on her by man is stronger than in the United States; hence the continuous striving of the fair sex to conquer certain fields of activity . . . and naturally they have not forgotten art."[2] While praising Reed's "great artistic qualities," De Soissons couched his commendations in highly gendered language, attributing the artist's success to her embrace of her femininity: "Ethel Reed knows well the marvellous secret of design and colours, and while she executes pictures with clever hands, she sees with her own, and not masculine eyes; her work has feminine qualities; one sees in it a woman, full of sweetness and delicacy, and this is the greatest praise one can bestow upon a woman."[3]

Reed's first poster design was published by *The Boston Sunday Herald* on February 24, 1895 (fig. 7). Although she initially conceived the composition for a work in stained glass, upon the suggestion of a friend she instead submitted it to the *Herald* for reproduction as a poster.[4] Set against a bold red background with large poppy flowers, a young woman reads a newspaper above the pithy advertising slogan "Ladies want it." Believed to be a self-portrait of the artist, the figure — with her jet-black hair, low-cut dress, and elongated neck — closely resembles Reed in contemporary images, including a cyanotype portrait by the photographer Frances Benjamin Johnston (fig. 8).[5]

Critics often noted the physical similarities between the artist and her female subjects. *The Washington Post*, for example, described Reed as "one of the most beautiful women Washington has seen in an age. . . . Her hair is as black as the hair of her poster women, and she wears it curled over her eyes in the real poster way."[6] Similarly, when visiting the artist's Boston studio in 1895, the critic James MacArthur observed that in her "portraits of women a certain uniformity of type began to assert itself as I glanced from one to another, and it dawned on me at last that the original of these studies was the artist herself. . . . I had the pleasure of congratulating her on her choice of a model."[7] In addition to conflating the artist with her subjects, critics tended to feminize Reed's designs, describing them as delicate, refined, and graceful — characteristics traditionally associated with women's work. In 1897 *The International Studio* noted: "It would be difficult to recall the work of any lady artist at once so fragile and yet sound as to its technique, and as gracefully fancied and wrought. For her delicacy is not weakness, but a curious restrained vigor."[8]

By 1890 male artists and critics were increasingly insecure about the prominence of women in the art world, prompting a profound backlash against their work. As gender-based critical rhetoric "became more insistent, more absolute, and more explicitly aligned with sex," argues the historian Kirsten Swinth, "critics called for greater individuality and virility in American art. . . . However, only men could achieve such art: from women, critics now demanded the 'essentially feminine,' something fundamentally different and almost always lesser."[9] This shift in American art criticism coincided with efforts by male illustrators to overcome what they negatively perceived as the feminization of their profession.[10] The art historian Michele Bogart demonstrates that women were believed to stigmatize illustration as "unserious" and that their prevalence served as "an indicator that illustration was not fully established as a profession; it lacked the image of masculine strength considered requisite for any truly professional enterprise."[11] Male illustrators thus aimed to dissociate their work from feminine (read: amateur) pursuits by elevating illustration to the more masculine (read: professional) realm of the so-called fine arts, on par with painting and sculpture.

As a result, critics tended to minimize or outright ignore women's contributions to the field, creating an art-historical canon that for decades overlooked the importance of women artists to the history of American illustration and graphic design.[12] However, critics and

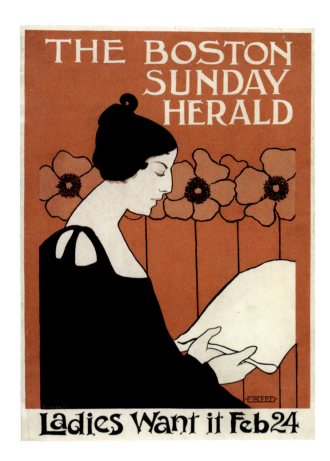 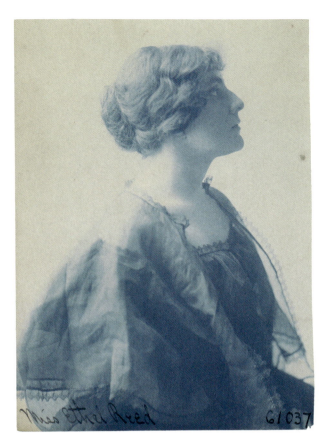

FIG. 7 | Ethel Reed (American, 1874–1912), *The Boston Sunday Herald*, February 24, 1895. Lithograph, 17¼ x 11⅞ in. (43.7 x 30.1 cm). Library of Congress, Washington, D.C., Prints and Photographs Division

FIG. 8 | Frances Benjamin Johnston (American, 1864–1952), *Miss Ethel Reed*, ca. 1896. Cyanotype, 6⁷⁄₁₆ x 4½ in. (16.3 x 11.4 cm). Library of Congress, Washington, D.C., Prints and Photographs Division

collectors could not simply ignore an artist such as Reed, who rivaled her male contemporaries in productivity and popularity. Between February 1895 and July 1896, she designed more than twenty art posters, many of which were critically acclaimed, publicly exhibited, and avidly collected.[13] Nevertheless, to limit the associations between women and illustration, Reed was portrayed in the press as an oddity and an anomaly — the exception to the rule, rather than a symbol of women's progress within the art world. In 1896 *Bradley: His Book* — a magazine founded by the illustrator Will H. Bradley — advanced the idea of Reed as an outlier in what was considered an otherwise male-dominated profession:

> *It is worth noting that so far the so-called "poster movement" has brought into first prominence but one woman designer. Whether this is due to a defect in the ordinary course of training for artistic purposes, from which young women students too seldom have the courage to break away, or is owing altogether to the lack of original inventiveness which women*

*themselves evince, it would be hard to say. Probably both conventional training and inherent incapacity for making ventures into new fields of work are to blame for the undeniable fact that thus far men hold the honors in this new branch of art productions, with the single exception, it may be, of Miss Ethel Reed of Boston.*[14]

Although Reed was the most prominent, prolific, and celebrated woman in the American art-poster movement — a short-lived but widely popular phenomenon — an examination of the historical record reveals that she was by no means alone. Rather, she was part of a larger community of women artists in cities across the United States who pursued professional careers in illustration, including book, magazine, and poster design. Their participation in the graphic and commercial arts of the era was far-reaching, thus repudiating the late nineteenth-century notion that women lacked the courage, training, and ability to enter new fields of art. The women of the American art-poster movement redefined themselves as more than mere passive consumers of American advertising, instead emerging as active creators and producers of art and visual culture.

**American Women in Illustration and Graphic Design**

The so-called golden age of American illustration, dating from about 1880 to 1930, coincided with a flourishing of illustrated books and magazines. As advances in printing technology made the reproduction of images both simpler and cheaper, weeklies and monthlies flooded the homes of middle- and upper-middle-class Americans. Increased literacy rates and leisure time also led to a heightened demand for illustrated periodicals, which provided readers with both entertainment and education in an array of categories, from general-interest stories and self-improvement advice to serious literature, poetry, and fiction.[15] By the 1890s newly created job opportunities made illustration a popular and lucrative career path for aspiring artists. Nevertheless, women faced considerable obstacles, including limited access to education, exhibition venues, artists' clubs, and professional networks.

During the first three decades of the nineteenth century, most women who achieved artistic recognition were related to successful male artists; it was through their fathers, uncles, husbands, or brothers that they obtained the apprenticeship training and professional connections

necessary to succeed. By the late 1840s social reformers began to address the scarcity of vocational training available to American women, who were entering the workforce in unprecedented numbers. Many believed that artmaking, specifically in the graphic and industrial arts, offered women a path for self-improvement and self-sustainment without compromising their femininity and status as "respectable" members of the middle class. In 1848 the Ohio-born philanthropist Sarah Worthington King Peter founded the Philadelphia School of Design for Women, the first of its kind in the nation.[16] It set an important precedent, and similar schools were soon established in New York, Boston, Cincinnati, and Pittsburgh, providing women with valuable instruction in drawing, wood engraving, lithography, etching, and industrial design.[17]

By the 1860s printing and publishing firms were hiring women in a variety of new roles. Compared to men, they were less expensive to employ, and their temperament was believed to be better suited to detail-oriented work. A critic writing in *The Crayon* in 1861 argued: "Man is not made for sedentary life; woman, on the contrary, conforms to it without inconvenience.... Her nimble fingers, accustomed to wield[ing] the needle, lend themselves more easily to minute operations.... Cutting on copper and steel demands also a patience and minutia much more compatible with the nature of woman."[18] Although biologically essentializing, this perceived connection between femininity and artmaking worked to the advantage of women who, according to the art historian Laura Prieto, could use it as a point of entry into the professional art world: "Women gradually transmuted ladylike leisure activities into opportunities for serious study and finally some degree of professionalism.... The ability to connect an occupation to ideas about 'woman's nature' proved crucial to overcoming obstacles erected against women's participation."[19]

The last quarter of the nineteenth century witnessed a growing enthusiasm among American artists and collectors for so-called little media, notably watercolor, etching, pastel, book-cover design, and illustration, as well as a dramatic increase in the number of women who pursued professional careers in these popular art forms. The 1890 U.S. census recorded nearly 11,000 women working as artists and art teachers, up from a mere 414 women counted in the census of 1870.[20] This increase reflects not only advances in art education but also the influence of the Aesthetic and Arts and Crafts movements, which aimed to eliminate the division between the fine and decorative arts — the latter traditionally

the province of women — thus legitimizing and elevating women's work. However, even within these progressive movements, artistic labor was divided along gendered lines with the designation of certain media as either "masculine" or "feminine."[21]

Given that illustration was believed to be an extension of a woman's natural ability to draw in graphite and watercolor, it was promoted as an acceptable art for women to pursue, although female illustrators were often restricted to subject matter viewed as feminine, notably domestic scenes and children's literature. Moreover, the motives of some Arts and Crafts reformers were less than altruistic. Writing in 1877, Walter Smith, the Massachusetts State Director of Art Education, saw artistic training as a means to divert women's attention away from their fight for equality: "Give our American women the same art facilities as their European sisters, and they will flock to the studios and let the ballot-box alone."[22] As women enrolled in art schools across the country in unprecedented numbers, they did not, as Smith projected, abandon the fight for the right to vote. Instead, they used their skills, notably as illustrators, to advocate for equality in their profession and in society.

**Women of the American Art-Poster Movement**

The 1893 World's Columbian Exposition in Chicago played an important role in promoting women's work, notably in the graphic arts. The New York–based designer Alice Cordelia Morse championed the profession in a chapter on women illustrators for a publication devoted to the art and handicraft in the fair's Woman's Building: "About twenty years ago, we could count on the fingers of one hand all the women seriously engaged in this work. . . . Having obtained an entering wedge, they were not long in availing themselves of their opportunity, and now it is an acknowledged fact that any woman possessing the requisite talent, training, and practical experience in working for reproduction, is assured a profitable return for her labor."[23] Illustration emerged as a promising career path for young women, who, Morse advised, "would do well to follow it more largely than they have done heretofore."[24]

In that same year the publisher Harper and Brothers launched a new advertising campaign with a poster promoting the April 1893 edition of *Harper's Monthly Magazine*. Designed by Edward Penfield, head of the magazine's art department, this poster started a popular craze for literary art posters in the United States. Over the next six years Penfield

designed a poster for each monthly issue of *Harper's* (pls. 76–85), and the immense success of his work inspired large and small publishers alike to commission posters advertising their latest books and magazines. Although commercial posters were not new in the United States, the literary posters of the 1890s differed dramatically from earlier examples in that they embraced avant-garde aesthetics and credited artists for their designs.[25] Reproduced in multiples for public display and private consumption, they functioned as not only advertisements but also collectible works of art.

As a new and relatively undefined art form, the poster appealed to aspiring women artists, who could access their design training and drafting skills to create works that would prominently bear their names. Much like the recently revived media of etching, pastel, and watercolor portrait miniatures, art posters offered these women important opportunities to compete on equal ground with their male contemporaries. Designs could be produced at home using readily available materials, such as graphite and watercolor, both of which were already closely associated with women's work. The poster was, therefore, an art form that women could pursue without disrupting the status quo or threatening popular perceptions of their femininity. Moreover, women were often associated with the commercial arts and consumerism more generally. Consumption was long understood as a feminine activity, and publishers geared their advertisements toward women, who, Bogart argues, "were important not only as readers but as purchasers of the goods publicized."[26] Within just two years of Penfield's first advertisement, women — who had been not only a primary subject of the poster but also its target audience — emerged as accomplished producers of this new medium.

The close relationship between publishers and artists during the 1890s provided women with an entrée into the field.[27] Many of the book and magazine publishing firms that commissioned advertising posters already employed women as illustrators and cover designers. Morse, for example, began designing book covers for Charles Scribner's Sons in 1887, and over the next decade she worked for several eminent firms, including Harper and Brothers, the Century Company, and Dodd, Mead and Company.[28] Her eye-catching poster for Ian Maclaren's book *Kate Carnegie* (pl. 68) demonstrates her familiarity with the tenets of advertising and the so-called poster aesthetic.[29] Integrating text and image, the work foregrounds a fashionably attired woman in a boldly simplified landscape. She appears to stride forward with some speed as her cape

blows open to reveal a plaid lining, adding to the decorative quality of the work. With its broad, flat areas of color, strong outlines, and elevated perspective, Morse's composition also shows the influence of popular Japanese wood-block prints and Art Nouveau aesthetics.

Stylistically, Morse's *Kate Carnegie by Ian Maclaren* poster departs from her book-cover designs, which tended to be ornamental rather than figural. The lack of uniformity between advertising posters and book covers was not uncommon in the era, as the two media developed independently, even though women artists such as Morse often worked in both fields.[30] Printed in 1896, the cover for *Kate Carnegie* (fig. 9), designed by Blanche McManus Mansfield, differs dramatically from Morse's poster. On the binding a decorative arrangement of bluebell flowers encircles the title and the author's name, while the artist's monogram "BMM" is entwined in a stem at lower right. Like Morse, McManus Mansfield designed book covers and advertising posters, varying her style to best suit the medium. Both art forms, despite their distinct qualities, required the illustrator's skillful integration of text and imagery.

The visual disparity between a book's cover and its advertising poster is evident even when a publisher employed a single designer for both. For example, McManus Mansfield adopted two very different styles in the cover (fig. 10) and the poster (pl. 64) for Rudyard Kipling's *Captains Courageous*. Published in 1897, the book follows the adventures of a wealthy New England teenager who is rescued by a fishing schooner after falling off a steamship in the North Atlantic Ocean. In her poster, the artist captured this critical moment: the black hull of the steamship bifurcates the composition on a diagonal as a fisherman reaches out to rescue the boy from rough, choppy waters. The poster's angular composition and bold color palette enhance the drama of the scene, whereas the cover design, which sets a schooner against a highly stylized fishing net with glass floats, is elegant and subdued.[31] *Captains Courageous* had no interior illustrations, but McManus Mansfield provided illustrations for later works by Kipling, including *Mandalay* (1898) and *Recessional: A Victorian Ode* (1899), both of which were published by her husband's firm, M. F. Mansfield and A. Wessels.

McManus Mansfield also illustrated and authored several children's books, a genre believed to be particularly well suited to the temperament of women artists. Her tour de force poster (pl. 63) advertising *The True Mother Goose with Notes and Pictures by Blanche McManus* was published by Boston's Lamson, Wolffe and Company in 1895. Both whimsical and

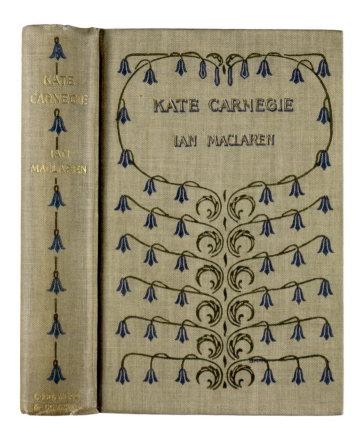
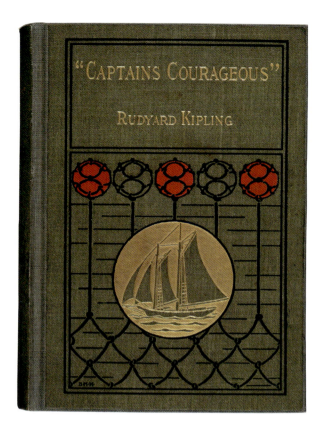

FIG. 9 | Blanche McManus Mansfield (American, 1870–1929), cover design for Ian Maclaren, *Kate Carnegie* (New York: Dodd, Mead and Company, 1896). Widener Library, Harvard University, Cambridge, Mass.

FIG. 10 | Blanche McManus Mansfield, cover design for Rudyard Kipling, *Captains Courageous* (New York: The Century Company, 1897). Houghton Library, Harvard University, Cambridge, Mass.

ominous, it features a flock of black and white geese flying over a carefully delineated cityscape. In addition to the poster, she designed the cover and interior illustrations of the book, for which she also wrote the introduction.[32] One year later, her poster for *The True Mother Goose* was included in an exhibition of contemporary American, French, British, and German posters held at the Pennsylvania Academy of the Fine Arts in Philadelphia.[33] Aimed at promoting the poster as a collectible fine art, the exhibition included the work of more than one hundred artists, seven of whom were women.

Ten posters by Reed were also displayed in the show, including *The Boston Sunday Herald, March 24* (pl. 111) and *Albert Morris Bagby's New Novel, Miss Träumerei* (pl. 105) — the latter praised in *Bradley: His Book* as "probably the best" of her designs.[34] In both posters young women engage in leisure activities, namely reading and playing music. Their upswept hairstyles and plunging low-backed dresses accentuate their bare shoulders and necks, which Reed dramatically elongated using a lithe, serpentine line. Although portrayed in a somewhat sensuous manner, the women are absorbed in their respective pastimes, as if oblivious

to the viewer's gaze. Her figures thus conform to contemporary depictions of idealized femininity and reflect the growing predominance of the modern woman — also known as the era's "New Woman"— as the primary subject and consumer of art posters and illustrated periodicals.

Both male and female illustrators placed women in recognizable and relatable social scenarios — reading (pls. 20, 100, 104), boating,[35] riding public transportation (pls. 38, 83), ice skating (pl. 117), playing with cats (pl. 80), and bicycling (pls. 12, 21, 36, 69, 87). As Bogart notes, these women were "always financially comfortable, always Caucasian. Together they presented heartwarming, affirmative views of a pre–World War I world of shared values and experiences touted as American. . . . As such, they represented a crucial shift from an older ideal of illustration as purely artistic medium to its newer purpose as instrument and expression of consumerist commercial values."[36] Reed adopted the popular trope of the female reader in several of the posters she designed in 1895–96, including *The Penny Magazine* (pl. 109), *The House of the Trees and Other Poems by Ethelwyn Wetherald*,[37] *The Best Guide to Boston*,[38] *The Boston Sunday Herald, March 24* (pl. 111), and *Behind the Arras by Bliss Carman* (pl. 112). Surrounded by natural elements, including chrysanthemums, lilies, and flowering trees, Reed's stylish women gaze down as if spellbound by the very books their images aim to sell. Publishers undoubtedly believed that Reed's identity as a woman gave her a particular aptitude for depicting other women, and the artist may have seized upon this essentializing notion to carve out space for herself as an illustrator and designer.

In 1897 the poet Bliss Carman penned "The Girl in the Poster: For a Design by Miss Ethel Reed" in response to the enigmatic female protagonist of the artist's poster for Carman's *Behind the Arras*: "With her head in the golden lilies, / She reads and is never done; / Why her girlish face so still is, / I know not under the sun . . . In a volume great and golden / Would better beseem a sage, / Her downcast look is holden; / But I cannot see the page."[39] Reed herself was an avid reader, as reported in the press. During a visit to the artist's studio, James MacArthur — the critic who emphasized the artist's interconnectedness with her female subjects — recalled "a little shelf containing about a score of books, composed for the most part of well-thumbed literary classics. I remarked especially a copy of Keats and an edition of *Omar Khayyám*, which bore evidences of frequent reading. There was another shelf, I must confess, which groaned beneath the weight of what looked like French novels, whose character I shrank

from inspecting lest I should dispel the pleasant illusion I had formed of Miss Reed's elegant and dignified tastes in literature."[40]

Reed also executed several posters advertising children's books, including *Fairy Tales*[41] and *Arabella and Araminta Stories* (pl. 107). Like many of her female contemporaries, she had great success in children's literature. In fact, her earliest known illustration, *Butterfly Thoughts*, was published in the June 1894 issue of the children's magazine *St. Nicholas*.[42] The designs she created for *Arabella and Araminta Stories* are among her finest illustrative works. Commissioned by the Boston-based publisher Copeland and Day, Reed employed one coherent visual aesthetic for the book's cover, endpapers, interior illustrations, and advertising poster (figs. 11–13, pl. 107). Although her consistent approach across media was ahead of its time, it became an industry standard by the turn of the twentieth century.[43]

Critics generally praised Reed's work for *Arabella and Araminta Stories*, notably her interior illustrations, which were described in *Bradley: His Book* as "conceived in a true poster spirit, and while grotesque and Japanesy, have a strong feeling for childhood" and in *The International Studio* as "deliciously naïve . . . concerned with bold lines and big silhouettes. The likeness to nature is as far removed as possible, and decoration is triumphant."[44] Reed later recalled, "I have never enjoyed doing anything so much . . . as the drawings for these stories. It was lots of fun; I was a child with Arabella and Araminta, and dwelt with them in the happy Land of Make-Believe."[45] However, the fantastical side of her work did generate some criticism. *The Book Buyer* found her illustrations to be "strange and mysterious," noting that "if all children were brought up in the most advanced school of aesthetics, the world would probably be a veritable garden of yellow asters . . . and the children will go to bed and dream about little girls who look like glorified queens of spades."[46] Nevertheless, limited signed copies of the book, printed in a variety of colors, became sought-after collectibles.[47]

Like the book's front and back covers, Reed's advertising poster features mirror images of the twin sisters, their dresses joined together to create one striking, flat black mass at center, the swelling forms outlined with sinuous black contours. The artist encircled the girls in a ring of bright red poppies — a favorite motif that she adopted in her first poster for *The Boston Sunday Herald* (fig. 7).[48] The poppy motif also appears on the book's cover, where the girls hold a garland that extends across the spine, and on the endpapers, where the highly stylized flowers

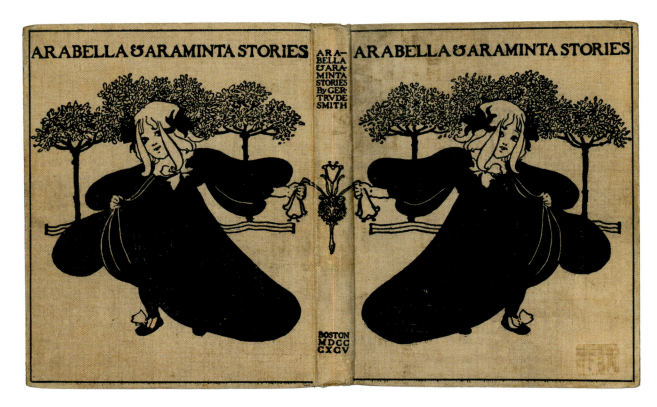

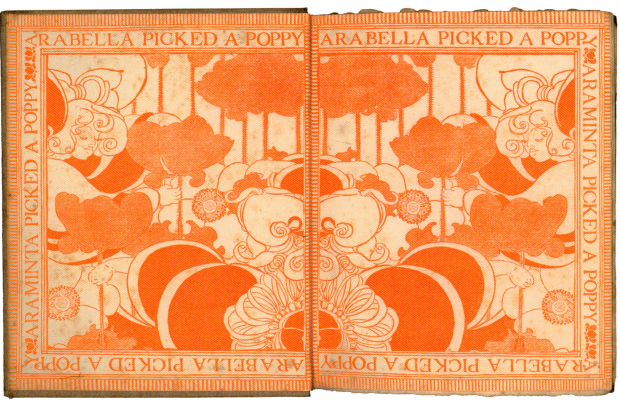

BY WOMEN, FOR WOMEN

36

FIGS. 11–13 | Ethel Reed, cover design, endpapers, and illustration for Gertrude Smith, *Arabella and Araminta Stories* (Boston: Copeland and Day, 1895). Delaware Art Museum, Wilmington, Helen Farr Sloan Library and Archives

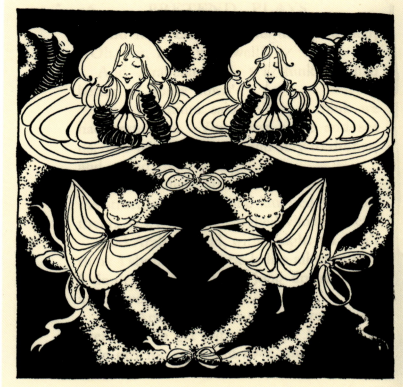

AND WHEN THE DOLLS BEGAN TO DANCE, YOU SHOULD HAVE HEARD THESE LITTLE GIRLS LAUGH.

are framed by a border of repeating text that reads: "Arabella Picked a Poppy" and "Araminta Picked a Poppy." Popular throughout the 1890s, poppies were employed by artists for both decorative and symbolic purposes, often taking on an erotically charged meaning. Reed incorporated poppies both in purely ornamental designs, such as her poster for Julia Ward Howe's *Is Polite Society Polite and Other Essays* (pl. 113), and in more suggestive, sensual contexts, such as her poster for José Echegaray's *Folly or Saintliness* (pl. 106). In the latter she distinguished the female figure from the black backdrop using only a serpentine orange line, displaying a skillful use of negative space. Provocatively holding a poppy and gazing directly at the viewer, the woman embodies the popular fin-de-siècle trope of the femme fatale, luring us in with her beauty and mysteriousness.

A slightly unsettling, subversive quality runs through several of Reed's posters, including those designed to advertise children's books.

As the art historian Erica Hirshler observes, Reed's design for Louise Chandler Moulton's *In Childhood's Country* (pl. 108) is "anything but juvenile . . . a young blonde girl teases the viewer: her eyes are partly closed, her lips are open, her blouse slips from her slim bare shoulders."[49] Although one contemporary critic compared the young girl to "the delicious bambinos of Della Robbia"— a reference to the colorful glazed terracotta sculptures by the family of Italian Renaissance artists — she does not embody the sweetness and innocence present in Reed's earlier designs, such as *Fairy Tales*; those qualities are here replaced by a disquieting sensuality characteristic of the British Decadent movement and the work of artists such as Aubrey Beardsley.[50] Additionally, Reed designed the cover, endpapers, and interior illustrations for Moulton's book, completing the commission after her move from Boston to London in 1896.[51] While abroad, she continued to design literary posters, including *The Quest of the Golden Girl*, which *The International Studio* noted "may be seen all over the London hoardings."[52] She was also appointed art editor of the London-based periodical *The Yellow Book*, taking over the position from Beardsley.[53]

Founded in 1894, *The Yellow Book* was an innovative quarterly magazine featuring poems, short stories, and illustrations by leading authors and avant-garde artists. Published in London by John Lane and in Boston by Copeland and Day, it was bound in book form with a yellow cloth reminiscent of the yellow paper used to wrap illicit French novels, such as those MacArthur saw in Reed's studio. Its first four volumes had cover designs and illustrations by Beardsley, whose sexualized and macabre imagery helped shape its notorious reputation. Reed, who had worked for Copeland and Day in Boston, may have obtained her new appointment through the publisher. Her first works for *The Yellow Book* appeared in the January 1897 volume, for which she contributed the cover design and frontispiece (figs. 14, 15), as well as four drawings, notably a self-portrait based on Frances Benjamin Johnston's earlier photograph (fig. 8).[54] Although she adopted an Art Nouveau style remarkably reminiscent of Beardsley's, critics were nevertheless grateful to have Reed at the helm, comparing the transition between the two illustrators as having "passed from strong drink to tea."[55] Despite their youthful beauty, alluring gazes, and seductive décolletage, Reed's female figures were seen as the antithesis of Beardsley's aggressively independent women, and the artist's own femininity was believed to neutralize any untoward undercurrents in her art.[56]

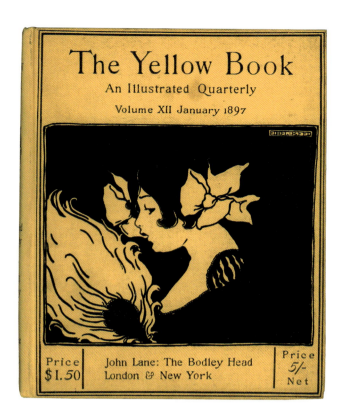
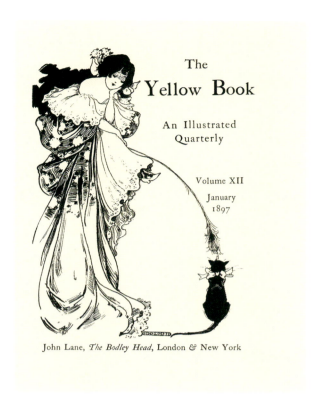

FIGS. 14, 15 | Ethel Reed, cover design and frontispiece for *The Yellow Book: An Illustrated Quarterly, Volume XII* (London and New York: John Lane, January 1897). Delaware Art Museum, Wilmington, Helen Farr Sloan Library and Archives

Reed also contributed two drawings to *The Yellow Book*'s final volume, published in April 1897. Although the publication was short-lived, its influence was far reaching, inspiring several so-called little magazines in cities across the United States, including *The Chap-Book* (1894–98) in Chicago, *The Fly Leaf* (1895–96) in Boston, *M'lle New York* (1895–98) in New York City, *Moods* (1895) in Philadelphia, *The Lotus* (1895–97) in Kansas City, and *The Lark* (1895–97) in San Francisco.[57] Dedicated to promoting avant-garde art and literature, little magazines employed many of the advertising strategies used by mainstream publishers, most notably marketing their publications with art posters. *The Lark* commissioned female illustrator Florence Lundborg to design several promotional posters during the publication's two-year run. Founded by artist-writers Frank Gelett Burgess and Bruce Porter, *The Lark* aimed to promote a new "California style" in art and literature, which they hoped would garner respect and appreciation for the unique cultural production of the Golden State.[58] In the end, Burgess and Porter's attempts to distinguish *The Lark* and establish a truly regional style yielded mixed results; yet many of the magazine's advertising posters, including those designed by Lundborg, represent an innovative departure from the East Coast

FIG. 16 | Florence Lundborg (American, 1871–1949), cover design for Bertha H. Smith, *Yosemite Legends* (San Francisco: Paul Elder and Company, 1904). The Metropolitan Museum of Art, New York, Watson Library Special Collections

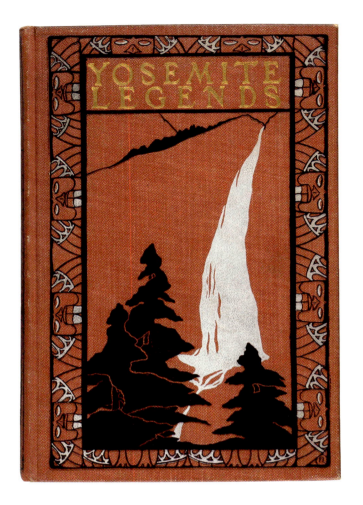

poster movement, most notably in their technique of wood-block printing, rather than lithography. Moreover, Lundborg looked to the unique topography of Northern California's landscape for inspiration. Her posters advertising the November 1895 and November 1896 issues (pls. 59 and 58, respectively) exemplify her distinctive style, in which she applied the aesthetic principles of the poster movement — including broad, flat areas of color; bold outlines; and simplified forms — to illustrations of Mount Tamalpais on the Marin Peninsula and the area's redwood forests.

Lundborg's poster for the August 1896 issue of *The Lark* centers on a nude, seemingly androgynous figure playing a pan flute against a decorative backdrop of green leaves (pl. 61). The design is reminiscent of Bradley's fifth poster for *The Chap-Book,* which was published in 1895 and depicts a nude, albeit clearly female, figure holding a pan flute in a verdant landscape (pl. 7). Lundborg's design may have been an artistic homage to Bradley, who had championed *The Lark* in his *Chap-Book*

and, following the publication's final issue in May 1897, would mourn its passing, noting that its cessation "snapped one of the threads which bound San Francisco, in a literary way, to the rest of the world."[59] Lundborg soon turned her attention to other artistic pursuits, including book-cover design, illustration, and mural painting. Like Reed, she adapted the aesthetics of the art poster to the conventions of book illustration, providing drawings for the publisher William Doxey's 1900 edition of *The Rubáiyát of Omar Khayyám*, as well as a cover design and interior illustrations for Bertha Smith's *Yosemite Legends*, published in San Francisco in 1904 (fig. 16).

The stylistic similarities between Lundborg's posters for *The Lark* and her later cover for *Yosemite Legends* also reflect a major shift in book and magazine design around the turn of the twentieth century — one that ultimately led to the demise of the literary art poster. These popular and collectible works of art soon came to overshadow the books and magazines they were intended to advertise, and the poster's failure to increase sales led publishers to lose interest in the medium. Instead, as the art historian Nancy Finlay explains, publishers commissioned artists to design book and magazine covers that looked like art posters.[60] Both male and female illustrators made the shift from poster to cover design, as evidenced by Lundborg's *Yosemite Legends*, although several women, including Morse, McManus Mansfield, and Reed, had been designing book covers throughout the 1890s.

In 1899 the critic Mabel Key wrote: "The bright colors and weird fancies which we have associated with the poster world, for the past four or five years, seem to have faded from our rapidly changing modern life."[61] Her retrospective look at the movement did not discuss the work of a single female artist, focusing instead on the contributions of male illustrators, including Bradley, Joseph Christian Leyendecker, Maxfield Parrish, and Penfield.[62] Women were thus being written out of the art-poster movement's history before the turn of the century, despite the prevalence and popularity of their work. By 1912 the critic Herbert Cecil Duce dismissed their contributions as nothing more than amateurish dabbling, writing: "Before poster advertising was established as one of the more important industries, poster art was one of the fads that greatly interested art amateurs and the host of gentle societies and women's clubs. When it developed into a great advertising force and became the greatest and most successful of all advertising media, its vogue was less dilettante and more strenuous."[63] Even after the passing of the literary art

poster in the late 1890s, women continued to design and print posters, utilizing the format to promote women's art and equality.

**Posters for Women**

In 1897 the artist-educator Emily Sartain and the illustrator Alice Barber Stephens established the Plastic Club in Philadelphia. As a women-only club, it aimed to provide the same professional development, networking, and socializing opportunities of other artists' clubs, the vast majority of which prohibited women from joining. Among the Plastic Club's founding members was the artist Violet Oakley, who worked as an illustrator, painter, muralist, and stained-glass designer.[64] Like many women artists of the era, her versatility in various media reflected both the principles of the Aesthetic and Arts and Crafts movements, which aimed to bring art to all aspects of life, and the reality of women's lower wages, which often necessitated pursuing a wide array of work to earn a sustainable living. In the 1890s Oakley freelanced as an illustrator, contributing drawings to popular periodicals such as *The Century* and *St. Nicholas*. She also designed advertising posters, including *A Puritan's Wife by Max Pemberton*, published by Dodd, Mead and Company in 1896 (pl. 71). Morse designed the book's cover, which like the poster includes red roses — a leitmotif of Oakley's art and life. Along with the illustrators Jessie Willcox Smith and Elizabeth Shippen Green, Oakley rented the Red Rose Inn in Villanova, Pennsylvania, beginning in 1901, and the women soon became known as the Red Rose Girls.

Rather than developing a signature style, Oakley altered her aesthetic depending on the medium and the subject. While *A Puritan's Wife* reflects the influence of the English Pre-Raphaelites, a later poster advertising the *Plastic Club Special Exhibition of the Work of Jessie Willcox Smith, Elizabeth Shippen Green, Violet Oakley* reveals her familiarity with the avant-garde art poster (fig. 17). Published in 1902, it depicts an oversize female figure watering three long-stemmed red roses and, in the background, a manicured garden and pergola. The bold typography, prominent outlines, flat planes of color, and asymmetrical composition are reminiscent of earlier literary posters.

Jessie Willcox Smith also experimented in poster design. Although widely known for her children's book illustrations, in 1900 she was commissioned by Charles Scribner's Sons to create a poster advertising the publication of Josephine Daskam's *Smith College Stories* (pl. 131).

FIG. 17 | Violet Oakley (American, 1874–1961). *Plastic Club Special Exhibition of the Work of Jessie Willcox Smith, Elizabeth Shippen Green, Violet Oakley*, 1902. Lithograph. Collection of Patricia Likos Ricci

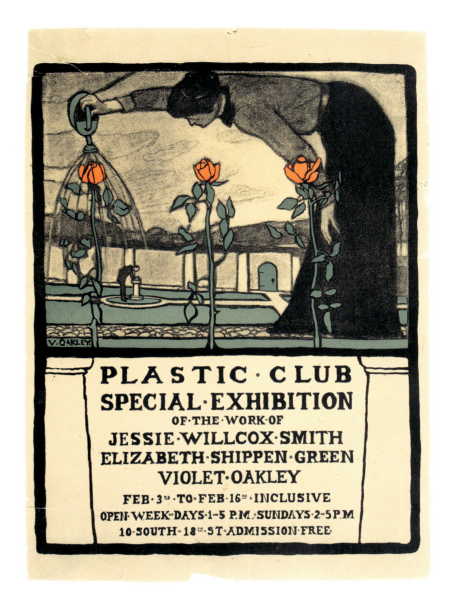

The image presents a row of five young women — presumably Smith College students — interlocking arms as they confidently stride forward in modern sportswear. Like Smith and the Red Rose Girls, they embody the active, independent ethos that defined the "New Woman." In the publication's preface, Daskam — herself a graduate of the women's college — noted, "If these simple tales serve to deepen in the slightest degree the rapidly growing conviction that the college girl is very much like any other girl — that this likeness is, indeed, one of her most striking characteristics — the author will consider their existence abundantly justified."[65]

FIG. 18 | Bertha Margaret Boyé (American, 1883–1930), *Votes for Women*, 1911. Lithograph, 23 x 15 in. (63.5 x 38.1 cm). The Arthur and Elizabeth Schlesinger Library on the History of Women in America, Radcliffe Institute for Advanced Study, Harvard University, Cambridge, Mass.

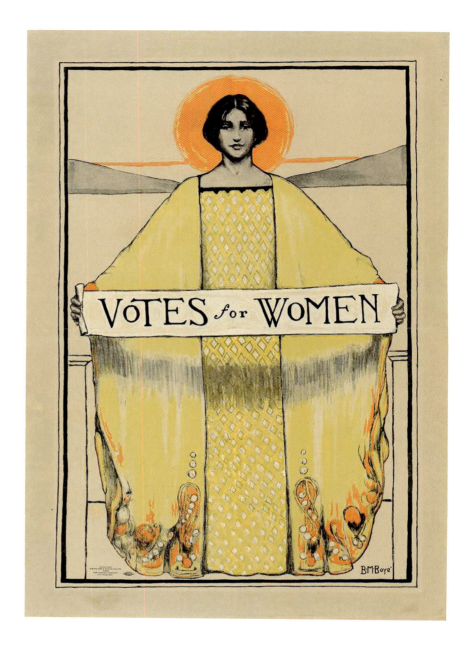

Similarly, Smith's poster, with its expressive design and bold use of negative space, demonstrates the "abundantly justified" existence of women in American illustration, which, as noted, was one of the artistic professions female students were encouraged to pursue. Although some reformers hoped art education would distract women from larger political causes, they nevertheless employed their training, particularly in illustration, to advocate for equality, perhaps most notably in the fight for the right to vote.[66] As male artists and critics worked to defeminize

illustration by minimizing women's contributions to the field, female artists and advocates saw the potential of the visual arts, particularly printed media, to advance the campaign for women's suffrage. The art poster became a potent tool in this struggle.

In 1911 the San Francisco College Equal Suffrage League organized a poster contest to select the best design promoting women's voting rights.[67] The winning design by Bertha Margaret Boyé reveals the continued influence of the art poster even after critics pronounced the movement obsolete (fig. 18). Standing against a stylized rendition of San Francisco Bay, Boyé's radiant female figure looks confidently at the viewer as she unfurls a banner reading "Votes for Women." Her Art Nouveau–inspired gown is elegantly draped over her outstretched arms to create a pyramidal form that fills nearly the entire picture plane. Drawing on the tried-and-true aesthetics of the art-poster movement, Boyé's simplified forms, bold outlines, striking color palette, and seamless integration of text and image led to the design's instant success. The poster was displayed in storefronts throughout San Francisco in the week leading up to California's vote for equal suffrage, which passed on October 10, 1911. As women continued their fight for equality, within both the art world and society at large, art posters by and for women proved to be powerful agents for change.

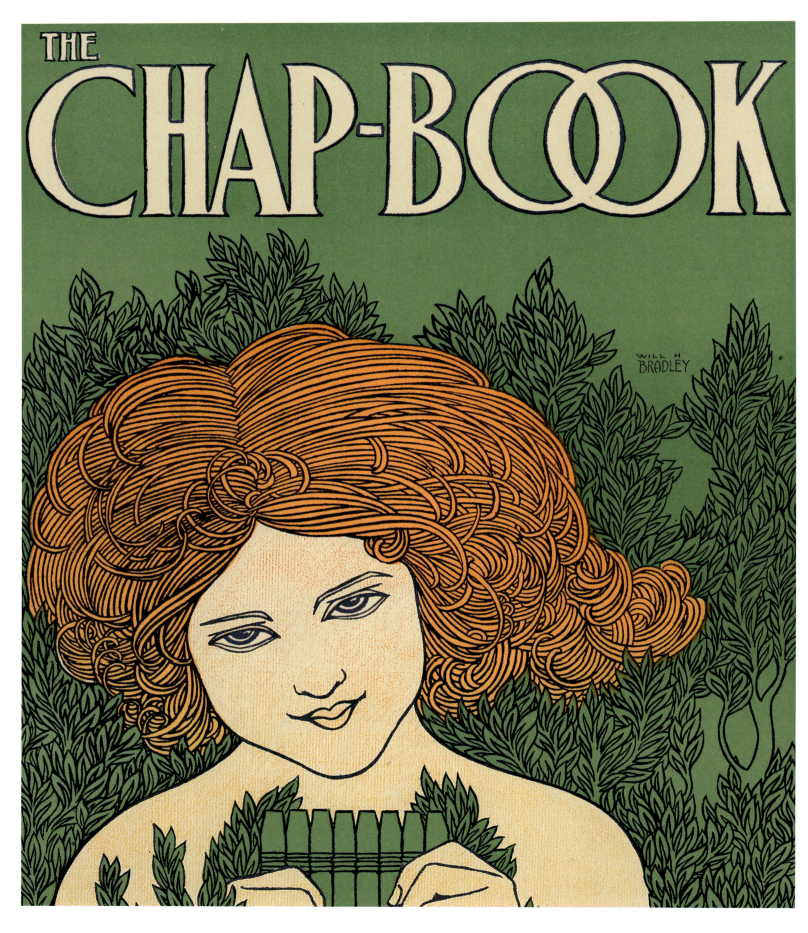

# POSTER PYROTECHNICS
## ADVERTISING PSYCHOLOGY AND THE FOUNDATIONS OF MODERN MARKETING

JENNIFER A. GREENHILL

IN EARLY 1914 the *Journal of the Royal Society of Arts* published a lecture titled "What Is a Poster?" by the English designer W. S. Rogers. By posing this question, Rogers invited renewed consideration of a pictorial selling format that had been around a long time. Rogers had spent more than a decade studying what he called "postercraft," which he addressed at length in a 1901 book covering design trends across cultures as well as practical considerations such as cataloguing and preservation.[1] His lecture retraced this ground with some notable updates and provocations, including a critique of English advertisers who spent "many thousands of pounds" annually on posters to sell their goods without investing in the systematic study of advertising's techniques and outcomes. He then pointed to research underway in the United States as an indication of progressive industry practices the English might follow: "In America [poster advertising] was being dealt with experimentally eleven years ago by Professor Walter D. Scott, Professor Gale, and others, who have determined what they term 'attention values' for various positions, styles, sizes, etc., of advertisements, and . . . the data they have accumulated would constitute a very excellent basis for anyone having time and inclination to follow up the matter in this country."[2]

The professors mentioned by name — Walter Dill Scott and Harlow Gale — were two of a group of American advertising psychologists who came of age professionally in the 1890s, having learned the principles of psychophysics and the methods of measuring human responses to external stimuli from Wilhelm Wundt, the founder of experimental psychology, at the University of Leipzig. Wundt's students returned to

their home country eager to make their study of the human mind serve practical concerns such as business productivity. Their research circulated internationally, and therefore the audience for Rogers's lecture at the Royal Society likely knew of advertising psychology through the English trade press. A series of essays titled "Experimental Science Applied to Advertising" had appeared from October 1903 to January 1904 in the London journal *Advertising*, inviting readers to improve upon Scott's methods with their own experiments and data.[3] Two months after this series began, another London journal, *The Advertising World*, ran the first of a twelve-part series, "The Psychology of Advertising," authored by Scott. Published from December 1903 to January 1905, the essays addressed "Beauty of Symmetry and Proportion," "Instincts Which Affect Advertising," and other topics, which inspired commentary in the London *Globe*.[4]

Gale and Scott had conducted experiments at the University of Minnesota and Northwestern University, respectively. Using actual print ads, both endeavored to establish which sorts of designs were most likely to attract attention and be remembered. Test subjects were exposed to a series of ads — projected on a wall, in Gale's case, or lodged in a makeshift periodical that Scott had created — and then asked which ones they could recall after a brief viewing. The psychologists based their evaluations on ad positioning, scale, legibility, tone, and balance between text and image, among other considerations. In summarizing their findings and prescribing strategies to improve the chances of recall, they developed a working proficiency in art theory and compositional principles. They essentially became connoisseurs of design and, in so doing, provided a necessary service to hard-nosed, profit-driven businessmen who found the workings of art to be just as mysterious as the workings of the human mind. Advertisers sought guidelines, which these specialists were happy to supply.

The researchers addressed the whole gamut of media available to advertisers seeking to make a positive impression on potential consumers, but the pictorial poster was fundamental to their thinking. It achieved its greatest visibility in the United States just as advertising psychology was beginning to influence industry practices and standards. It also gained its greatest respectability at this time, establishing new aesthetic standards for commercial imagery. Scholars tend to refer to the high-quality designs by Will H. Bradley, Edward Penfield, Ethel Reed, and others — which were often, but not exclusively, commissioned

by publishers to promote books and magazines — as self-consciously "artistic" posters. Infused with modernist design principles and made in sizes that facilitated collectability, the artistic poster was distinct from the often anonymous "commercial" poster, which could be "crude" in both its message (too pushy) and its style (too busy).[5] In contrast, the small-scale artistic posters are little gems of edgy design commissioned and collected by those who "felt an affinity with things foreign, urbane, and stylistically progressive."[6] But to sketch too sharp a division between "artistic" and "commercial" posters may make it difficult to see a larger truth about the former and its importance to emerging commercial techniques at the turn of the century.

The psychologists working in the context of an international explosion of interest in posters in the 1880s and 1890s were obliged to reckon with the power of these unusual and suggestive visual statements, which made long-winded argument superfluous to the commercial motive. So-called poster values — including eye-catching novelty, suggestiveness, and visual economy — would determine the look of advertising long after the craze in posters died down, as new formats diversified the field. As Mabel Key noted in an important 1899 essay, "the poster idea" was not on its way out but rather "passing on into other forms and interests of the moment."[7] By that point, the visual language associated with high-quality poster design had thoroughly rewired American advertising practice in ways that are still felt in image-driven marketing today.

I

Charles Matlack Price, a leading American authority on poster design in the early twentieth century, spelled out the visual fundamentals in a lavishly illustrated 1913 study that hit all of the high points of international poster design, featuring artists from Théophile-Alexandre Steinlen (whose work served as the book's frontispiece) to Ludwig Hohlwein to the Americans Bradley, Penfield, Reed, Maxfield Parrish, brothers Joseph Christian and Frank Xavier Leyendecker, and several others. By this time, it was well understood that "the poster must first catch the eye" if the beholder was to devote further thought to its message.[8] Price thought the poster had the best chance of doing so if it "suggested" an idea or storyline instead of meticulously delineating it.[9] Eye-catching designs conveyed ideas "directly, clearly, and pictorially" by avoiding masses of small letters and overly elaborate detail (including "ill-studied

values in shade and shadow") and favoring strong foreground action ("as though thrown on a screen").[10] The person encountering a poster should sense it more than see it — "a flash of thought in the brain-pan, flaring up in a blaze of line and color."[11] In Price's estimation, the successful poster was thus something like a fireworks show: "It should be pyrotechnic, and should depend for its impression, like a rocket, upon the rushing flight of its motion, and the brilliant, even if momentary, surprise of its explosion."[12]

The poster did not need to be big to create the conditions for such an immersive experience, and even the smallest posters could achieve a broad effect that made them feel much larger than they actually were. This was why book-cover designs in a bookseller's window could entice passersby to cross the street for a closer look while "the average theatrical poster occupying a space ten feet by twenty has not caused any sensation of interest, either optical or mental."[13] Nor did the number of colors used determine the result. Simple black and white could do the trick far more effectively than an overwrought design in "six colors and gold."[14] The successful poster's look of casual simplicity was calculated to tell the whole story "in the fraction of a second," requiring "no conscious effort" on the part of beholders to understand and appreciate it. The impression was strong — and, if successful, lasting — because it made "its story felt *instinctively* by the senses" rather than appealing to logic or reason.[15]

Published the same year that the groundbreaking *International Exhibition of Modern Art* opened at the Sixty-Ninth Regiment Armory in New York, Price's study conjures the sensorial pyrotechnics of modernist abstraction.[16] For him, the poster was implicitly artistic and, more specifically, modern, a product aligned with the broader innovations on view at the Armory show. But he took care to address the medium on its own terms, drawing on specific examples to make his case and establishing guidelines that the budding posterist might follow. Throughout, Price used the language of advertising psychology. To exemplify his principle of instinctive appeal, for example, he pointed to Robert J. Wildhack's design for the September 1906 issue of *Scribner's* magazine (fig. 19):

*This poster flares from a magazine stand, and carries with it a group of physical sensations as instantaneous as they are irresistible. One knows that it is summer, that it is very warm, with the sun almost overhead, and that one is on a sea-beach. The vista of dismal city streets is lost for the moment, and one feels almost grateful to this bit of colored paper for its*

FIG. 19 | Robert J. Wildhack (American, 1881–1940), *Scribner's, September*, 1906, reproduced in Charles Matlack Price, *Posters: A Critical Study of the Development of Poster Design in Continental Europe, England and America* (New York: George W. Bricka, 1913), 15

*vacation suggestions. And yet how little of actual delineation the mind has to feed upon in this poster. The secret lies in an apparently unerring conception, on the part of the designer, of the psychology of the thing. . . . One knows that a flat monotone of fine-textured grey, in the blinding, shadeless out-of-doors, is a beach. That a girl in spotless white would not be standing in a desert, is an idea which is grasped and dismissed in the first registration of thought between eye and mind. The conception, indeed, is so instinctive as to be instantaneous and to involve no mental effort. The downward shadow makes the sun almost a physical as well as an optical sensation.*[17]

Wildhack's design sold the September *Scribner's* to the middle-class readers of the illustrated literary monthly by associating it with the pleasurable experience of late summer leisure. Suffused with warm oranges and subtle peach tones, the composition flares like the sun's rays from the magazine stand, in Price's formulation, as if to invite the consumer to bask in its glow. Wildhack presents the magazine as a device for maintaining the warmth of vacation even when one has left the beach to return to "dismal city streets."[18]

If the purchaser took Wildhack's cue and reached for the September issue of *Scribner's*, she would mimic the action modeled by the woman on the poster. How could she not, since, according to Price, Wildhack had pictured an "irresistible" and self-reflective circuit between magazine and purchaser? Note how the ocher wrapper of *Scribner's* blends visually into the tanned hands of the redheaded woman who holds it open, up to her face. That enclosed subjective loop, which links hand and eye to mind in the upper half of the composition, gestures outward to communicate with the viewer in the bottom half, where words are given to the experience pictured. With an overlay of warm orange lettering operating like a legend for the scene, the poster suggests that this is how the September issue *feels*.

Wildhack's cover for the May 1908 issue of *The Century* takes feeling to new heights in a dramatically angled view of a woman perched along a biplane glider in the sky (fig. 20). With her prone body braced against the glider's wooden frame, she becomes one with the technological marvel, which allows her to defy the limitations of gravity — a potent metaphor for the promise of self-improvement offered by the commodity more generally. Many early twentieth-century poster designers struck a modern note with dramatic diagonals and figures swept similarly off

FIG. 20 | Robert J. Wildhack, *The Century, May*, 1908. Lithograph, 22½ x 14⅞ in. (57.2 x 37.8 cm). The Metropolitan Museum of Art, New York, Purchase, Leonard A. Lauder Gift, 1988 (1988.1120.17)

their feet. In a design by Ernest Haskell (who was clearly inspired by the work of the influential French poster artist Jules Chéret), a reader of *Truth* hovers in midair with copies of the magazine fluttering around her like paper birds, high above the figures at lower left and right, including an artist and a musician who fills the scene with sound (pl. 43). Red rose-petal-like formations whoosh up and down around the space,

notes of visual interest that appear to issue from both the trombone and the painter's brush, which is poised to pick up more red paint from the palette in hand. In another example — a poster promoting Albert Morris Bagby's novel *Miss Träumerei* (1895) — Ethel Reed rendered spiky, almost firework-like vegetation darting up from the lower left corner to connect a musician to her piano, as if to visualize the sounds springing forth from the instrument she plays (pl. 105). The music sheets before her, which contain no visible notes, seem to amplify the expressive properties of the foreground plant life — bright spots of color in what is a largely monochrome composition.

Despite their stylistic differences, these artists sought to activate a multisensorial experience through visual means. The advertising psychologists endorsed such tactics. They believed that an advertisement should excite the human nervous system by appealing to multiple senses, thereby deepening its impression. The consumer should be able to *hear* the piano, *taste* the food, *smell* the perfume, and *feel* the "pleasant contact" of a garment on her skin through the mental images sparked by the ad's descriptive content, both textual and pictorial.[19] Design that managed the challenge was, by definition, psychological advertising. As one business-school professor explained, an illustration capable of "calling up a multitude of sensations at one time, has so aptly adjusted itself to the mind of humanity, that even he who 'runs' may receive the message."[20] This was the domain of the poster, whose visual shorthand was communicated to people on the move and taking in myriad sensations along the way — the sights, sounds, smells, and textures of modernity.

II

The art of advertising was as fleeting as the passersby it sought to transform into consumers. For the psychologists, the end product was not the printed advertisement but rather the mental imagery that it stimulated. Imagery that left something to the imagination, such as that in Wildhack's posters, invited beholders to participate in the design by filling out the picture mentally or supplying details based on their own experiences. Poster advertisements might attract attention with what Price called a "vigorous" and even "bizarre" concept or treatment, but those that made a deeper impression managed, at the same time, to merge with the target consumers' experiences, priorities, or habits.[21] If the message could worm its way into viewers' minds without their knowledge of the

imposition, so much the better. That way, when a need or opportunity to make a purchase arose, the consumer was likely to feel that she had come up with the idea herself.

The effectiveness of this long-game strategizing was difficult, if not impossible, to measure. Evidence that exposure to an ad led to retention of the sales message was the holy grail of advertising research in its early days, although anecdotal information was in far greater supply than verifiable data points.[22] For example, Walter Dill Scott told the story of a young woman in Chicago who felt sure that she had never noticed the advertising placards lining the streetcars she rode regularly. But she ended up knowing "by heart" almost every ad placed there and had developed a high opinion of the products. "She was not aware of the fact that she had been studying the advertisements," Scott reported, "and flatly resented the suggestion that she had been influenced by them."[23] The fact that the young woman had forgotten the source of her knowledge about the goods was evidence of the power of streetcar advertising, which gave commuters a visual diversion to help pass the time on their journey (an average of fifteen minutes per ride, Scott estimated). The woman valued the goods advertised because she had unwittingly devoted so much time to getting to know them. A welcome distraction from the discomfort of public transportation (described in great detail by Scott) and the awkwardness of physical intimacy among strangers, these placards perhaps came to function like familiar friends on repeat viewings.[24]

Or perhaps the streetcar ads had simply worn down the commuter's defenses. In an essay equating advertising and hypnotism, one critic in 1892 argued that the barrage of ads encountered "in the papers and on the fences and in the street cars" brought about a "state of exhaustion" in the optic nerve, inducing the beholder's compliance with the suggestion to buy, "without stopping to consider why."[25] This was conversion by coercion, a perspective on advertising that would inform later treatments such as Vance Packard's controversial book *The Hidden Persuaders* (1957).[26] Even Price, the poster advocate writing in 1913, used aggressive language to describe the forceful imposition of that advertising medium on the public: "The poster is literally thrown in their faces."[27] The omnipresence of the poster was exacerbated by the transmission of poster values into other forms of commercial media. "Poster style," as defined by Price, turned out to be portable and unattached to any specific material configuration.[28]

## III

Price considered "poster style" to be synonymous with "advertising power," which helps to explain the visual dominance of poster values across commercial media in the late nineteenth and early twentieth centuries.[29] He devoted an entire chapter of his book to magazine covers, a regular topic of discussion in the advertising trade literature, which evaluated and compared the work of different designers from a marketing perspective. Because magazines were "hung conspicuously on news-stands with a view of attracting attention," Price wrote, "they differ in no essential features from posters proper."[30] Bradley agreed, advocating a "poster effect" from the newsstand.[31] Tasked with designing new layouts that would increase sales for *Collier's Weekly*, *Good Housekeeping*, and other journals for which he served as art director early in the twentieth century, Bradley advised illustrators to follow the lead of his own work. A restricted palette and a composition structured on flat planes of color made a sharper impact from the newsstand and outsold more naturalistic designs, he argued. But the color had to be just right given that, according to one handbook, certain contrasts would induce "wearying" labor in the act of perception instead of making the eye "dance" merrily.[32] Bradley sometimes made significant chromatic alterations to the designs his illustrators submitted in order to activate "pleasing" eye movement.[33]

The magazine format, with its page-turning dynamic, complicated the fine line between pleasant and unpleasant perceptual labor. Max Eastman, the editor of the socialist journal *The Masses*, protested the lengths to which the editors of general-interest journals went to keep the magazine consumer glued to the page, riveted by the novelty of bizarre layouts and jarring image-and-text arrangements that were designed with page flipping in mind.[34] Active diagonals, acute angles, and variations of scale were also employed to pitch products from the sides of buildings, sites of chaotic visual variety in their own right. But for critics of the magazine, wherein the hand-eye motions of consumption added a layer of animation, this disorderliness seemed amplified.

Eastman wrote about such animation in vivid terms. "The principal function of the art-editor," he wrote, "is to fix a magazine so that when it is held loosely in the left hand, and the pages run off rapidly by the right thumb, a sort of kaleidoscopic motion-picture results. Black spots and queer blotches are seen dashing from one part of the page to another, and the effect is quite stimulating to the curiosity."[35] In this account,

Eastman defamiliarizes the popular magazine, rendering it into a kinetic abstract object activated by the beholder's hands. Informed by the medium of film, Eastman's assessment of the mechanics of the magazine situates it as a related modern technology. He ultimately considered the magazine trade's investment in using such tactics to be a specious marketing ploy whose enticement necessarily wore off after the initial perusal. In his estimation, this kaleidoscopic approach to stimulating curiosity made for bad magazine pictures: "It is impossible to put much heart into the creation of a picture that is to be so treated."[36]

With this last assertion, Eastman betrays a conventional bias associating respectful reception with stilled, focused attention. He seems to define art (a picture with heart) as a thing that should not be transmuted into an abstract sign of the power of the consumer (into a blur created by flippant page thumbing). Eastman challenged the mystification of market capitalism within the pages of *The Masses*, championing an aesthetic of social purpose that was praised for the lively realism of its "rude, raw drawings."[37] The fracturing, kinetic abstraction that Eastman presents

FIG. 21 | Coles Phillips (American, 1880–1927), cover design for *Good Housekeeping*, November 1917. Sterling Memorial Library, Yale University, New Haven, Conn.

FIG. 22 | Coles Phillips (left foreground) and Edward Hopper (right foreground) at work in the C. C. Phillips Advertising Agency, 1906. Whitney Museum of American Art Archives, New York, Edward Hopper Research Collection

almost as an inevitability of the commercial press might be resisted by imagery that refused to idealize according to vague generalities and would instead insist on the specificity of both the subject portrayed and the artist's vision.[38] By contrast, images cultivated by those with an eye toward sales did not stand their ground in quite the same way — they were too malleable, too eagerly accommodating.

Such graphic design was posteresque. The term aptly describes the work of those who were the target of Eastman's criticism: the magazine illustrators who, following Bradley's example, extended the design principles of the poster into the popular press. Eastman may have had in mind, specifically, the artist Coles Phillips when he described the "magazine poster prodigy" whose work was like a "diagram" (fig. 21).[39] Phillips supplied designs to Bradley for *Good Housekeeping* and was a favorite among advertisers over the two-decade span of his career as an illustrator (1907–27), perhaps in part because he knew his advertising psychology. Before committing to illustration full time, he ran his own advertising agency in New York, employing fellow artists such as Edward Hopper. A photo of the C. C. Phillips Advertising Agency in 1906 shows Phillips at work across from Hopper, with Parrish's poster for the August 1897 Fiction Number of *Scribner's* tacked up on the wall as inspiration (fig. 22, pl. 73).

Phillips made a name for himself as an artist by adapting poster design to the framework of the magazine. Instead of treating all compositional elements uniformly, as Bradley and Wildhack did, Phillips created a contrast between worked-up features — typically the head, hands, and feet — and the flat areas where the figure's clothing merges into the image ground. By drawing attention to that ground, Phillips emphasized the materiality of the magazine itself, the paper and ink held in the hands of the consumer, who mentally supplied the missing outlines of the figures. In this way, he linked conceptual stimulation to the immediate sensuous reward of touch.[40]

At times Phillips offers graphic hints of his investment in the consumer's encounter with the magazine. In his *Good Housekeeping* cover from November 1917 (fig. 21) he guides the eye from the masthead and the additional text at upper right with a curvilinear swoop that whooshes counterclockwise around the figure and out of the frame at bottom right. In this example, Phillips seems to predict the gliding of fingers across the image surface and to understand that they would stop to grip the edge before moving into the letterpress sheets stacked behind. For cover imagery to operate successfully as an advertising proposition it had to momentarily halt the beholder while simultaneously inviting her to look beyond, to turn the page and repeat, again and again. The fade-away technique was Phillips's attempt to make the most of this tension.

## IV

The transference of poster values to magazine covers initiated complex thinking around design, materiality, and consumer engagement in the early twentieth century. But before this could happen, publishers had to see the cover's potential from a marketing perspective. It had been uncommon for magazine covers to change from issue to issue before Bradley proposed a series of varied cover designs for the Chicago-based technical journal *Inland Printer* in 1894.[41] As more publishers adopted this practice — encouraged to invest in imagery by advances in printing technologies and an influx of advertising dollars — they acknowledged the cover's capacity to function as an advertisement. "The cover of the magazine, changing each month, is a poster in itself," noted Frank Weitenkampf, head of the New York Public Library's Art and Prints Division, in 1912. "The cover is an 'ad,'" with the "unchanged cover" now "the exception."[42] Some publishers and their art directors began to conceive

FIG. 23 | Will H. Bradley, front and back covers of the first issue of *Bradley: His Book*, May 1896. Periodical with letterpress (relief process) illustrations, 10¼ x 5⅛ in. (26 x 13 cm). The Metropolitan Museum of Art, New York, The Will Bradley Collection, Gift of Fern Bradley Dufner, 1952 (52.625.29)

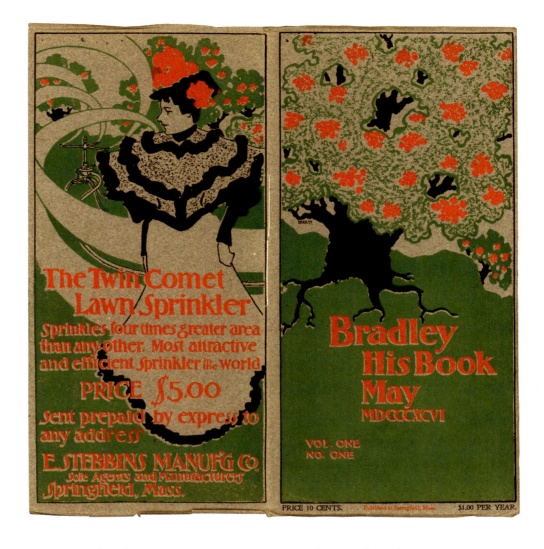

of front- and back-cover designs in concert, extending a color scheme, layout, or iconographical program from one side of the binding to the other. For the first issue of *Bradley: His Book* (an eight-number art and literature monthly Bradley launched in 1896), a back-cover ad for "The Twin Comet Lawn Sprinkler" is united with the front cover in form, tone, and even geography — the woman in the ad appears to occupy a position just left of the flowering oak tree on the front cover (fig. 23). The trade journal *Profitable Advertising* would later praise Bradley's thoughtful approach to the total magazine product in his art direction of *Collier's Weekly*.[43]

The 1908 Easter issue of *Collier's* was a standout, according to *Profitable Advertising*'s editor, George French, because it was so "Bradleyesque, in decoration and coloring (fig. 24)."[44] "I see Bradley all through it,"

FIG. 24 | Will H. Bradley (art director), front and back covers of *Collier's: The National Weekly*, April 11, 1908. Collection of the author

FIG. 25 | Will H. Bradley (art director), advertisement for Cluett, Peabody and Company, *Collier's: The National Weekly*, April 11, 1908. Collection of the author

French wrote in a letter requesting permission to reproduce the cover pages and a double-page ad in the next issue of his own magazine.[45] Bradley treated each page of the Easter *Collier's* as an "artistic whole" that conformed to "art standards as regards typography, balance, proportion, harmony, and color." The total product thus constituted, in French's estimation, "the best example of the application of the rules of art to large periodical pages."[46] For the headings on the front and back covers, Bradley used Gothic-style letterforms that signal the requisite ceremony and severity of the religious occasion but printed them in the bold orange that was his signature.[47] He set off the capitals with the sort of filigree found in illuminated manuscripts, the gold hearkening back to a medieval golden age of spiritually inflected page design. A lyre appears at the bottom of the back cover, mimicking the placement of a cherub on the front, an alteration cued by the ad's subject, Edison's phonograph. Guernsey Moore's illustration featuring a woman outfitted in vaguely Japanese garb folds the phonograph into the trappings of an Aesthetic lifestyle. But Bradley's art direction arguably does a better job of elevating the modern device to the status of art by its association with the lyre, thus rooting it in an ancient musical tradition. Both covers emphasize the immaterial but atmosphere-generating product of sound, which Bradley evoked visually with curvilinear forms that extend upward from the lyre and the cherub. That connection helps to solidify the harmonious relationship between the front and back covers. Note how his capital for "Easter" on the front cover not only rhymes with the "C" in *Collier's* but also echoes the shape of the lyre on the back. Closing the magazine issue in the same key in which it opened and making the phonograph integral to the journal's literal framework, Bradley situated the commodity on the level of the Easter service as a fundamental feature of American popular experience.

Edison's National Phonograph Company paid for this space of high visibility on the back cover of *Collier's* through its New York advertising agency, Calkins and Holden. However, Edison's ad manager, L. C. McChesney, understood that the credit was due to Bradley for this design. There seem to have been some reservations about Bradley's initial layout, but once the design was published, McChesney wrote, "Mr. Bradley has succeeded in winning an approval of his design without our really knowing it." The company would trust his judgment henceforth: "Should a similar occasion arise in the future, we will place ourselves more completely in Mr. Bradley's hands than we did in the present

instance."[48] McChesney also perceived Bradley's touch in the Cluett, Peabody and Company spread within the issue, whose color scheme and architectural framing blend with the covers (fig. 25). Similar elements inform an illustrated centerfold dedicated to the Easter holiday.[49] Together, these six color pages, spaced at roughly even intervals, gave order to the miscellany of the magazine, threading the cover, interior illustration, and advertising matter into a coherent and artistic whole.

V

Unlike art critics and industry insiders, the average consumer was not supposed to see the hand of an art editor throughout a magazine, for that would mean paying attention to details that were not meant to stand out. Bradley's goal was to make the structuring framework he supplied fade into the background, subsidiary to the magazine's featured content. His most successful design solutions were meant to disappear; indeed, disappearing was the true art of not only art direction but also advertising psychology, which infused every aspect of his practice. Bradley had always created in order to sell. "At the age of twelve I had begun to learn that type display is primarily for the purpose of selling something," he wrote in his autobiography. "In 1889, as a free-lance artist in Chicago, I had discovered that to sell something was also the prime purpose of designs for book and magazine covers and for posters. Later I was to realize that salesmanship possessed the same importance in editorial headings and blurbs." These "never-to-be-forgotten lessons" fused in the young designer's mind with the latest advertising theory.[50] He was working in Chicago on his first magazine designs (a masthead for *The Graphic*, decorative capitals for *The Century*, and a wider range of contributions to *Inland Printer*) when the city became the epicenter of advertising psychology around 1900.[51] In 1901–2 Walter Dill Scott explained in lectures and in print how psychological research could be mobilized for selling purposes.[52] Bradley, the "artist advertiser," as one critic described him, seems to have paid close attention.[53]

Bradley's poster designs from the 1890s give a strong indication of the decorative sensibilities that would become important to his later magazine art direction. Many of these are explorations of the pictorial potential of ornament when it is moved from the margins to take center stage. In a striking poster for *The Chap-Book* (1895), for example, a black Pegasus with wings outstretched repeats in diagonal formations across

FIG. 26 | Will H. Bradley, *The Chap-Book*, September 1895. Lithograph, 21 3/16 x 14 3/16 in. (53.8 x 36 cm). The Metropolitan Museum of Art, New York, Museum Accession, transferred from the Library (57.627.4[13])

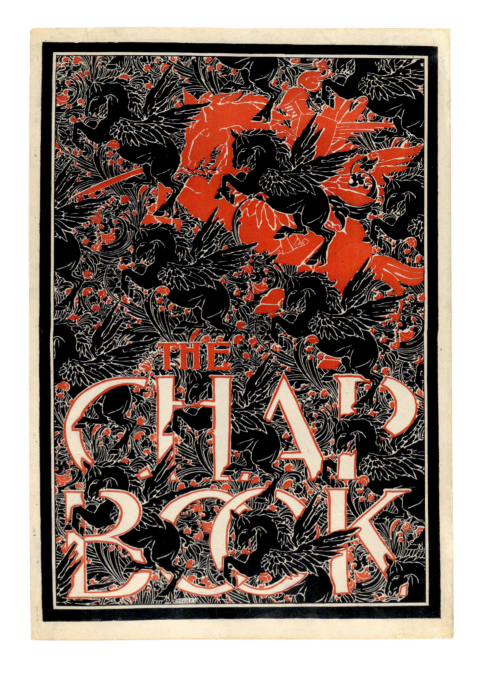

the sheet (fig. 26). The little winged horses interlock with the letterforms of the journal's title and superimpose a magnified version in red, ridden by an armored knight. The dense arrangement challenges the legibility of the journal title and the scene overall, creating a contest between "icon and word," as Ruth Iskin argues, "a dynamic battleground where neither element has the upper hand and both remain permanently enmeshed."[54] Bradley saw different units of type — whether letterform or ornament —

FIGS. 27, 28 | Will H. Bradley, illustration from "The Use of Borders and Ornaments" and cover design, *The American Chap-Book*, November 1904. Book with letterpress (relief process) illustrations, 7 1/16 x 4 5/16 in. (18 x 11 cm). The Metropolitan Museum of Art, New York, The Will Bradley Collection, Gift of Fern Bradley Dufner, 1952 (52.625.49)

as part of the same field, and he understood how to adapt them to just about any situation. The growing demand for commercial display at the turn of the twentieth century required that printers learn to make the most of the types they had on hand. When a client called for a "special drawing," Bradley advised that a picture composed out of type might be substituted, thus saving the money and time involved in hiring an artist to make a drawing whose use would likely be limited to one occasion.[55]

Countless fresh formations could be generated out of just a few decorative options, Bradley insisted. The *Chap-Book* Pegasus poster is a strong example of this principle.

Bradley explained his methods to fellow designers and potential clients in articles published throughout his career. The American Type Founders gave him free rein in the design of the promotional *American Chap-Book* (September 1904–August 1905), a house organ

that intermingled ads for the company's products with treatises authored by Bradley, all on pages illustrating the merits of the principles therein explained. For the November 1904 issue focused on borders and ornaments, he demonstrated how to work with the type units he offered for sale by using the same border decoration as both framing device and internal filler — the latter turned on its side and magnified to twenty-four point (fig. 27). A square joining unit anchors the corners of the external border and a smaller square frame in the upper register. The latter sets off a jaunty little character, the sort of graphic device a printer might acquire for use in a range of formats. (In the previous pages of the little *Chap-Book*, Bradley showed how this figure in eighteenth-century attire holding a tray could be used to visualize a hospitable server at "Jordan's Restaurant," for example.[56]) Reproducing these characters in a range of sizes on the chapbook's cover, Bradley communicated his willingness to tailor his designs for a client's specific needs (fig. 28). He referred to such figures as "trade ticklers," whose goal was to attract attention and create "a favorable first impression" so that the ad's message would, as he put it, "get by the barriers of the waste basket to the mind of the receiver."[57]

## VI

Maxfield Parrish made these types of whimsical characters the bread and butter of his commercial output. He was a master of cloaking the serious business of buying and selling in a fanciful storybook atmosphere. As the artist John La Farge wrote early in Parrish's career, the young artist's "marvellous imaginativeness" could "transport one suddenly into . . . fairyland."[58] Parrish had illustrated L. Frank Baum's *Mother Goose in Prose* (1897), and the figural formations that appear in that book migrated into his commercial commissions.[59] For example, Mother Goose later made an appearance in a Fisk Tires campaign, and fairy-tale kings found their way into both mural paintings and placards selling Jell-O. These characters, of course, also populated the ads and cover illustrations of magazines (fig. 29). Parrish was a pragmatic artist-businessman who sought to maximize his art's circulation, solidifying his brand in the process and achieving the highest possible return on his creative output. The commercial artist's work was designed to function as a flexible commodity, he believed, and it was only by cultivating its versatility — which depended on a certain degree of repetition — that the artist could fully reap the rewards of his product.

FIG. 29 | Maxfield Parrish (American, 1870–1966), inside front cover advertisement for Fisk Tires, *Life*, September 13, 1917. Collection of the author

Early examples of Parrish's work showcase his commercial intelligence. The composition that earned second place in *The Century* magazine's poster contest in 1896 established an iconography of timeless wonder that would be integral to the Parrish brand (pl. 75). In these "girl-on-rock" pictures, as they were later described, solitary figures lost in thought within natural surroundings seem to train their eyes on the air itself, as if to designate it as the amorphous, abstract stuff stimulating their simultaneous desire and fulfillment.[60] Parrish's work exemplifies early twentieth-century advertising's preoccupation with atmosphere. If "dematerialized desire . . . animated consumer culture" in this period, as the historian Jackson Lears explains, advertising imagery's fundamental task was to take the material substance of a given product and transmute it into something beyond its obdurate particulars, reinforcing Karl Marx's conception of the "mysterious character of the commodity-form."[61] Parrish's compositions embody a tension of commercial rhetoric when the advertising psychologists and their followers sought to guide the consumer's stream of consciousness toward a particular object, but indirectly, through positive associations and sensations. In some ways, therefore, Parrish's works are about consumer psychology, about the kind of conceptual flight that advertisers knew they had to produce as the first step toward converting viewers into buyers. As metacritical testaments to early twentieth-century marketing procedures, goals, and expectations, his compositions are far more rooted in everyday particulars than their fantasy frameworks suggest.

The Vermont Association for Billboard Restriction bought into the fantasy framework by using Parrish's art as a contrast to the billboards that compromised the view on New England roadsides. "Buy Products Not Advertised on Our Roadsides," reads a postcard featuring a Parrish landscape blocked by a billboard (fig. 30). The depicted billboard illustrates the sentiment expressed at right, "The Billboard/A Blot on Nature," making the mountain view inaccessible and supplanting the vanishing point with a black hole — a blot of splattered paint.[62] By associating Parrish's art with a natural beauty worth protecting from commercial intrusion, the campaign demonstrates just how successfully the artist had sublimated the commercial logic of his output. A Parrish picture was nature itself.

Billboards are essentially posters of mammoth scale. A promotional book published by the Outdoor Advertising Association of America in 1928, *Outdoor Advertising — The Modern Marketing Force*, insisted on the

FIG. 30 | Postcard issued by the Vermont Association for Billboard Restriction and the National Roadside Council, featuring a Maxfield Parrish landscape. Dartmouth College Library, Hanover, N.H.

FIG. 31 | Michael M. Heiter (American, 1883–1963), "The Spirit of the Poster," frontispiece for *Outdoor Advertising — The Modern Marketing Force* (Chicago: Outdoor Advertising Association of America, 1928). Collection of the author

artistic potential and value of billboards. Michele H. Bogart explains the triumphant tone of this rhetoric, which aimed to ensure the association's ability to regulate itself without external intervention: "With the defeats of the reformers and the rise of the highways as advertising territory, outdoor advertisers were flexing their muscles and asserting influence. By means of statements on standards and articles on power art and artists in house organs like *The Poster*, outdoor advertisers took an active

role in educating clients about the value of art, as they defined it."[63] Unsurprisingly, advertising psychology was at the root of the Outdoor Advertising Association's conception of quality billboard art. The 1928 book includes a chapter titled "Psychology of Outdoor Advertising," with a section treating "The Power of Suggestion," and a bibliography listing works that influenced the advertising psychologists, such as Boris Sidis's *Power of Suggestion* (1898), two books by Walter Dill Scott, and Daniel Starch's *Principles of Advertising* (1923).[64] The practitioners of outdoor advertising thus relied as much on high-level theorizing about human nature as they did on art principles to carry their sales messages. The book's frontispiece, "The Spirit of the Poster"—presenting the medium as a bringer of light in allegorical form—was equal parts mystification and illumination (fig. 31).

Art and psychology were intrinsically linked in this period of the advertising industry's consolidation as an explicitly pictorial enterprise. "The cold, hard, implacable, indisputable fact, is that no advertisement whatever can approach the maximum of its power unless in its creation both psychology and art have a controlling influence," George French declared in *The Art and Science of Advertising* (1909).[65] The posters of the 1890s played a crucial role in establishing this link between art and psychology. By thinking with the poster, the advertising psychologists codified the principles that would help to fuel the industry's widespread shift toward pictorial, consumer-focused campaigns. Poster values therefore determined the language of commercial persuasion, broadly conceived, and continue to inform our own digital-marketing strategies in the twenty-first century.

# A COMPLEX ART
## TECHNIQUES FOR A NEW POSTER AESTHETIC

RACHEL MUSTALISH

IN THE LATE NINETEENTH CENTURY, the expansion of the publishing industry, the increased proliferation of newspapers and magazines, and the development of illustrative advertising spurred the rapid invention and refinement of methods for printing images. As part of this boom, publishers commissioned artists to design strikingly modern posters to advertise their publications. Concurrent advancements in lithographic technology enabled the production of these posters, which are characterized by a strong graphic sensibility, large, flat areas of color, handwritten text, innovative patterning, and minimal yet pronounced lines. It was the job of skilled printers to translate the poster artists' original designs into cost-effective, mass-produced sheets, availing themselves of the latest techniques. An in-depth analysis of posters in the Leonard A. Lauder Collection has led to the discovery that, despite their commercial purpose, many of these prints are highly complex and sophisticated in their manufacture, demonstrating how the combination of artistic vision and creative printing can yield remarkable results.[1]

The term *lithography* stems from the Greek words for stone (*litho*) and writing or drawing (*graphy*). Lithography is a called a planographic technique because the matrix — the surface from which printing is done — is relatively flat, unlike the plates used in relief printing, engraving, and etching. In 1796 the German inventor Alois Senefelder invented the lithographic process, which relied on the inherent immiscibility of oil and water to make prints from matrices of Bavarian limestone. Areas where greasy matter, such as fats or oils, was applied to the smooth, porous surface of the polished stone became oleophilic; during the printing process such areas accepted an oil-based printing ink and repelled

water. In contrast, the unmarked areas, when dampened with water-based materials such as gums, repelled the oil-based printing ink, leaving them blank during the printing process. Together, the two chemically distinct areas formed the design.[2]

Over the years, lithography was refined to produce cleaner and crisper images. The availability of a wider variety of inks expanded the chromatic possibilities, and that of steam-powered presses increased efficiency. In the nineteenth century, the method was adapted to sheet-metal matrices, often called *zincographs* or *algraphs* (after zinc and aluminum, respectively). However, the chemical processes originally conceived to work on limestone remained unchanged. Although metal matrices offered advantages, lithographic stones could be readily modified and reused by grinding and repolishing the surface. In the United States, where a robust apparatus for lithographic printing was established, lithography was used into the twentieth century to print everything from tickets, show cards, and bookplates to detailed reproductions of works of art.[3]

The lithographic process was fast and inexpensive compared to other printing techniques. A capable printer could produce about fifty lithographs per hour with a manual press and between one thousand and three thousand lithographs per hour with a steam-driven press.[4] Lithography also had a notable creative edge because it captured the artist's stroke directly: one could apply the greasy lithographic material with a pen, brush, or airbrush; draw thin lines with an oily pencil; and imitate chalk, pastel, or other drawing media with a crayon stick. Another advantage to the lithographic process was that artists and designers could employ a transfer paper, which obviated the need to work directly on the stone by enabling the original design to be created on paper and then transferred to the lithographic matrix. Thus, artists could work anywhere without the need to transport heavy matrices (a stone measuring twenty-one by fifteen inches had an average weight of eighty-five pounds).[5] In addition, making changes or corrections to transfer paper was easier and cheaper than grinding and repolishing a stone block.

Edward Penfield's preparatory drawing for a poster advertising the April 1894 issue of *Harper's* (see fig. 5) exhibits hallmarks of the bold, new aesthetic — broad areas of solid color, lettering that interacts with other design elements, and minimal outlines — that were readily transferable to the lithographic process. This drawing can be considered a cartoon, as it is a one-to-one rendering of the finished design bearing guide marks

FIGS. 32–34 | Details of Edward Penfield, Study for *Harper's, April*, 1894. Cut-and-pasted painted paper, watercolor, ink, and gouache on paper (see fig. 5). The guidelines for the text and the collaged elements of the head, the hands and umbrella, and the magazine, as well as notations of the matrix colors, are visible on the cartoon. A comparison of this study to the final print (pl. 78) reveals how the lithographer translated the original art by choosing the correct patterns, colors, and order of printing to produce the final desired results.

to align the text (fig. 32). The head, the hands and umbrella, and the magazine are collaged elements that not only supply details, such as the miniature *Harper's* logo, but also indicate revisions to the design (fig. 33). Although some changes were made, the study and the final print (pl. 78) are very similar. Given that Penfield was both the designer of this poster and the artistic director of *Harper's*, he was likely able to collaborate closely with the lithographer during the printing process.

After an artist created the design for a poster, a specially trained member of the printshop, sometimes called a lithographic artist, evaluated the original drawing, analyzed the color scheme to determine the minimum number of colors required, and transferred the design to the matrices in preparation for printing. Written in graphite at the lower right of the study are the printer's notes indicating the four colors needed for the matrices: sepia, scarlet vermilion, black, and yellow (fig. 34).

The lithographer's next task after choosing the colors, and thus the number of matrices required, was to create a design key. Also referred to as a key block, this drawing serves as the template for the composition, outlines the figures, and often provides narrative details. Importantly, it ensures that the image is the same size and shape and in the same position on all the matrices, allowing the colors to line up correctly, or register, on the paper as each matrix is printed in succession. Prints from many cultures and periods employ this device, such as the Japanese woodcuts that were popular among artists in the United States and Europe during the height of the poster craze. The key block is clearly visible in the realized print of Penfield's poster for the April 1894 issue of *Harper's*. While traditionally printed in black, sometimes the key blocks used in the production of literary posters were printed in green (pl. 88) or blue (pl. 40), attesting to the lithographer's inventive use of color. In another departure from the norm, some of the posters in this genre do not include the key block as a printed element in the final design. For example, in Frank Hazenplug's 1895 poster for *The Chap-Book* (pl. 46), the printer artfully arranged fields of black and red while leaving areas of the paper unprinted (in reserve) to define the linear elements of the composition, details, and lettering.

Ingenious approaches to printing with a limited number of colors are evident in many of the literary posters. Unlike lithographic practices in the early nineteenth century, which entailed as many as twenty stones, each inked with a different color, poster printing required a faster and more economical process. Therefore, printers sought to minimize the

FIG. 35 | Detail of Ernest Haskell, *Truth,* 1896. Lithograph and relief print (pl. 43). Fine dots of ink were overlaid and positioned to optically mix the printing inks, creating a wide range of colors.

number of matrices, and hence colors, needed to achieve a design; most literary posters were made from three or four matrices. Expanding the palette relied heavily on meticulous mixing and registration of colors. For example, Ernest Haskell's 1896 poster for *Truth* (pl. 43, fig. 35) was printed with four matrices — red, yellow, blue, and black — that produced additional hues of orange, green, and purple when combined. The sequence in which the matrices were printed also had to be considered, as some printing inks are opaque and will obscure the underlying tone if placed on top but will optically blend in the desired fashion when placed below. While the three primaries — red, yellow, and blue — were commonly used for designs that demanded a wide variety of colors, printers of literary posters often interpreted artists' drawings using customized color choices that heightened a work's artistry and produced unusual effects. Of note are the unconventional olive, red, and gray inks in George Reiter Brill's poster for the June 9, 1895, issue of the *Philadelphia Sunday Press* (pl. 14) and the bronze powder meant to simulate gold in select areas of Joseph Christian Leyendecker's poster for *The Century*'s August 1896 issue (pl. 53).[6]

The distinctive appearance of the literary posters is indebted in part to the deft application of patterns, which broaden a print's chromatic range without requiring the use of extra matrices. This important technical aspect of the lithographic process is akin to the practices of stippling and crosshatching employed in various types of printing for centuries.

FIGS. 36, 37 | Details of William L. Carqueville, *International, November*, 1896. Lithograph (left, pl. 19); Frank Hazenplug, *The Chap-Book*, 1896. Lithograph (right, pl. 47). The use of an airbrush created arrays of fine, random dots.

Printmakers can produce shifts in tone by adding patterns to certain areas of an image. For instance, in Will H. Bradley's *Modern Poster, Charles Scribner's Sons, New York* (pl. 10), a single ink looks green as a solid field in the background but gray in the margins of the poster, where it is applied in small dots that alternate with the white of the paper.

Applying a lithographic crayon or tusche (a liquid medium) to a grained stone, the surface of which added random irregularities to each stroke, was another way to produce a pattern. Similarly, drawing on a grained or heavily textured transfer paper created broken lines or fields with gaps. Louis Prang, a pioneer of multicolor lithography in the United States, favored a hand-applied stipple method, adding small dots to each matrix. However, grained stones required extra preparation, textured paper could be challenging to work with, and Prang's technique relied on highly skilled workers. Instead, printers of literary posters developed labor-saving, simplified, and readily reproducible means to render patterns.

One such method was airbrushing, introduced in 1880. With this technique, the lithographic tusche was sprayed in a random fine pattern, as seen in William L. Carqueville's poster for the November 1896 issue of *International* (pl. 19, fig. 36) and Hazenplug's 1896 poster for *The Chap-Book* (pl. 47, fig. 37). This too required some skill, as an even distribution of lines or dots was difficult to achieve. To reduce the manual labor involved and improve the consistency of the outcome, Benjamin Day

FIG. 38 | A selection of dot patterns manufactured by Ben Day, illustrated in Charles J. Hayes, *Engraving and Printing Methods* (Scranton, PA: International Textbook Company, 1930), 27

invented reusable templates called "mechanical tints," which he patented in 1879. In common use by 1890, the invention governed the appearance of many literary posters.

Day's tints were produced using photomechanical methods. In the early nineteenth century, numerous chemists and photographers, including Paul Pretsch, Nicéphore Niépce, and Alphonse Louis Poitevin, found that the chemical and physical properties of certain substances, most importantly bitumen of Judea and bichromated gelatin, changed according to the amount of light to which they were exposed. The light caused

FIG. 39 | Photomicrograph (20x) of Joseph Christian Leyendecker, *Self Culture, October,* 1897. Relief print (pl. 55). The printer manipulated the shape of the Benday dots and shifted the direction of the patterns to fully exploit the medium for artistic effect.

FIG. 40 | Detail of Ethel Reed, *The Penny Magazine,* ca. 1896. Lithograph (pl. 109). A fan-shaped pattern of Benday dots was used to produce the figure's skin tone.

the substance to harden and made it insoluble in water, resistant to acid, and able to hold printing ink. This finding opened the door to a dizzying array of printing processes.

Day supplied printmakers with hardened gelatin sheets bearing photographically transferred patterns of dots, lines, and amorphous shapes that could be inked with tusche and then stamped onto a lithographic stone or, more commonly, a transfer paper, giving them readily reproducible patterns that were reliably consistent from print to print (fig. 38). Later called "Benday dots" or "Benday screens," these tints were adapted to other types of printmaking and used for decades.

The printer would place one of Day's gelatin sheets that was inked with lithographic tusche in a jig slightly above the transfer paper and, using the key design as a guide, would press a stylus onto the areas where a particular pattern was desired. Changing the orientation of the sheet produced crisscross or diagonal patterns. The jig also had a precision screw to enable minute movements of the paper that would widen fine lines or enlarge dots, further increasing the range of patterns available to the printer.[7]

The variety and adaptability of the patterns belie the notion that manipulating them was an unskilled technique. Analysis of the literary posters using microscopy and a differential diagnostic approach reveals a high degree of customization in the application of mechanical tints. Although sometimes applied in a slapdash manner — as seen in F. Gilbert Edge's poster for the June 7, 1896, issue of *The Sunday World* (pl. 31), in which the sheets of gelatin were overlapped sloppily and the edges are irregular — in the hands of a talented matrix preparer

FIG. 41 | Photomicrograph (6x) of Edward Penfield, *Harper's, January, 1895*. Lithograph (pl. 76). The lithographer manually overlapped and adjusted Benday patterns to create the effect of brushstrokes.

mechanical tints were an effective tool for creating complexity and nuance in a composition. For example, in Joseph Christian Leyendecker's poster for the October 1897 issue of *Self Culture* (pl. 55, fig. 39), the pattern was shifted so that the red dots merge together, creating denser areas. In Ethel Reed's poster for *The Penny Magazine* from about 1896 (pl. 109, fig. 40), the printer chose a fan-shaped pattern to harmonize with and augment the curving lines of the design. Edward Penfield's poster for the January 1895 issue of *Harper's* (pl. 76) is particularly sophisticated in its use of tints to create a brushy effect. The printer rendered the green dress by printing a solid layer of yellow overlaid with blue dots and repositioned a regular dot tint multiple times to simulate the variable density of the brushstrokes in the original watercolor (fig. 41). In addition, the man's coat has the hand-drawn appearance of a crayon skipping across the chain lines of laid paper, demonstrating how the inherent qualities of some lithographic transfer papers were deliberately employed to impart a pattern.

FIG. 42 | Detail of Joseph J. Gould Jr., *Lippincott's, December*, 1896. Lithograph (pl. 38)

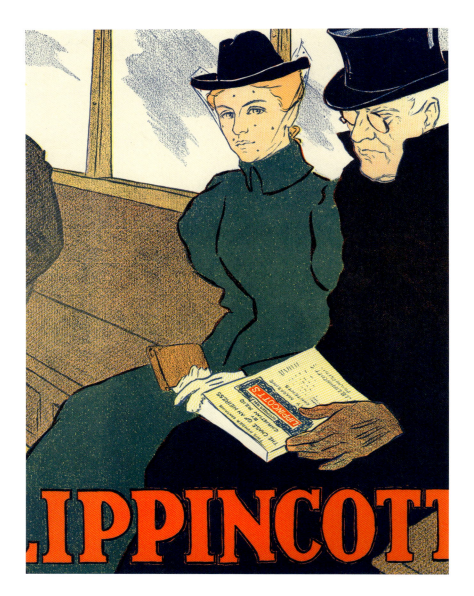

A close study of Joseph J. Gould Jr.'s poster for the December 1896 issue of *Lippincott's* (pl. 38, fig. 42) reveals that it required four matrices: a red, a yellow, and two slightly different shades of blue. The lithographer used Benday tints and transfer paper to create a multitude of colors, shades, and textural effects. The key block, printed in blue, is readily apparent in the facial and architectural details. To produce areas of black — such as the outlines of the red letters (fig. 43), the man's coat, and the top hat — three colors were required; the yellow matrix was printed first, then the red, and then the blue. The rendering of the top hat highlights the skill of the lithographer, who left areas unprinted to simulate a sheen on the satin that contrasts with the texture of the man's

Details of Joseph J. Gould Jr., *Lippincott's*, December, 1896. Lithograph (pl. 38)

FIG. 43 | Photomicrograph (12x). The overlap of red, yellow, and blue inks produced areas of black, as seen in the outlines of the red letters.

FIG. 44 | Photomicrograph (12x). The figures' faces were tinted a pale orange by printing a series of thin red horizontal lines over yellow vertical lines. Local adjustment of the width of the red lines enhanced the effect of light and shadow produced by the man's glasses.

FIG. 45 | Photomicrograph (12x). Two different patterns in the same yellow were used to distinguish the man's skin and hair.

FIG. 46 | Photomicrograph (6x). Red, yellow, and blue inks were combined in different patterns, orientations, and densities to create the bluish-brown coat of the figure on the left, the yellow window trim, and the reddish-brown bench.

wool coat. Other areas in reserve, accompanied by small touches of blue, suggest reflections in the windows. The woman's vivid green coat is composed of a nearly solid field of blue printed over yellow. The faces of the figures were tinted a pale orange by printing a series of thin red horizontal lines over yellow vertical lines. The printer thickened the lines around the man's eyes to convey the subtle changes in light and shadow created by his glasses (fig. 44). The man's gray hair, rendered with a pattern of dashes oriented diagonally and printed with the yellow matrix, varies texturally from his face (fig. 45). Using transfer paper, the printer added random patterns to the regularized yet manipulable Benday tints. This customization can be seen in many parts of the poster, such as the brown bench, the yellow trim, and the tweedy coat of the figure in the background. Examination in an area with intersecting colors highlights the differences in printing (fig. 46). All three areas have red horizontal lines, which were made thicker in certain areas of the bench and coat. A field of solid yellow was used in the window trim, but in the other two areas the yellow was printed in diagonal bands. The blue, across all three areas, has the irregular appearance of a drawing, suggesting the use of transfer paper on which the lithographic crayon was pressed more heavily in the coat, less heavily in the bench, and very lightly in the trim. The chain and laid lines of the transfer paper are visible in the final image.

Another type of print prevalent in this period was the metal-plate relief. This technology, which included line-block, letterpress, and other relief processes, had been used to print text and line drawings for decades and offered a very fast and economical way to print large quantities. After a design was etched into the metal-plate matrix, an image was printed from the unetched part of the metal that was left in relief. The desire for tonal and color images led to the merging of metal-plate relief printing and photographic technology, a combination that lent itself to the making of literary posters. Much like lithographic printing, the process involved translating an artist's drawing into a key block and then creating separate matrices for each color. And, similarly, printers modified relief-printing techniques to suit the poster aesthetic.

To create a metal-relief matrix, a printing plate was first coated with bitumen of Judea, which hardened and became resistant to acid when exposed to light. Only the areas that had received light would resist etching when the prepared metal plate was placed in an acid bath. Therefore, a photographic image was translated directly into the highs and lows of the metal plate. In traditional manual etching, the etching resist was

FIGS. 47, 48 | Photomicrographs (12x) of Howard Chandler Christy, *The Bookman, September,* 1890s (left, pl. 20), a relief print; and Edward Penfield, *Harper's, January,* 1895 (right, pl. 76), a lithograph. Both processes can produce "ink squash" at the edges of the printed areas.

removed by hand, relying upon the translation and copying skills of the plate preparer working for the printer. The ability to use photography to transfer images led to a reduction in the need for skilled copyists. In this photomechanical method, the same preparatory drawings, patterns, and other markings used to make lithographic matrices, including Benday mechanical tints, were photographed and then transferred to a metal plate. The resulting prints thus displayed the same aesthetic effects and approaches to color mixing attained with lithography.

The two processes — lithography and metal-plate relief etching — produce very similar, if not indistinguishable, results. While relief printing often leaves an impression or dent in the paper and "ink squash" around the edges of a printed shape (fig. 47), commercial lithography at times exhibits similar traits; a buildup of ink around printed areas can occur from using overly etched stones, exacerbated by the lateral force of the lithographic press and the dampening of the sheet with water before printing (fig. 48).

Although many of the printing techniques utilized in the production of literary posters were becoming increasingly mechanized at the end of the nineteenth century, talented and creative lithographers were still required to achieve high-quality results. It is important to remember that, in general, these prints filled an artistic niche. They were not intended to reproduce photographs or other works of art; rather, they engendered and perfected an original poster aesthetic. The attention to detail and manipulation of commercial processes are what made the literary poster stand out as a striking and independent art form that was recognized and collected from its inception.

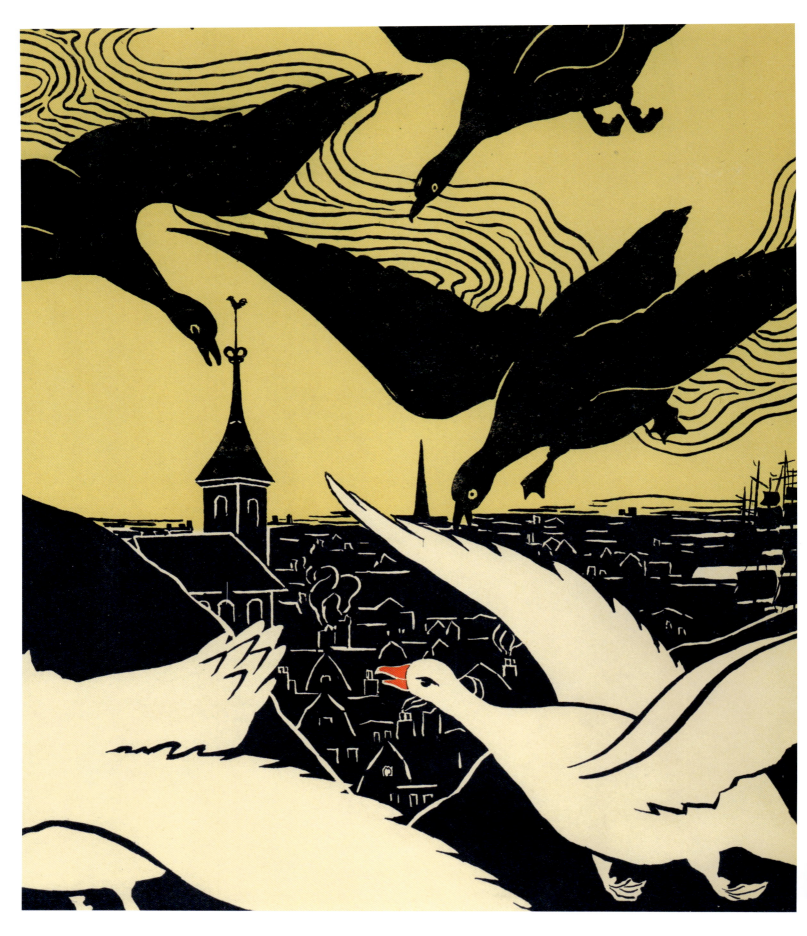

# PLATES

1 | ELISHA BROWN BIRD | *The Captured Cunarder by William H. Rideing*, 1896

2 | ELISHA BROWN BIRD | *The Red Letter*, 1896

3 | ELISHA BROWN BIRD | *The Poster, March [Miss Art and Miss Litho]*, 1896

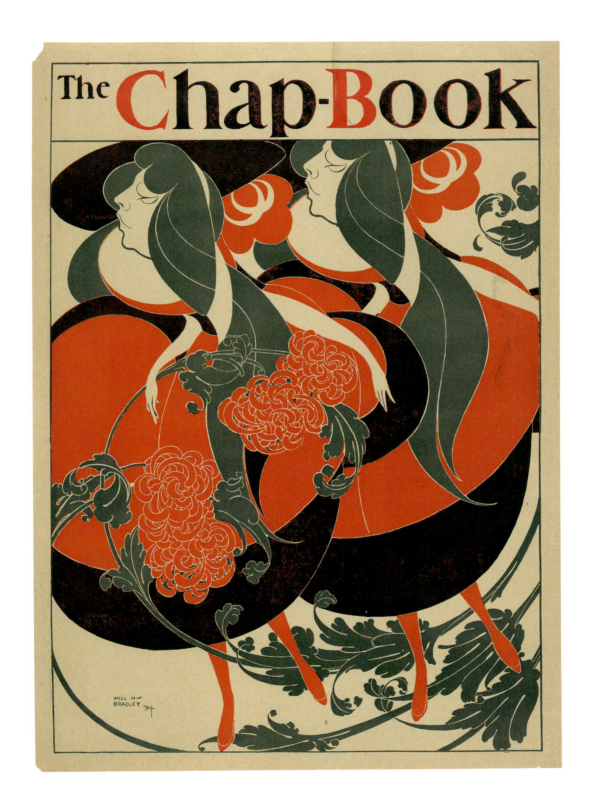

4 | WILL H. BRADLEY | *The Chap-Book [The Twins]*, 1894

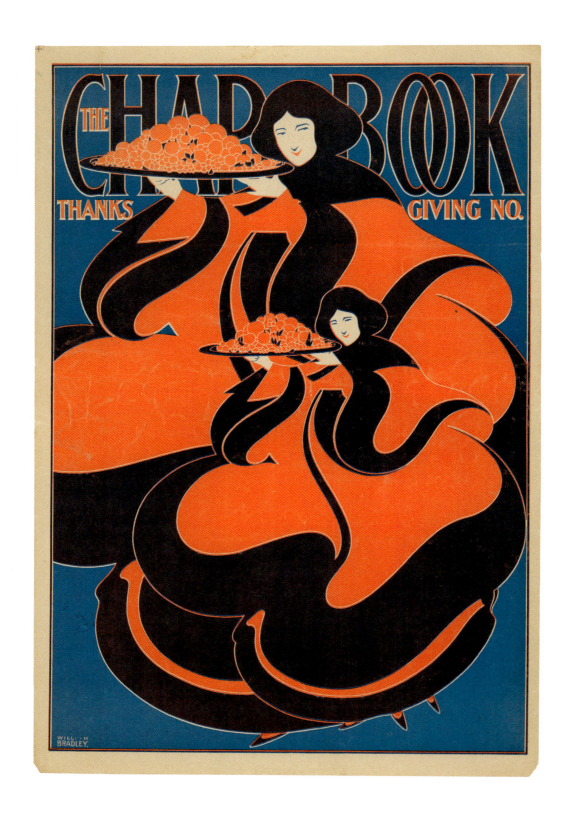

5 | WILL H. BRADLEY | *The Chap-Book, Thanksgiving Number,* 1895

6 | WILL H. BRADLEY | *When Hearts Are Trumps by Tom Hall*, 1894

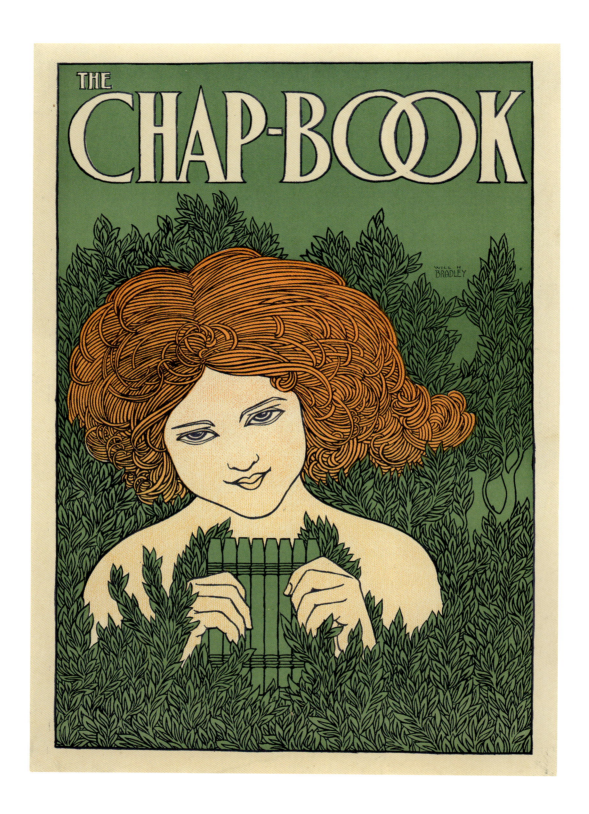

7 | WILL H. BRADLEY | *The Chap-Book [The Pipes]*, 1895

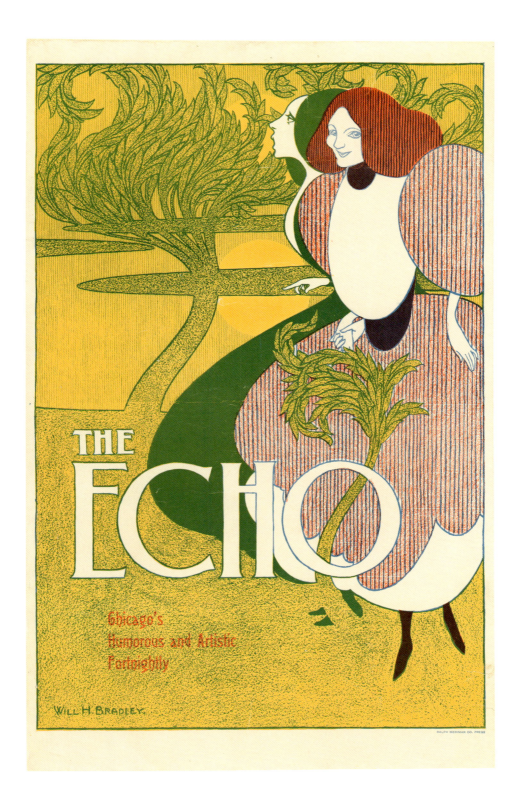

WILL H. BRADLEY | *The Echo*, 1895

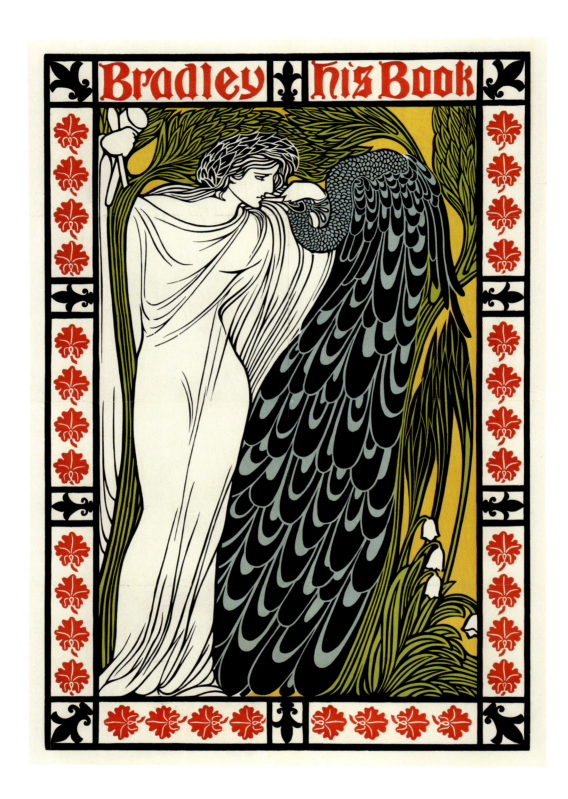

9 | WILL H. BRADLEY | *Bradley: His Book [The Kiss]*, 1896

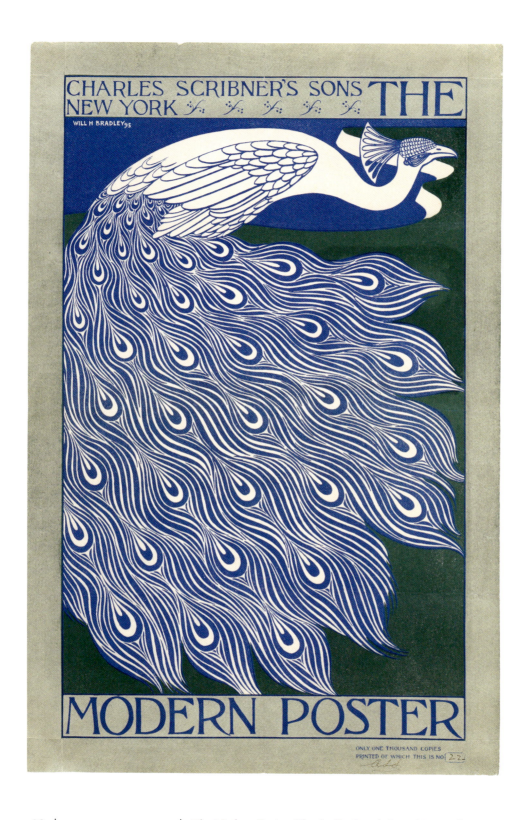

10 | WILL H. BRADLEY | *The Modern Poster, Charles Scribner's Sons, New York, 1895*

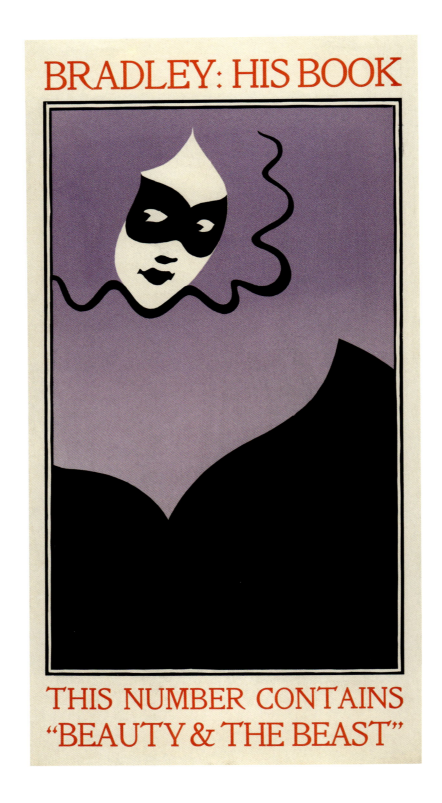

11 | WILL H. BRADLEY | *Bradley: His Book [Beauty and the Beast]*, 1896

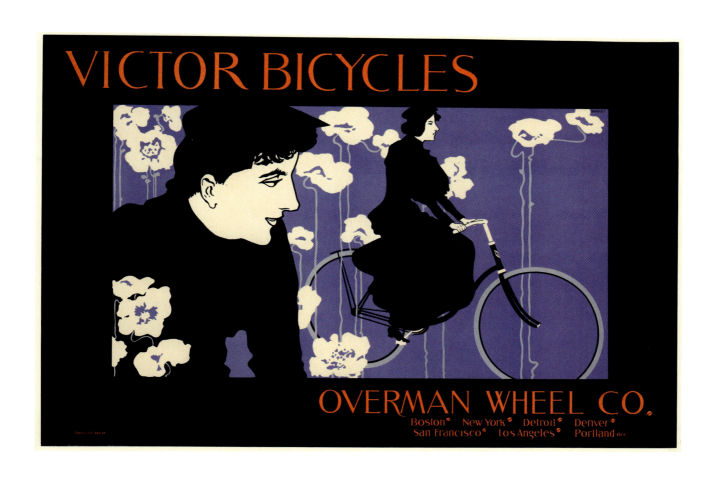

12 | WILL H. BRADLEY | *Victor Bicycles, Overman Wheel Company, 1896*

13 | GEORGE REITER BRILL | *Tribune*, late 19th century

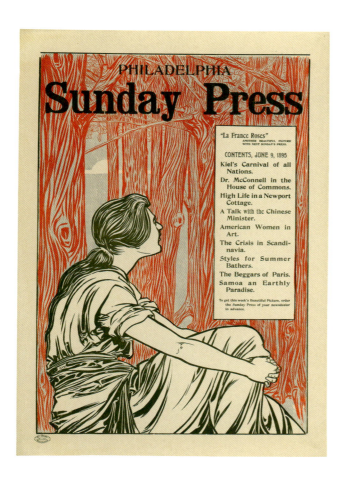
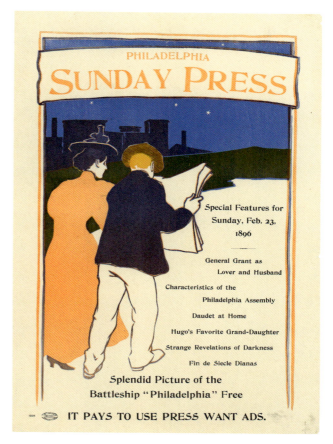

14 | GEORGE REITER BRILL | *Philadelphia Sunday Press, June 9, 1895*

15 | GEORGE REITER BRILL | *Philadelphia Sunday Press, February 23, 1896*

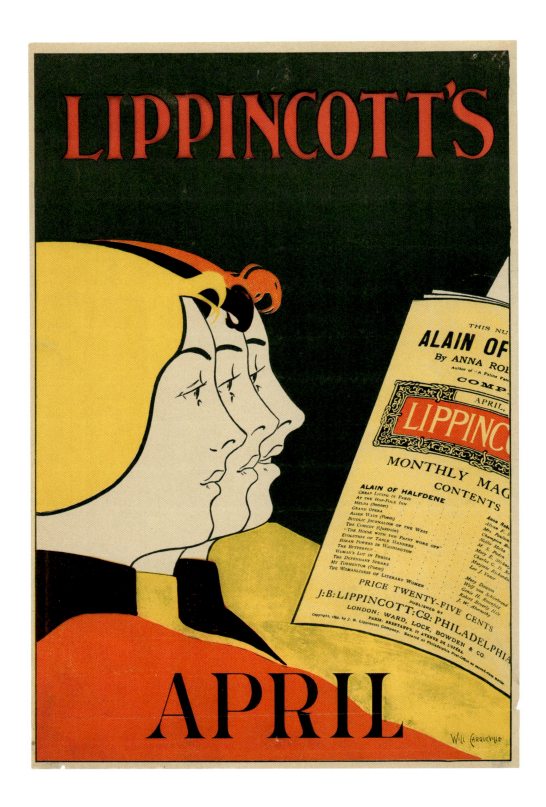

WILLIAM L. CARQUEVILLE | *Lippincott's, April*, 1895

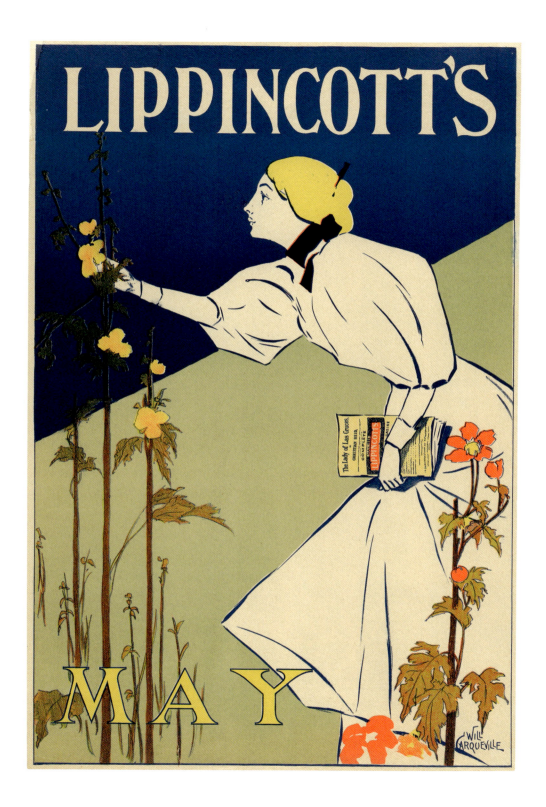

17 | WILLIAM L. CARQUEVILLE | *Lippincott's, May,* 1895

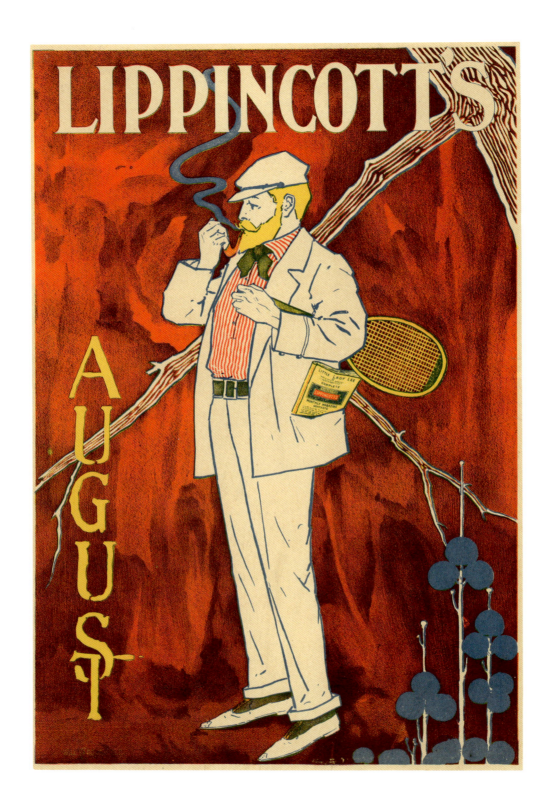

18 | WILLIAM L. CARQUEVILLE | *Lippincott's, August*, 1895

19 | WILLIAM L. CARQUEVILLE | *International, November,* 1896

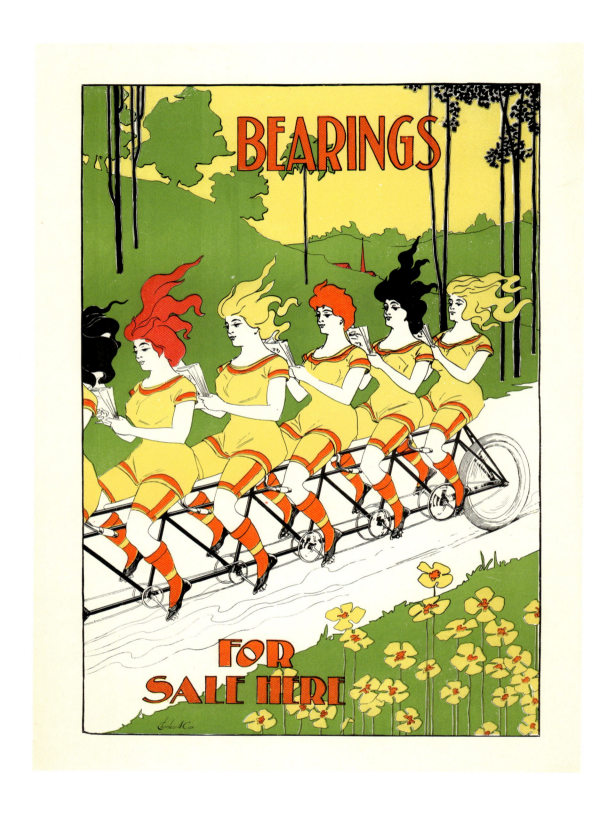

CHARLES ARTHUR COX | *Bearings*, ca. 1895

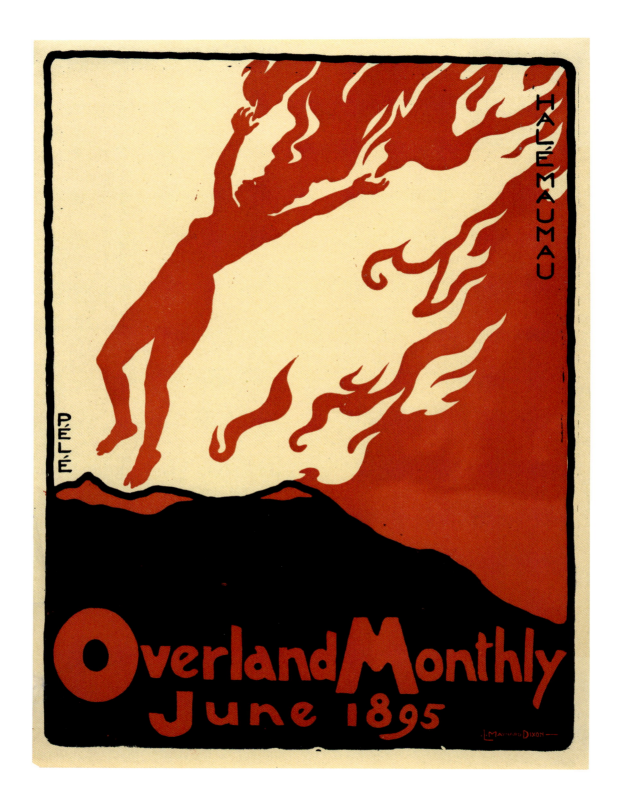

23 | LAFAYETTE MAYNARD DIXON | *Overland Monthly, June, 1895*

24 | LAFAYETTE MAYNARD DIXON | *Overland Monthly, July, 1895*

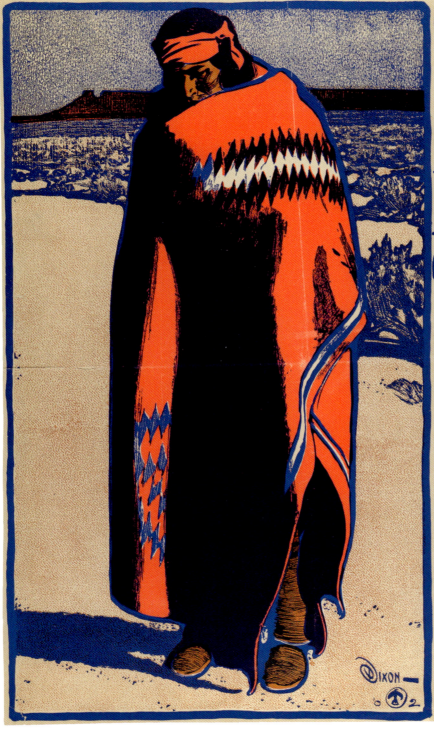

25 | LAFAYETTE MAYNARD DIXON | *Sunset Magazine, October,* 1902

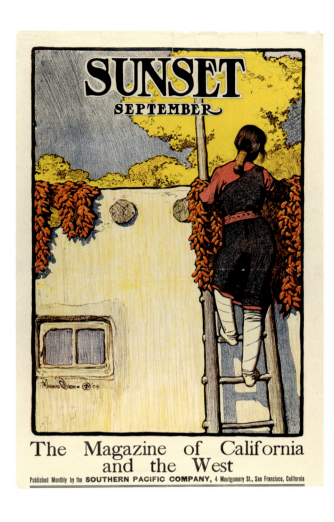
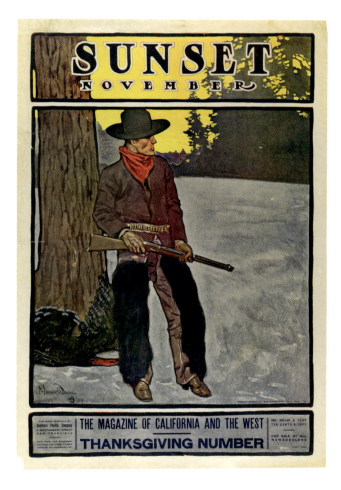

26 | LAFAYETTE MAYNARD DIXON | *Sunset Magazine, September, 1904*

27 | LAFAYETTE MAYNARD DIXON | *Sunset Magazine, November, 1904*

28 | ARTHUR WESLEY DOW | *Modern Art, Edited by J. M. Bowles, Published by L. Prang and Company*, 1895

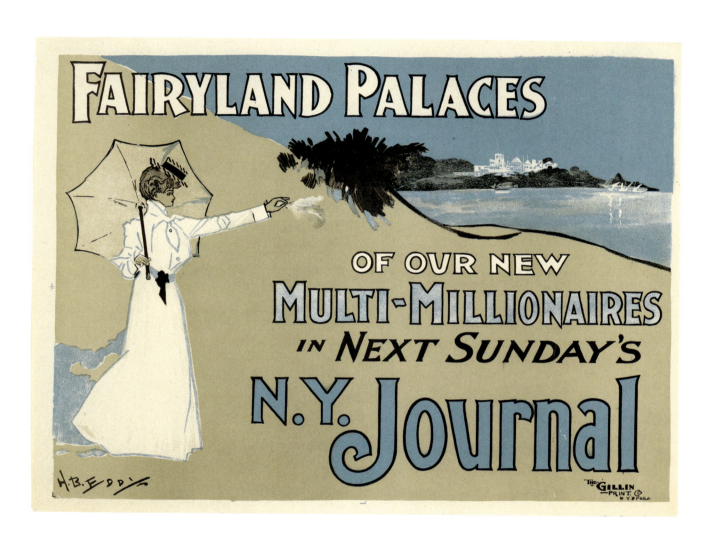

29 | HENRY BREVOORT EDDY | *New York Journal*, 1900

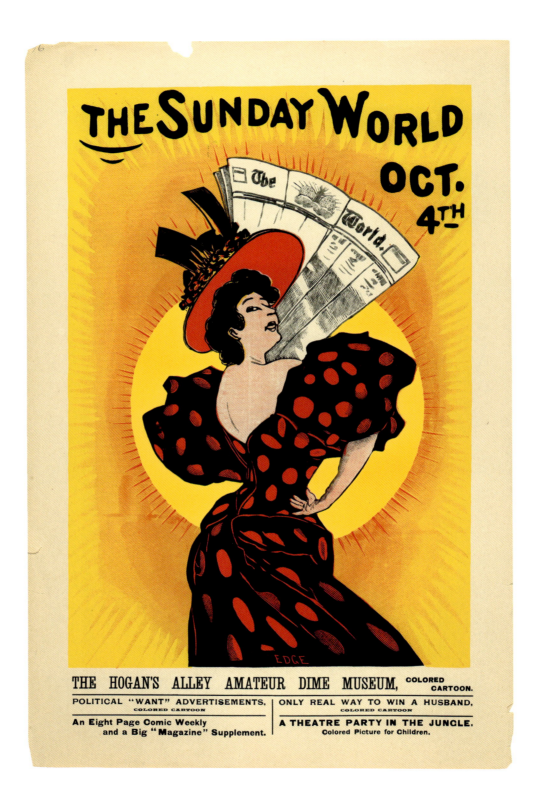

30 | F. GILBERT EDGE | *The Sunday World, October 4, 1896*

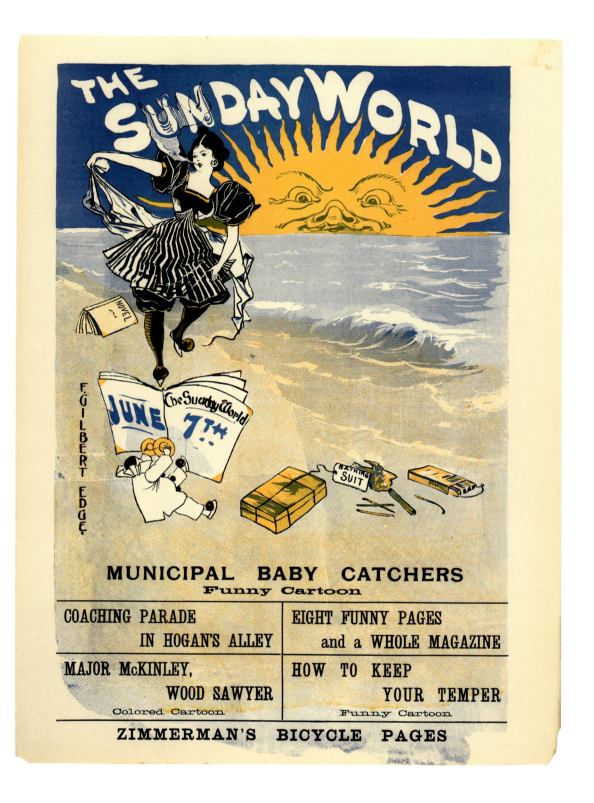

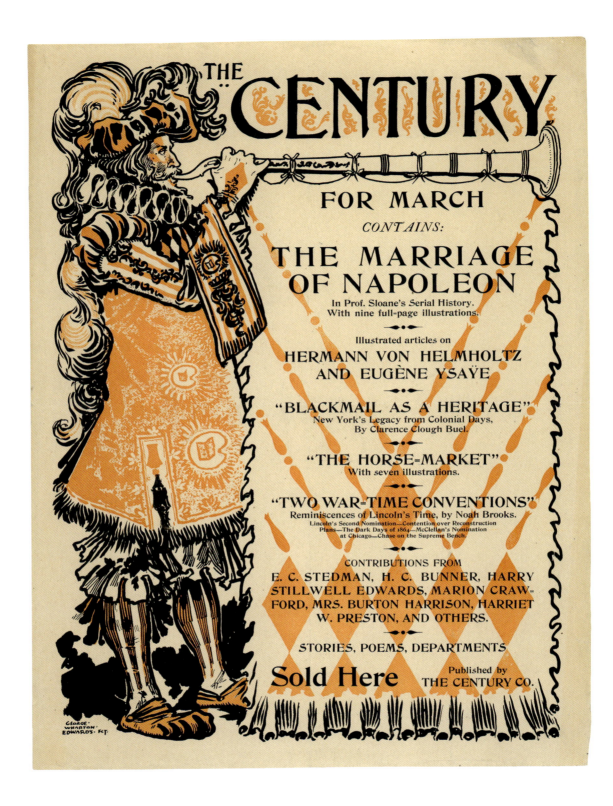

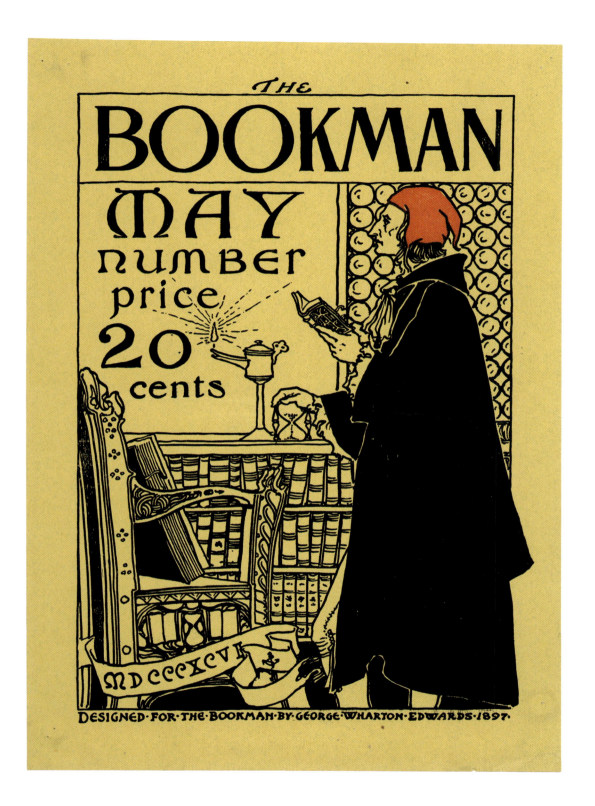

33 | GEORGE WHARTON EDWARDS | *The Bookman, May,* 1897

34 | WILLIAM JAMES GLACKENS | *Lippincott's, August,* 1894

35 | JOSEPH J. GOULD JR. | *Lippincott's, June,* 1896

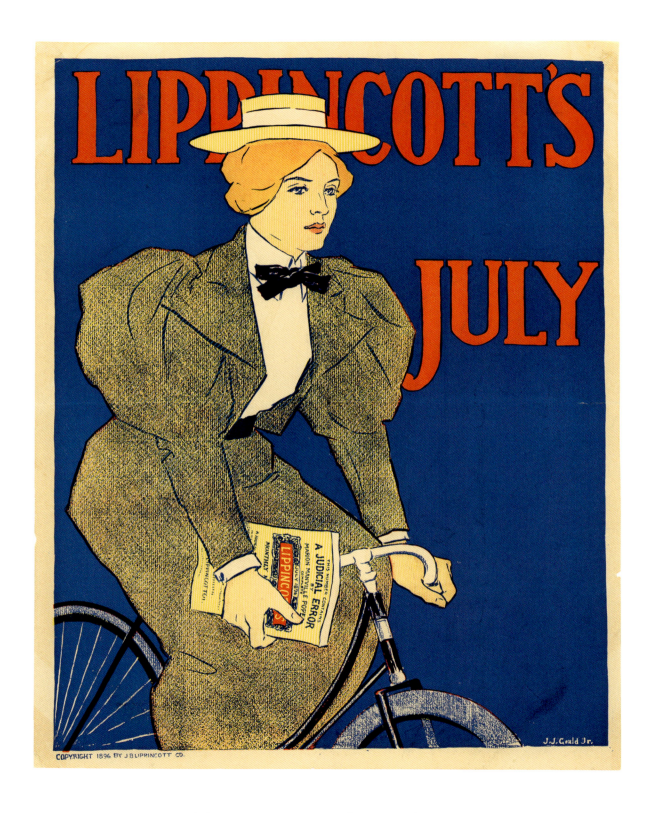

36 | JOSEPH J. GOULD JR. | *Lippincott's, July*, 1896

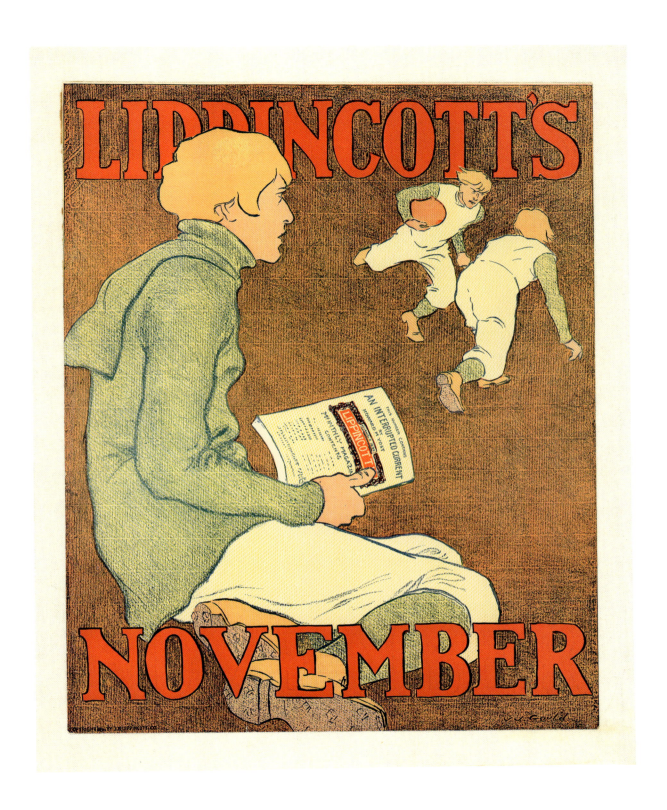

37 | JOSEPH J. GOULD JR. | *Lippincott's, November*, 1896

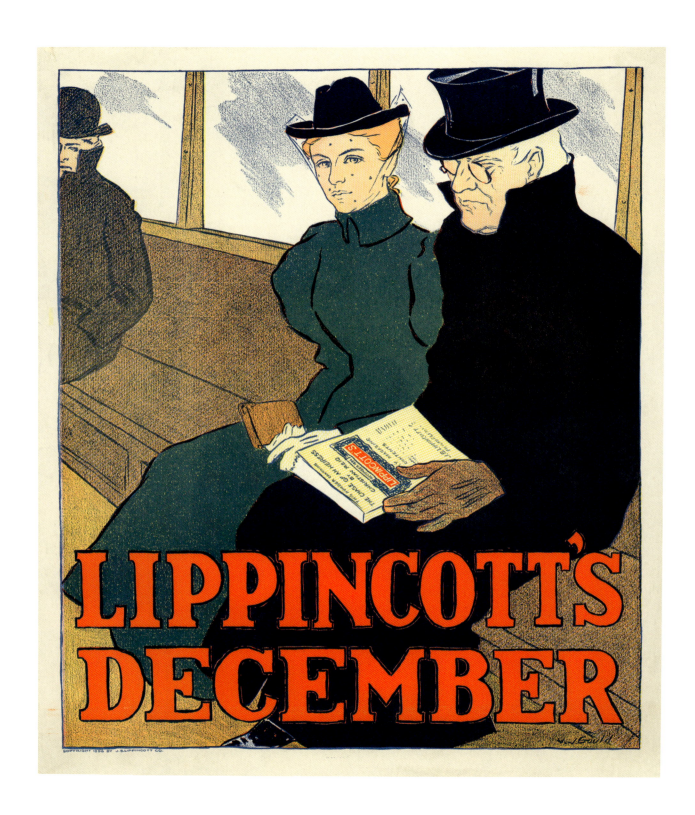

38 | JOSEPH J. GOULD JR. | *Lippincott's, December, 1896*

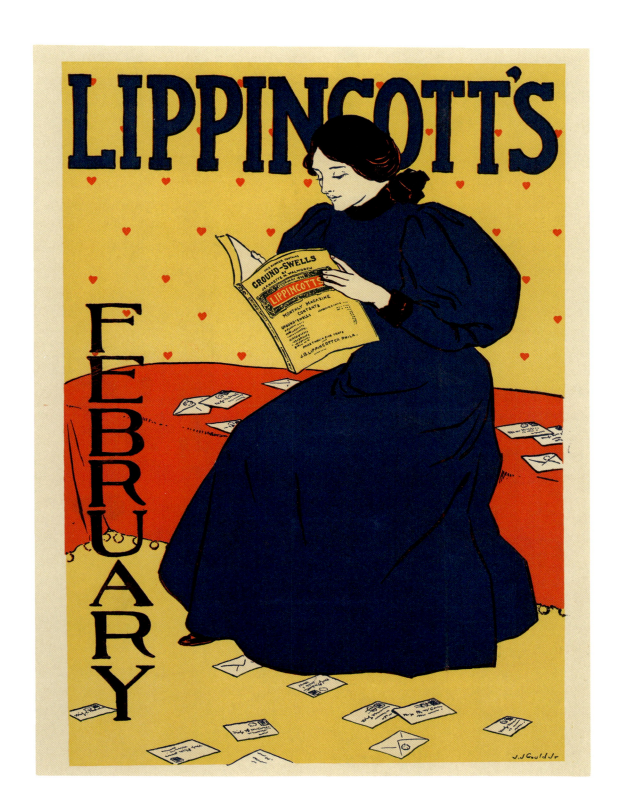

39 | JOSEPH J. GOULD JR. | *Lippincott's, February,* 1896

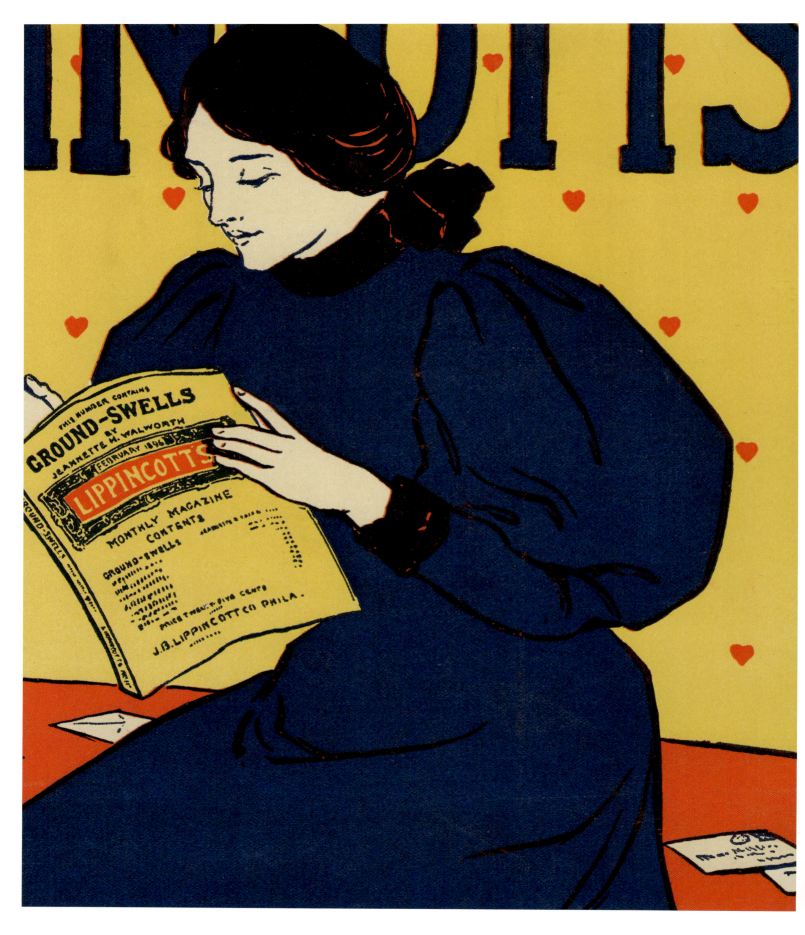

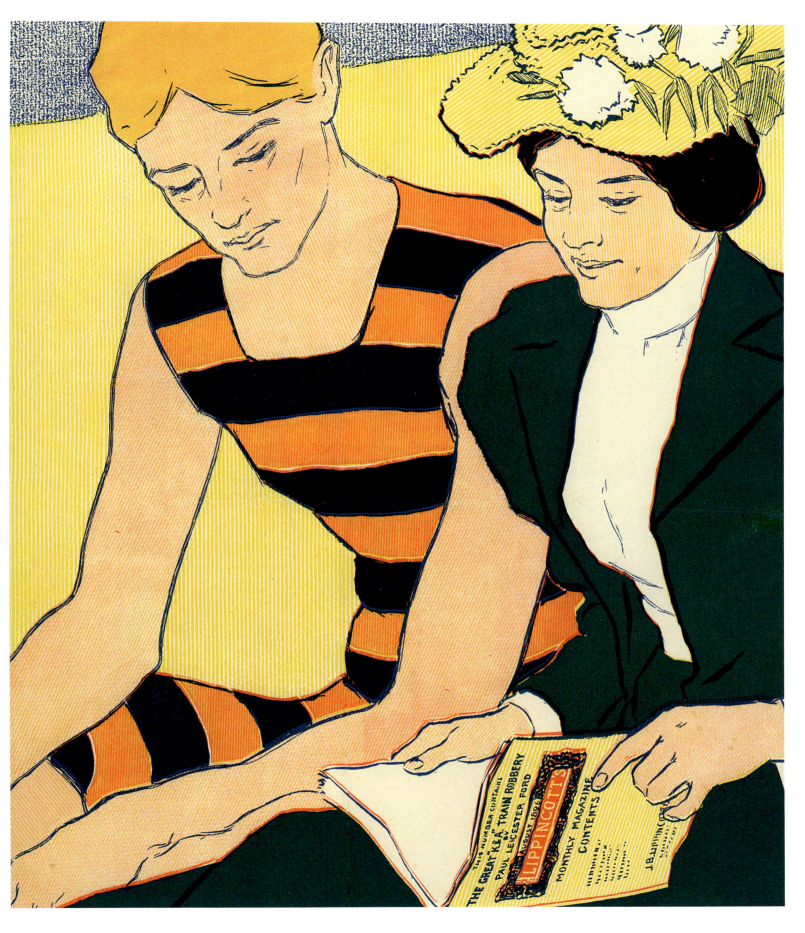

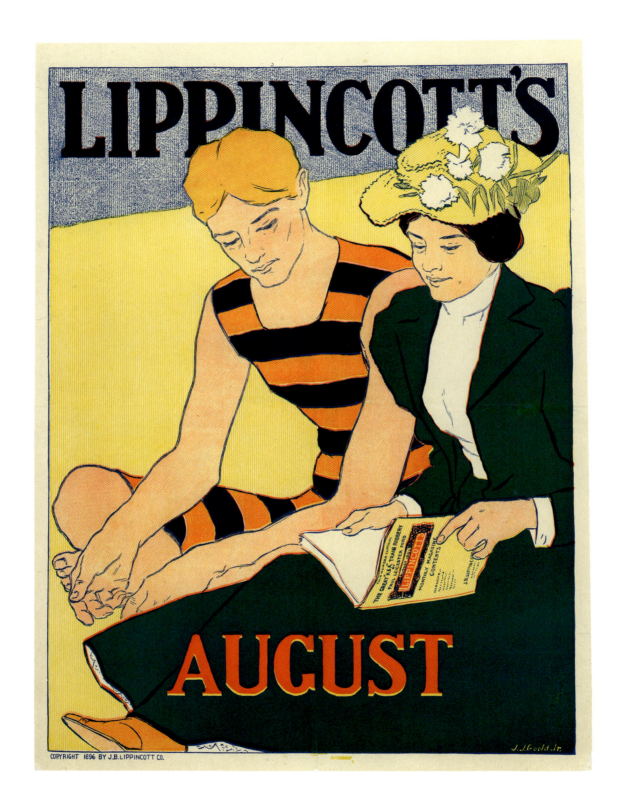

40 | JOSEPH J. GOULD JR. | *Lippincott's, August*, 1896

41 | JOSEPH J. GOULD JR. | *Lippincott's, April*, 1897

42 | JOSEPH J. GOULD JR. | *Lippincott's, January*, 1896

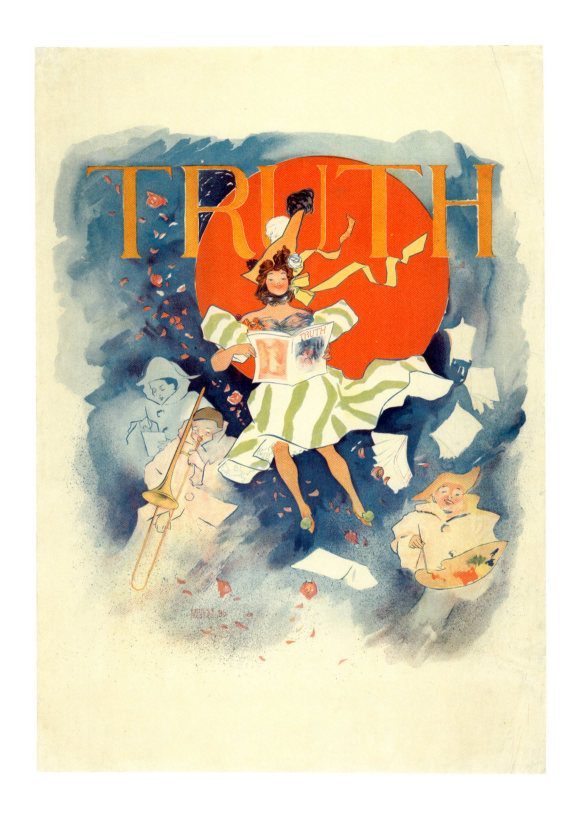

43 | ERNEST HASKELL | *Truth*, 1896

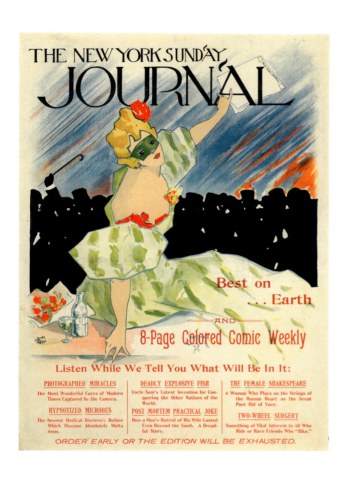
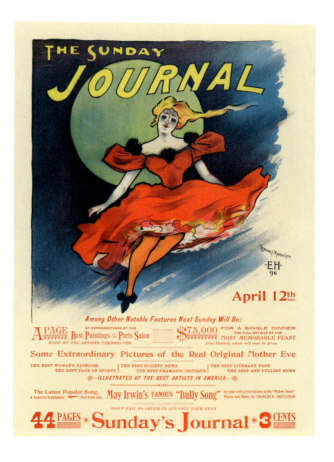

44 | ERNEST HASKELL | *The New York Sunday Journal*, 1896

45 | ERNEST HASKELL | *The New York Sunday Journal, April 12, 1896*

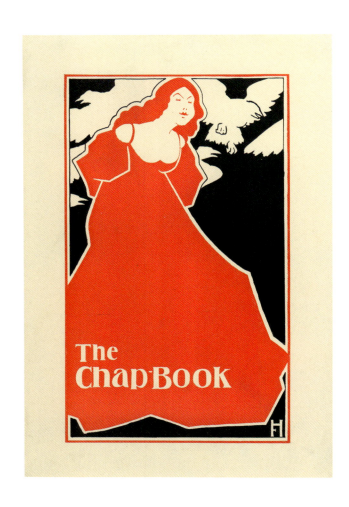
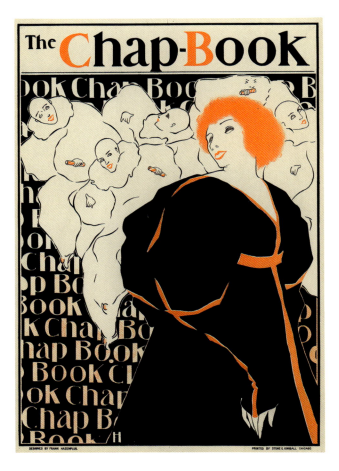

46 | FRANK HAZENPLUG | *The Chap-Book*, 1895

47 | FRANK HAZENPLUG | *The Chap-Book*, 1896

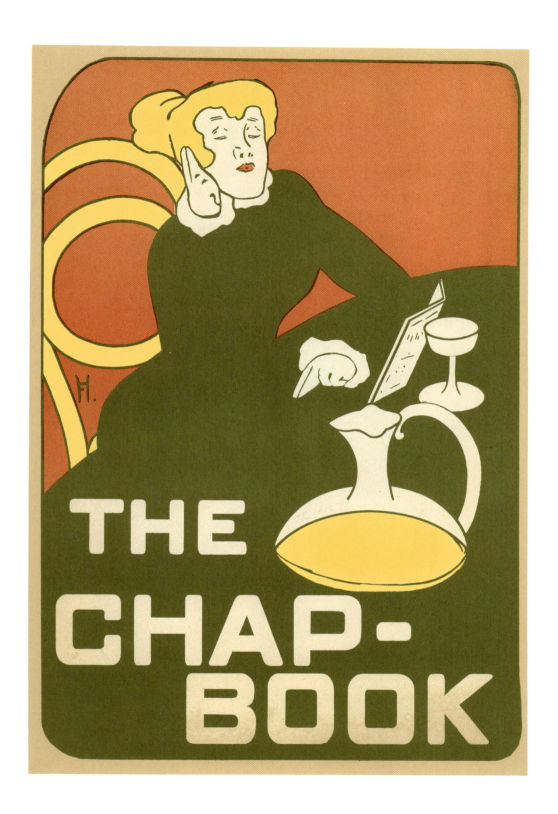

48 | FRANK HAZENPLUG | *The Chap-Book*, 1896

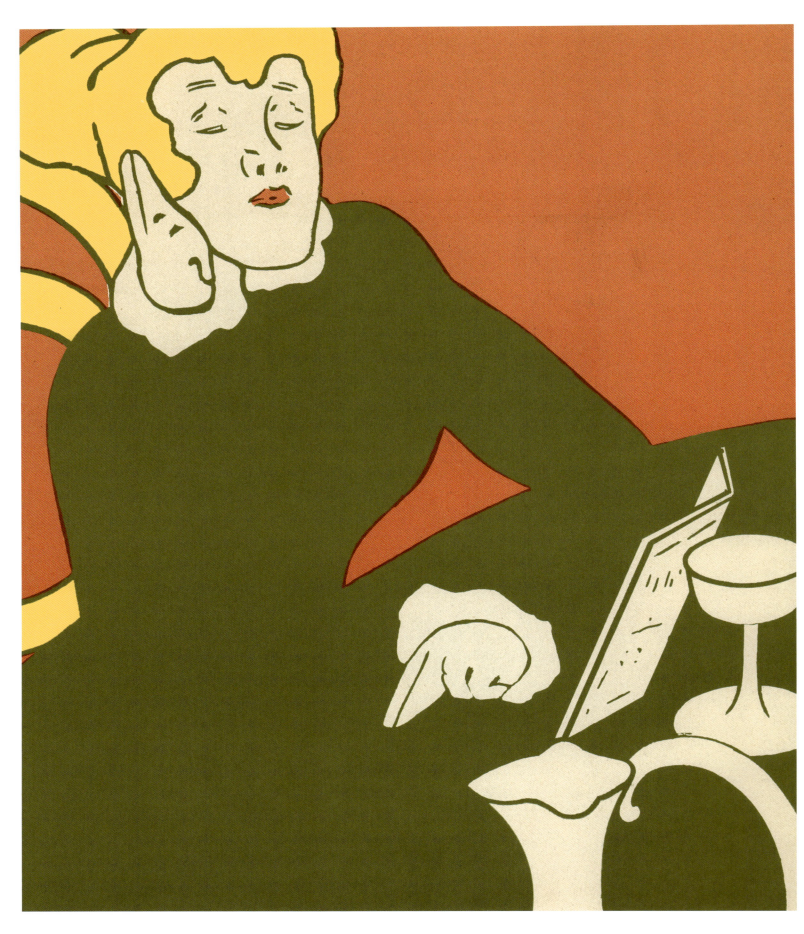

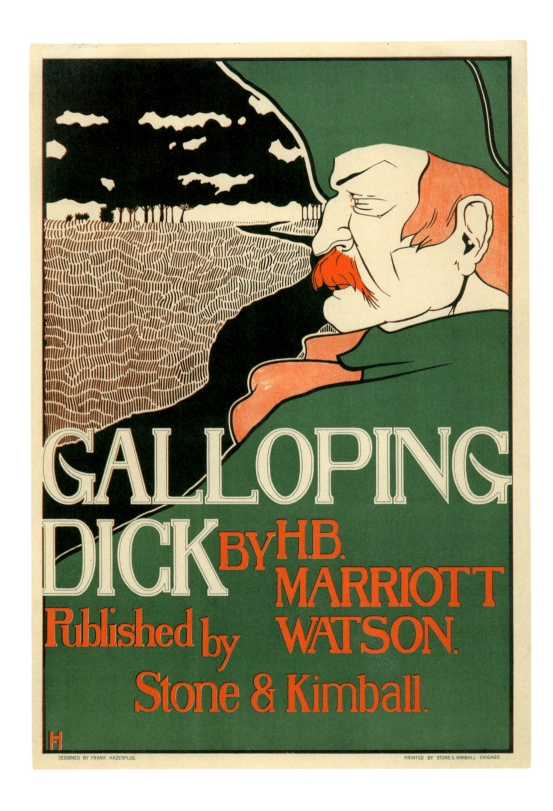

49 | FRANK HAZENPLUG | *Galloping Dick by H. B. Marriott Watson*, 1896

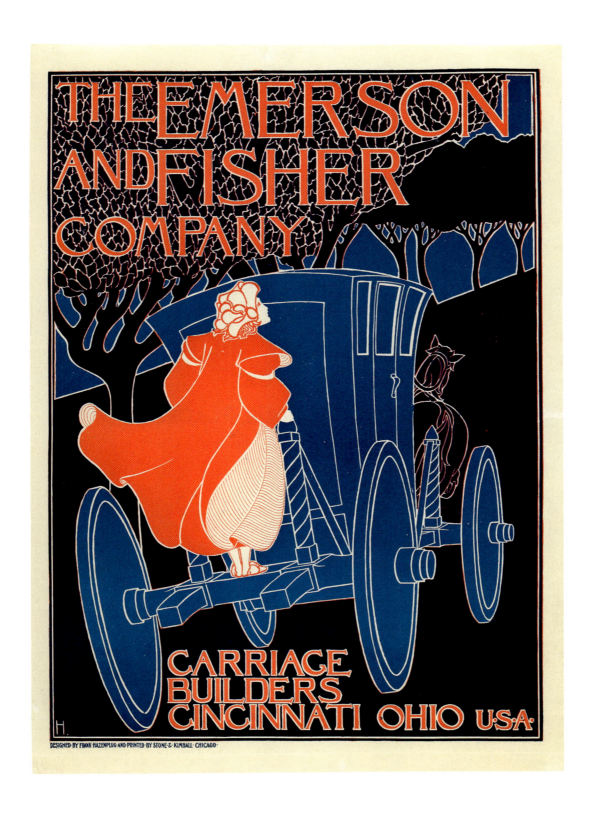

50 | FRANK HAZENPLUG | *The Emerson and Fisher Company, Carriage Builders, Cincinnati, Ohio, USA, 1896*

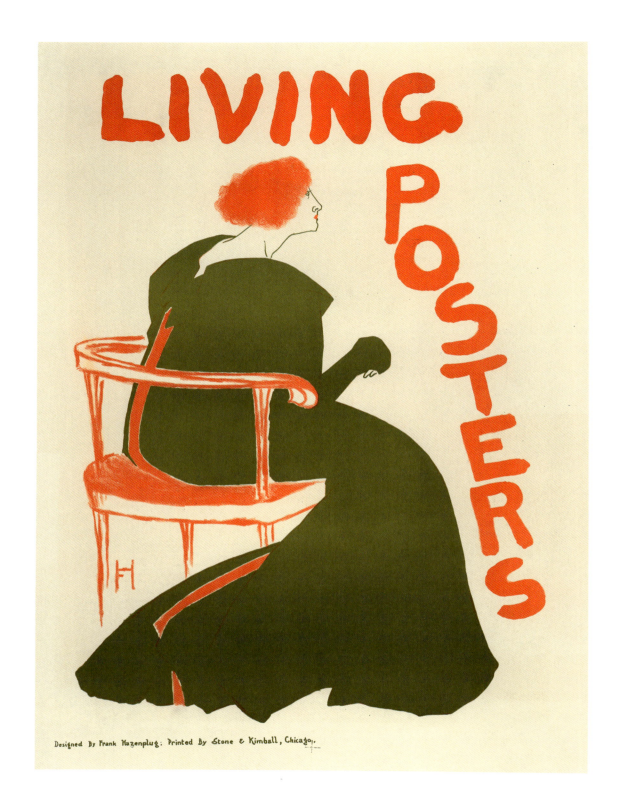

51 | FRANK HAZENPLUG | *Living Posters*, 1895

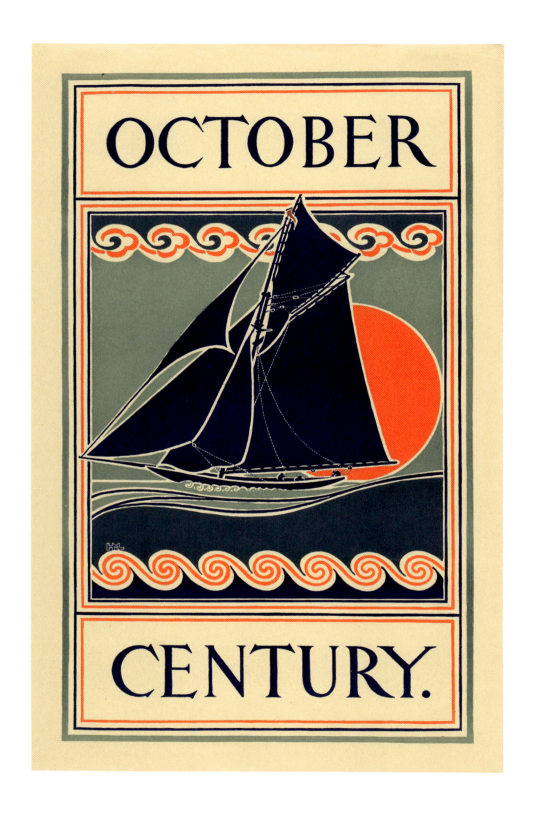

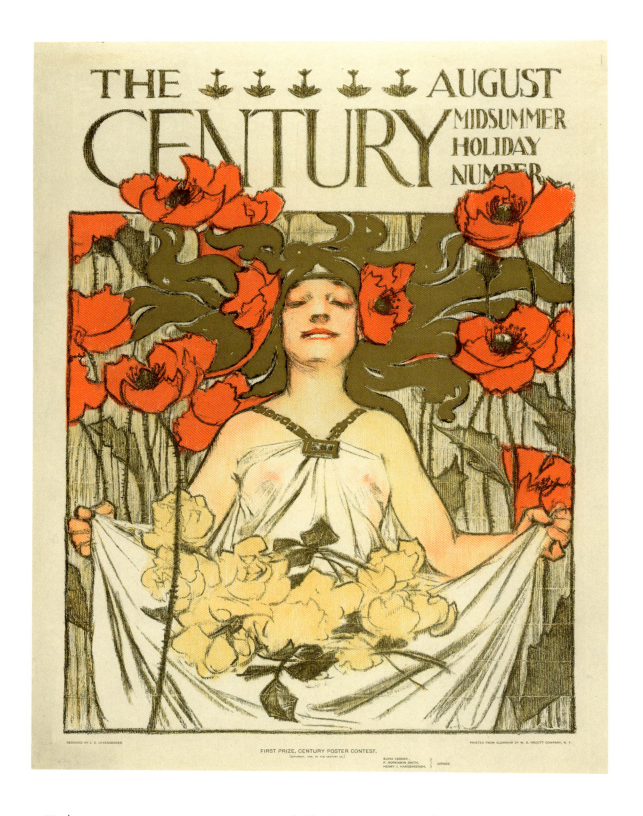

53 | JOSEPH CHRISTIAN LEYENDECKER | *The Century, August, Midsummer Holiday Number*, 1896

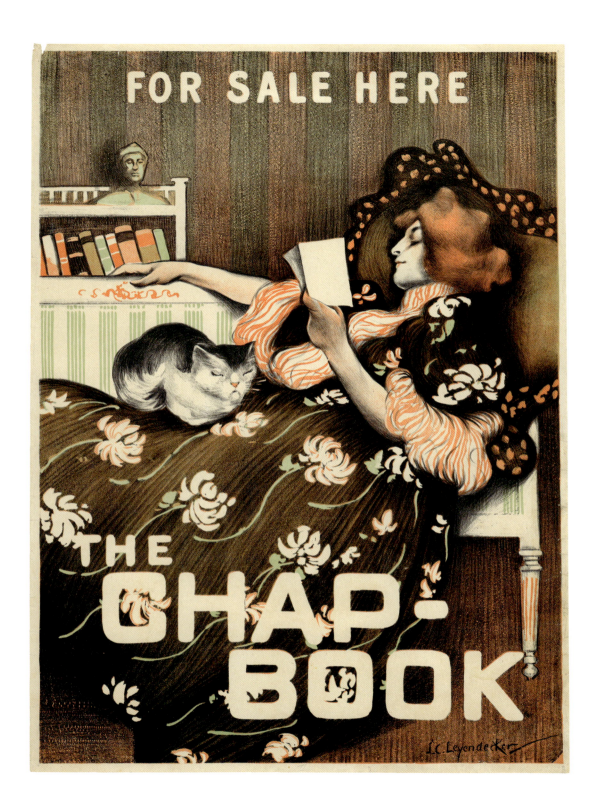

55 | JOSEPH CHRISTIAN LEYENDECKER | *Self Culture, October*, 1897

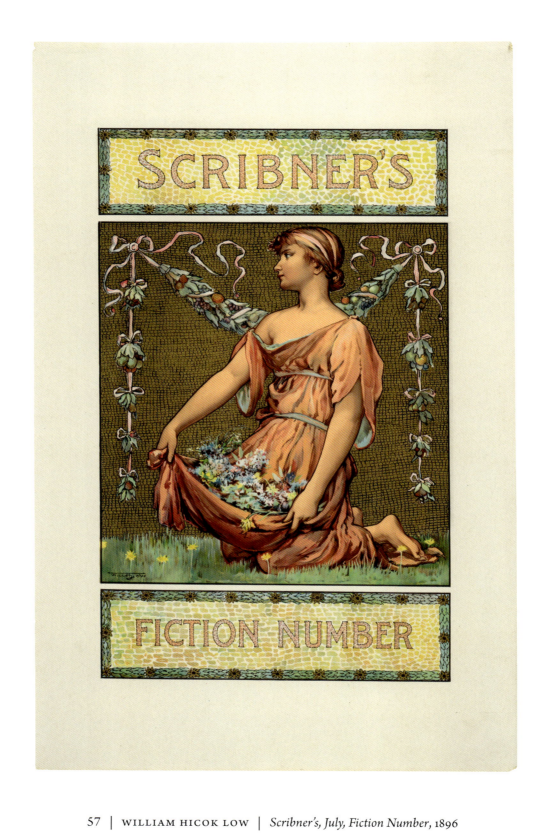

57 | WILLIAM HICOK LOW | *Scribner's, July, Fiction Number,* 1896

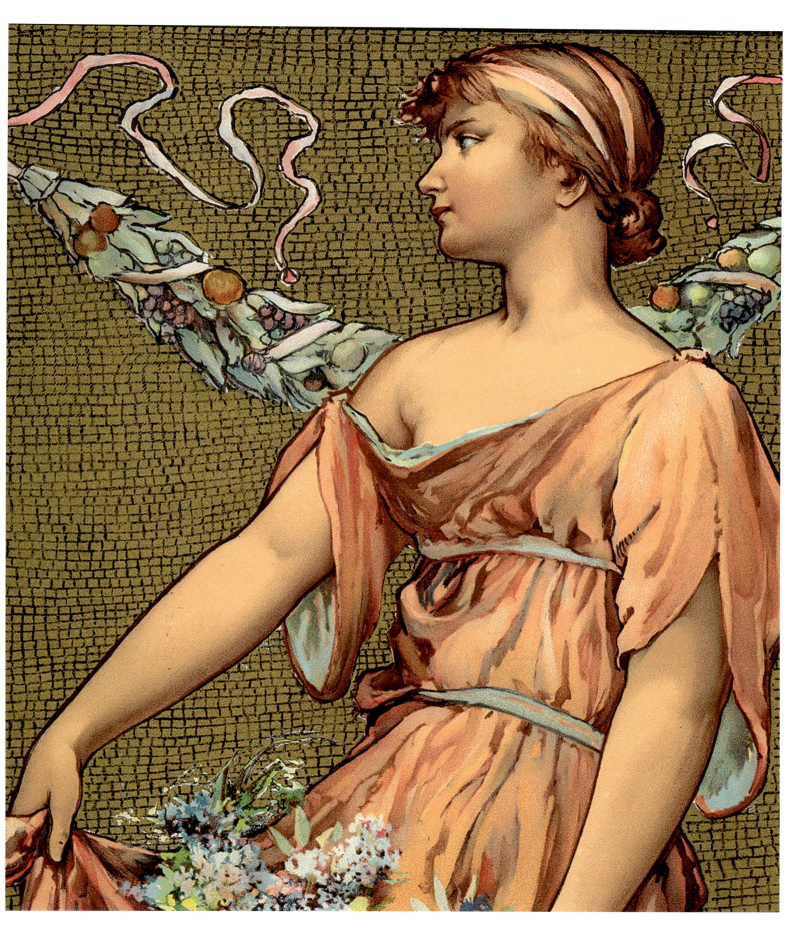

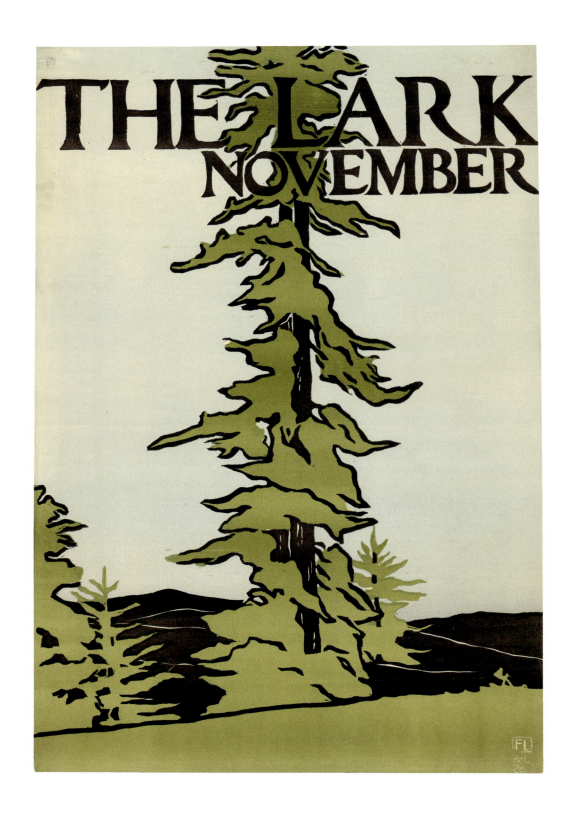

58 | FLORENCE LUNDBORG | *The Lark, November,* 1896

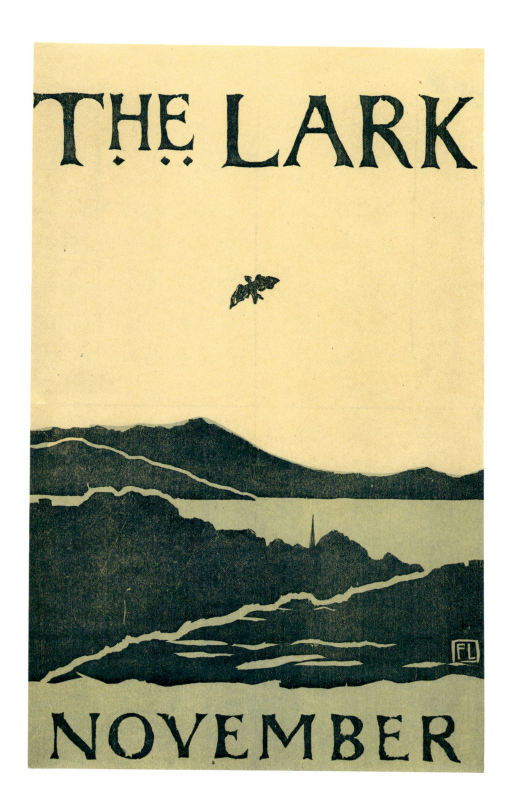

59 | FLORENCE LUNDBORG | *The Lark, November*, 1895

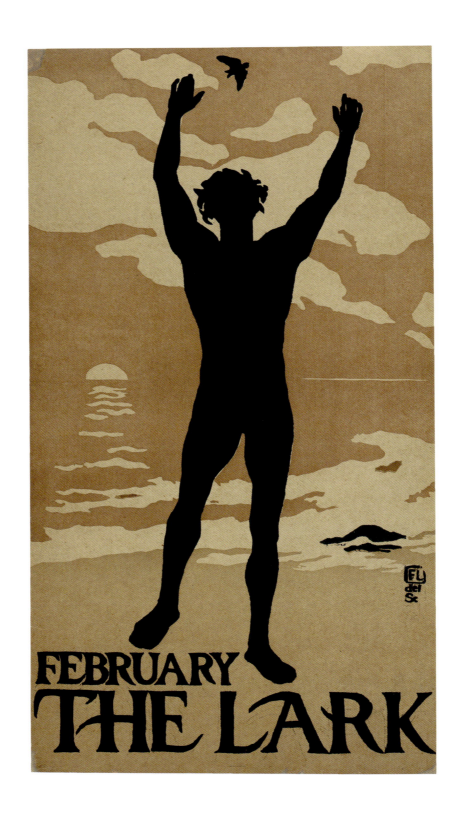

60 | florence lundborg | *The Lark, February*, 1897

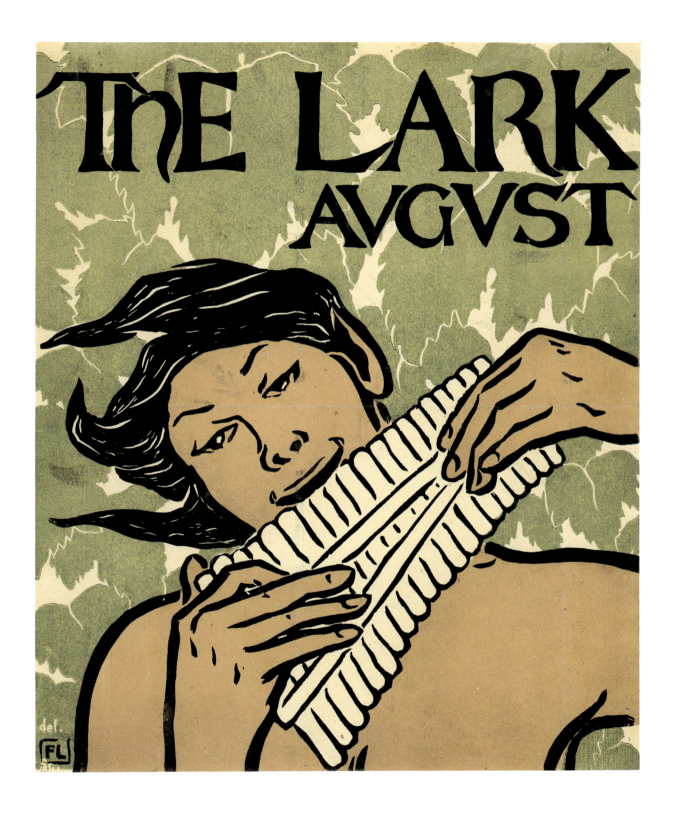

61 | FLORENCE LUNDBORG | *The Lark, August*, 1896

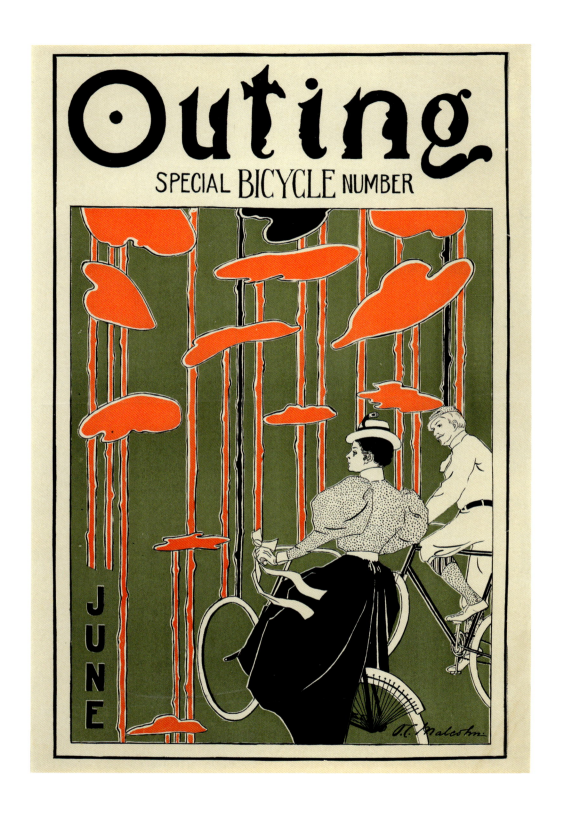

62 | o. c. malcolm | *Outing, Special Bicycle Number, June,* ca. 1895

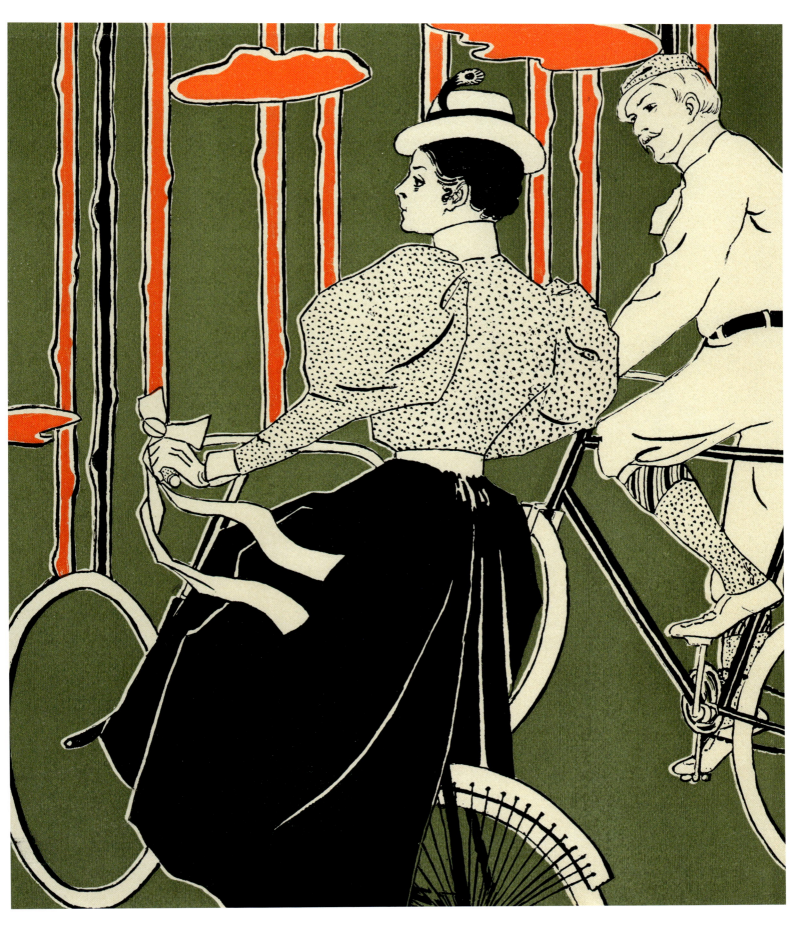

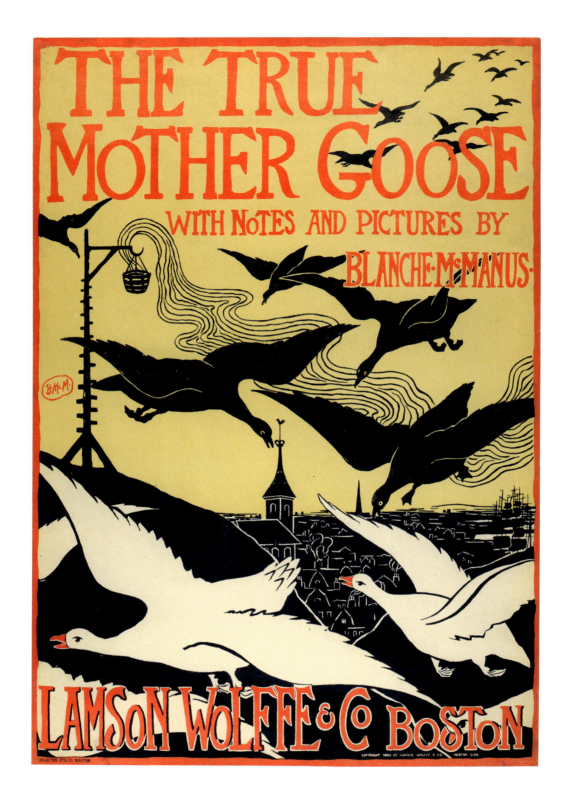

63 | BLANCHE MCMANUS MANSFIELD | *The True Mother Goose with Notes and Pictures by Blanche McManus*, 1895

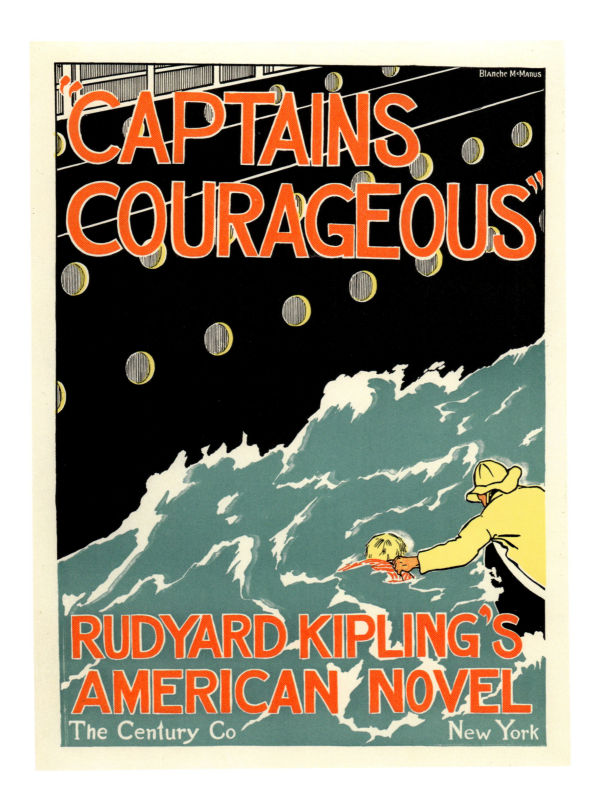

BLANCHE MCMANUS MANSFIELD | *Captains Courageous, Rudyard Kipling's American Novel,* 1897

65 | H. W. MCVICKAR | *The Evolution of Woman* by H. W. McVickar, ca. 1896

A. K. MOE | *Harvard Lampoon [Crew]*, 1895

67 | A. K. MOE | *Harvard Lampoon [Pegasus]*, 1895

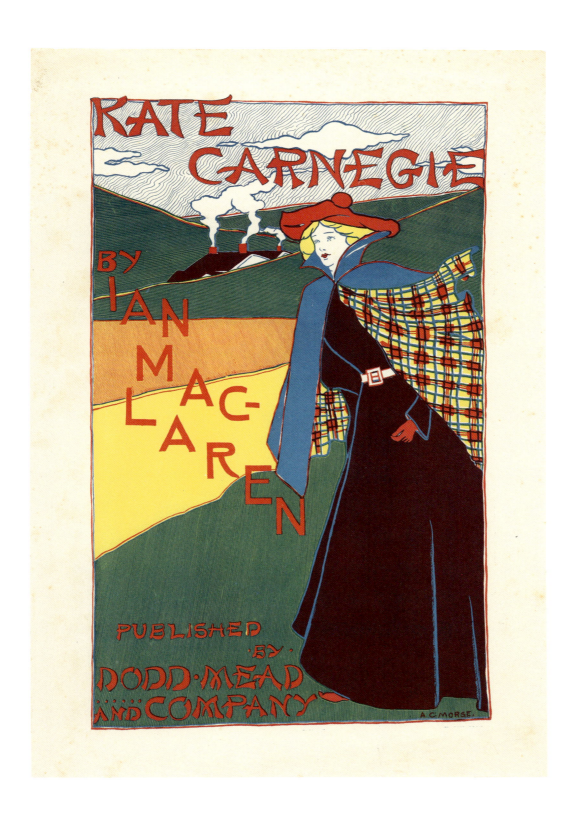

alice cordelia morse | *Kate Carnegie by Ian Maclaren*, 1896

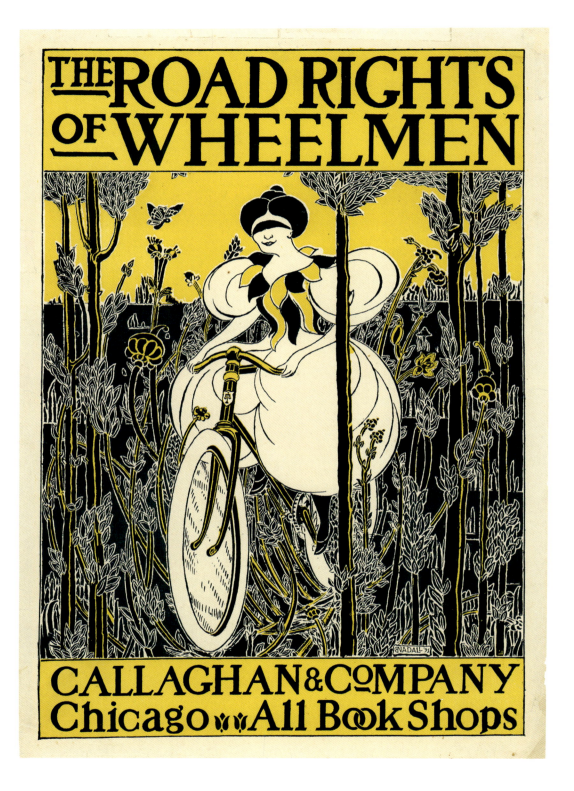

69 | E. NADALL | *The Road Rights of Wheelmen, Callaghan and Company, Chicago, 1895*

70 | FRANK ARTHUR NANKIVELL | *The Echo*, 1895

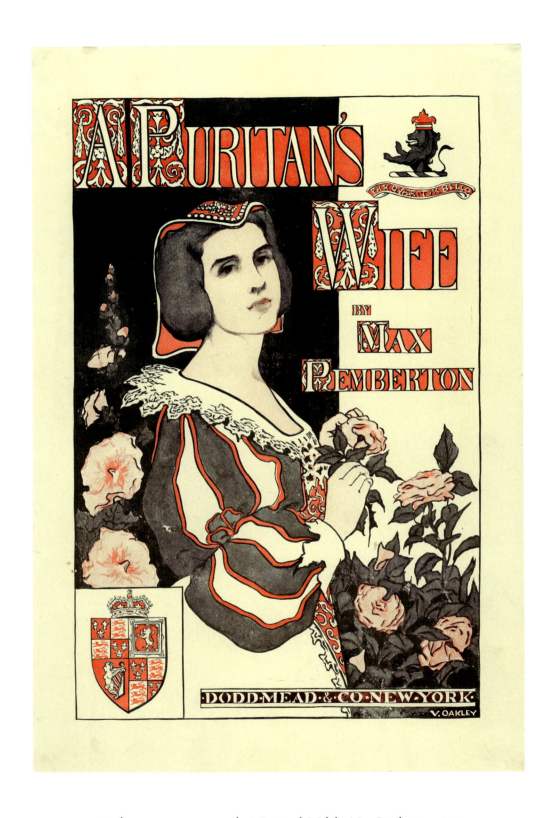

71 | VIOLET OAKLEY | *A Puritan's Wife by Max Pemberton*, 1896

RICHARD FELTON OUTCAULT | *The Sunday World, February 9, 1896*

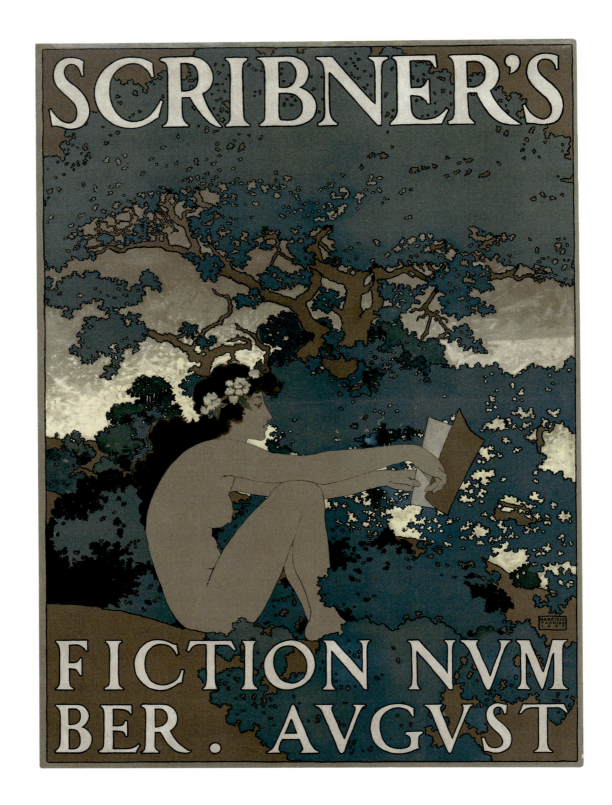

73 | MAXFIELD PARRISH | *Scribner's, August, Fiction Number*, 1897

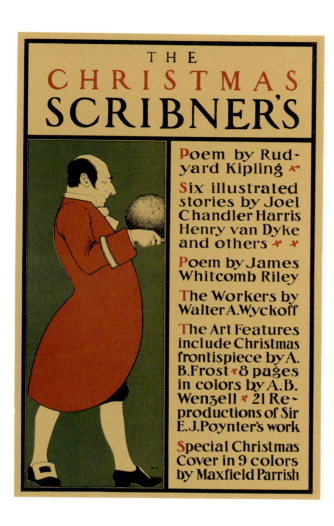
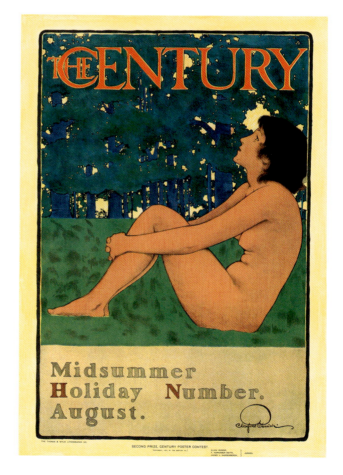

74 | MAXFIELD PARRISH | *Scribner's, December, Christmas Special*, 1897

75 | MAXFIELD PARRISH | *The Century, August, Midsummer Holiday Number*, 1897

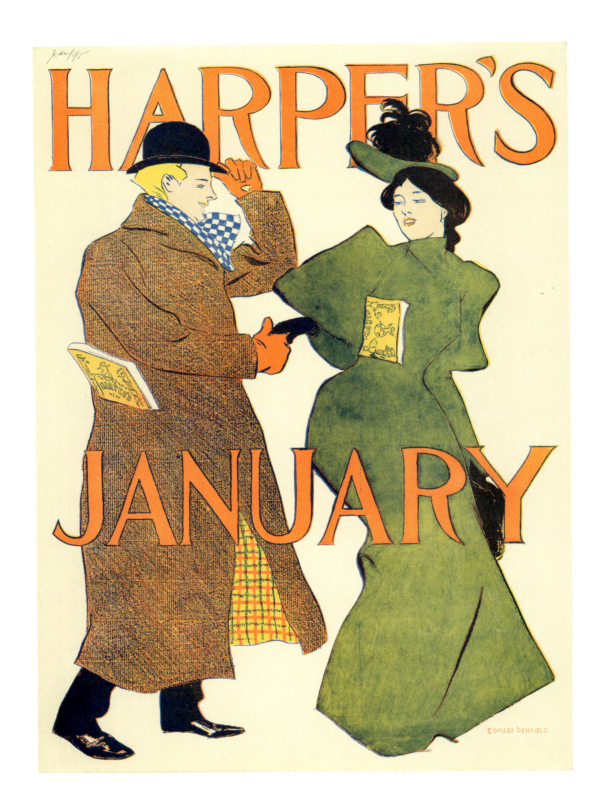

76 | EDWARD PENFIELD | *Harper's, January,* 1895

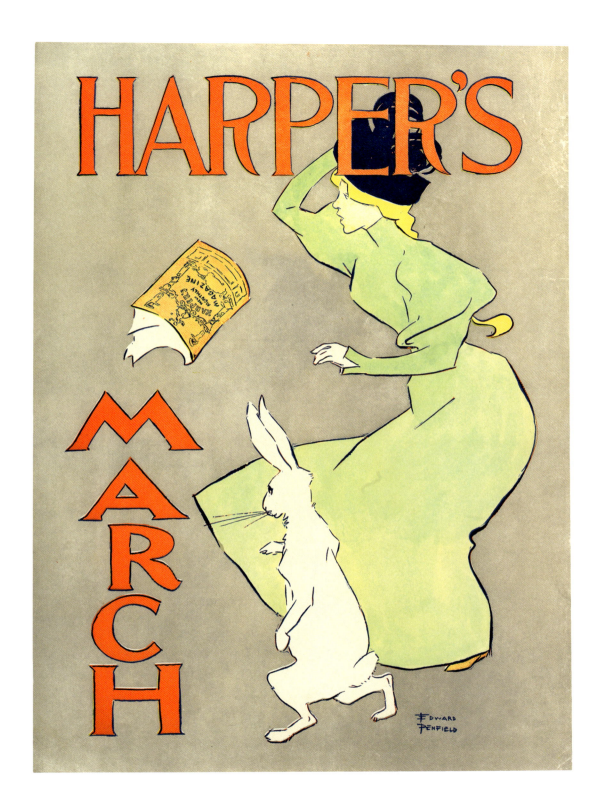

77 | EDWARD PENFIELD | *Harper's, March*, 1895

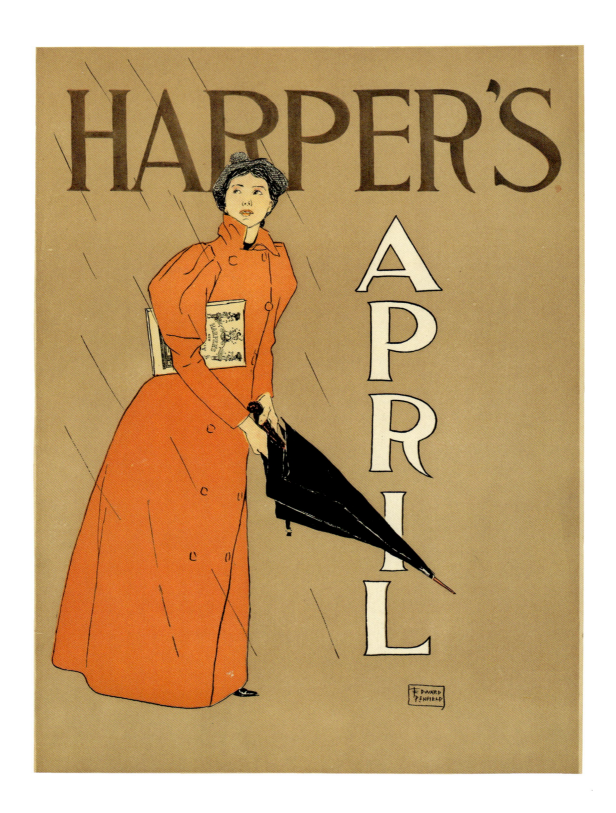

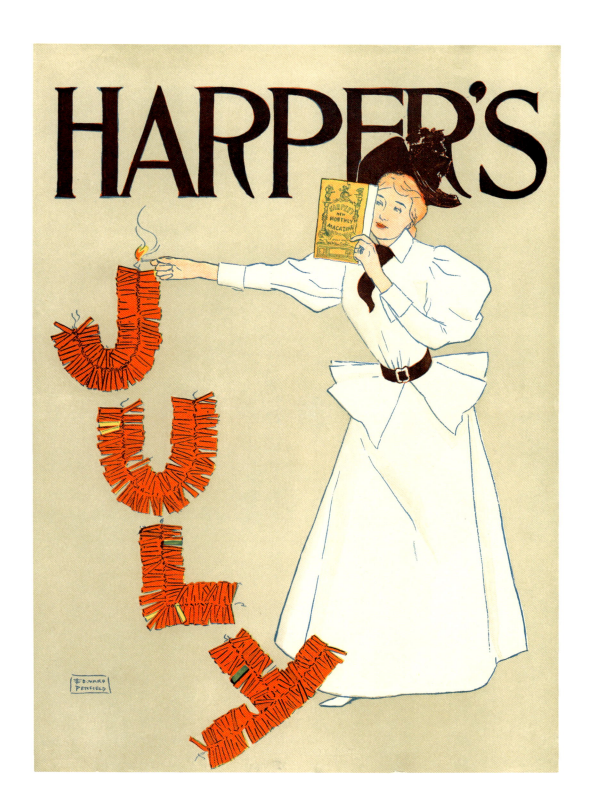

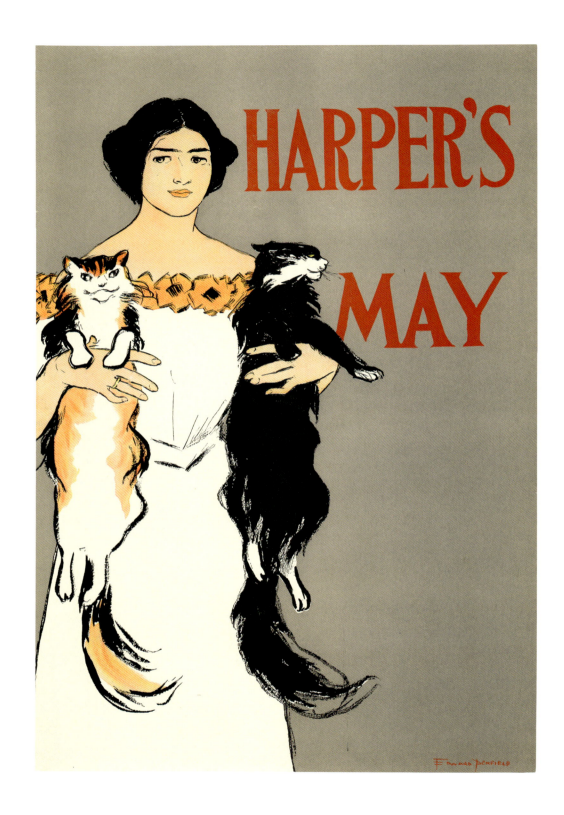

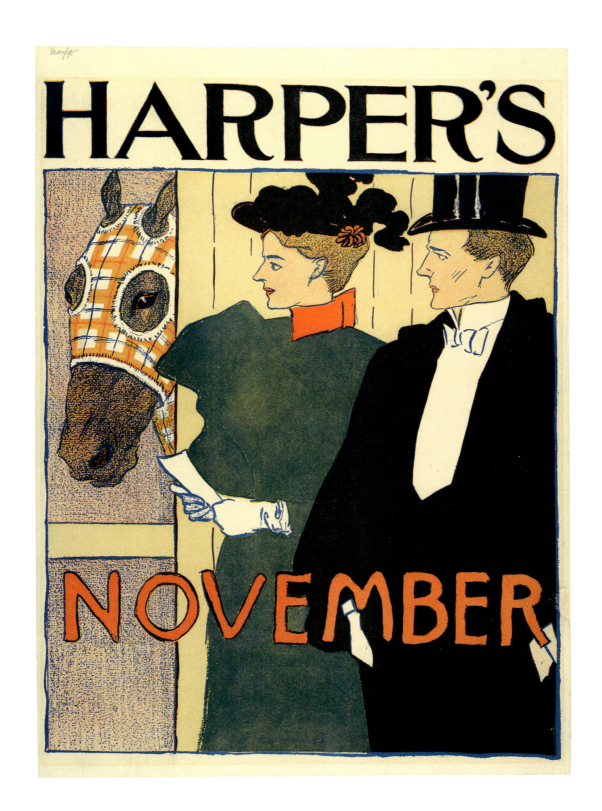

EDWARD PENFIELD | *Harper's, November, 1895*

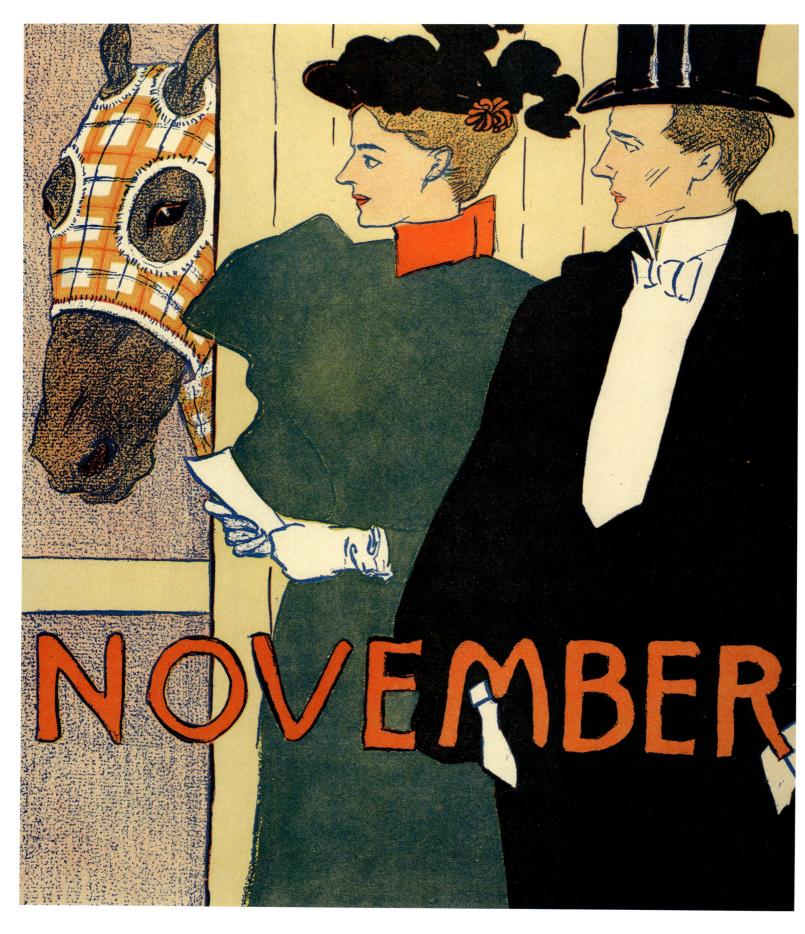

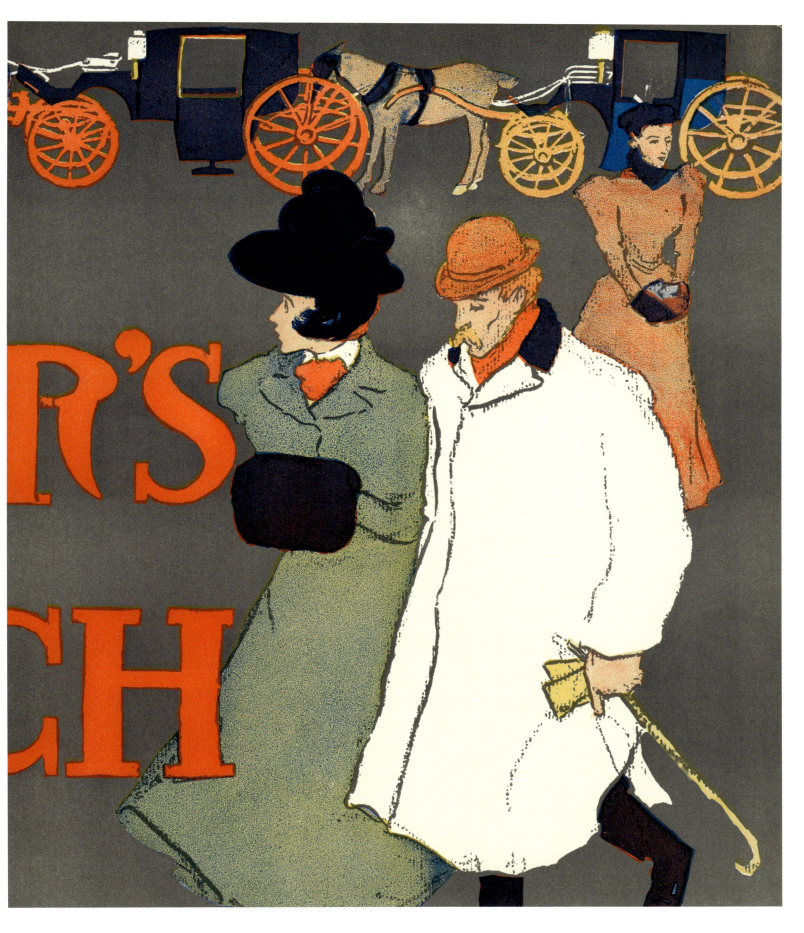

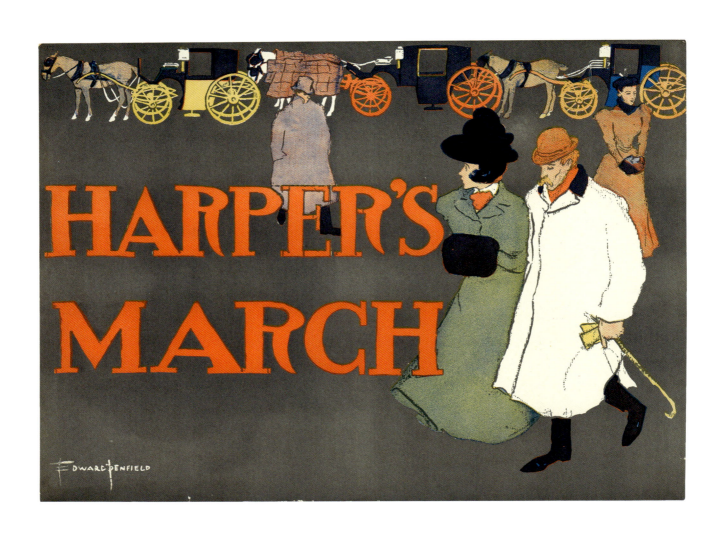

82 | EDWARD PENFIELD | *Harper's, March*, 1897

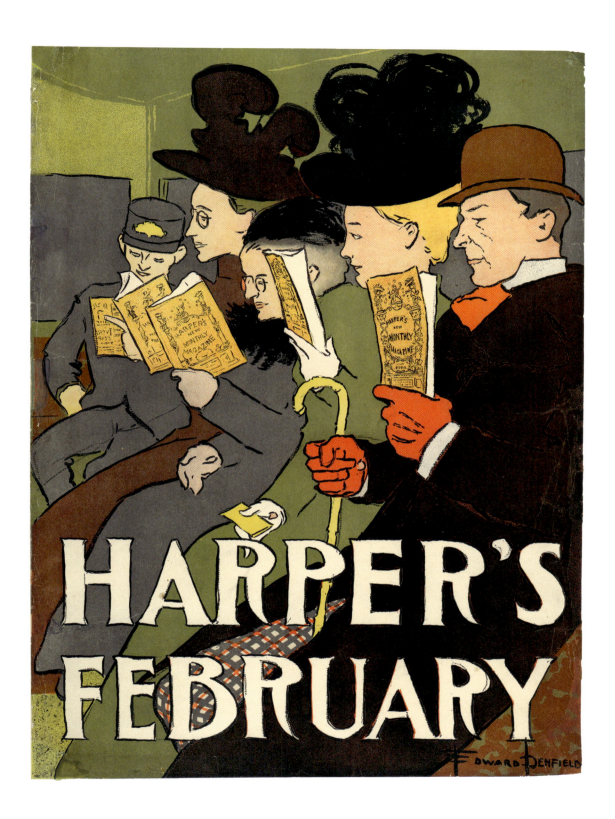

83 | EDWARD PENFIELD | *Harper's, February*, 1897

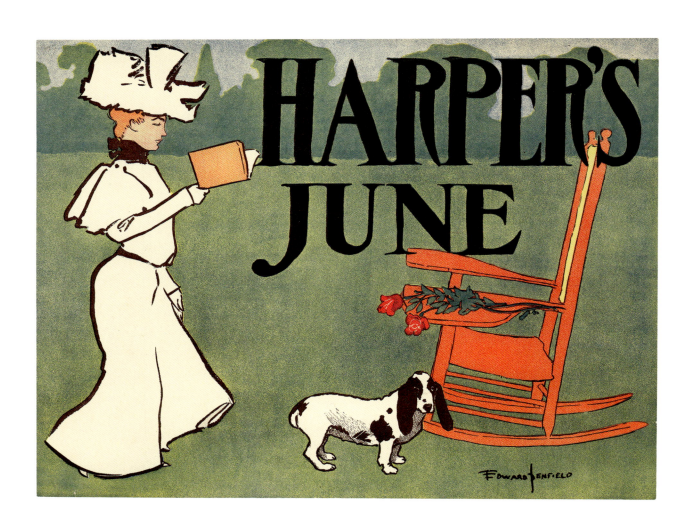

84 | EDWARD PENFIELD | *Harper's, June*, 1897

85 | EDWARD PENFIELD | *Harper's, July*, 1897

EDWARD PENFIELD | *Orient Cycles: Lead the Leaders*, ca. 1895

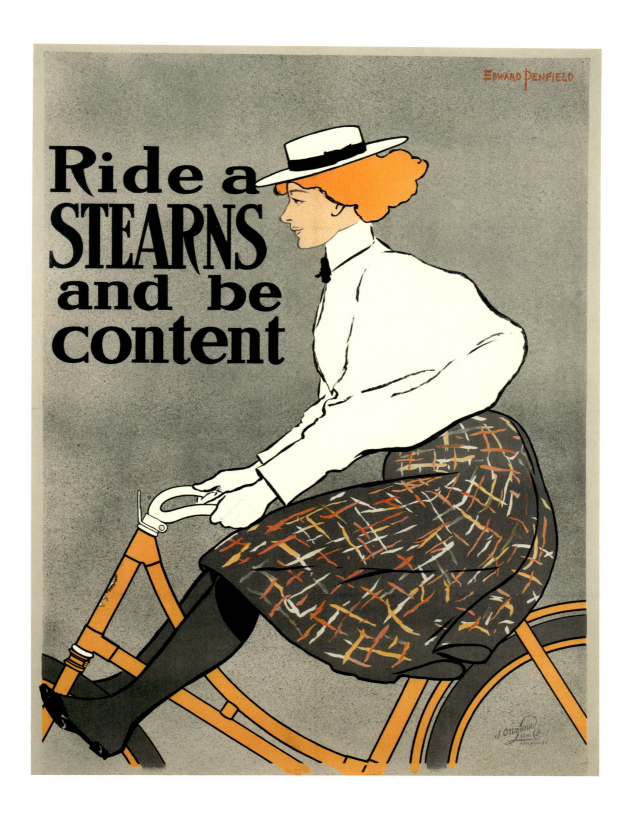

87 | EDWARD PENFIELD | *Ride a Stearns and Be Content,* 1896

88 | EDWARD PENFIELD | *Poster Calendar 1897: Cover, 1896*

89 | EDWARD PENFIELD | Proof for *Poster Calendar 1897: January, February, March*, 1896

90 | EDWARD PENFIELD | *Poster Calendar 1897: January, February, March*, 1896

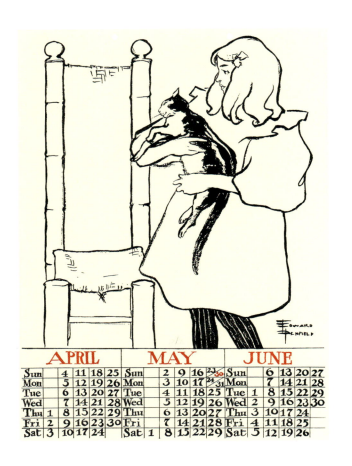
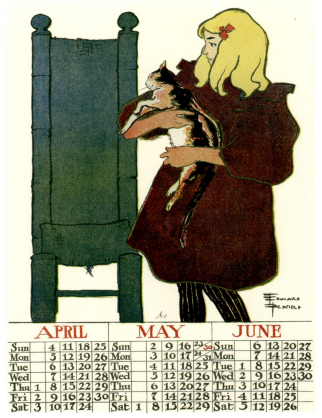

91 | edward penfield | Proof for *Poster Calendar 1897: April, May, June,* 1896

92 | edward penfield | *Poster Calendar 1897: April, May, June,* 1896

93 | EDWARD PENFIELD | Proof for *Poster Calendar 1897: July, August, September*, 1896

94 | EDWARD PENFIELD | *Poster Calendar 1897: July, August, September*, 1896

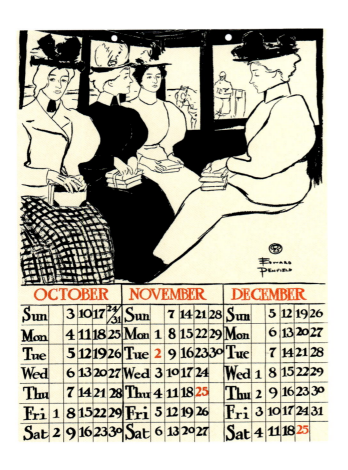
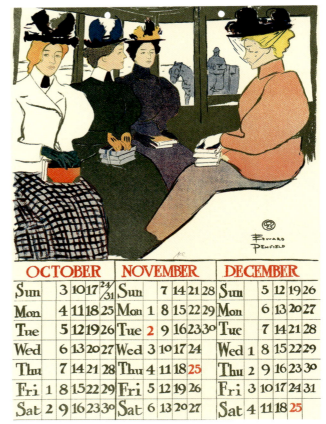

95 | edward penfield | Proof for *Poster Calendar 1897: October, November, December*, 1896

96 | edward penfield | *Poster Calendar 1897: October, November, December*, 1896

97 | EDWARD PENFIELD | *English Society by George du Maurier*, 1897

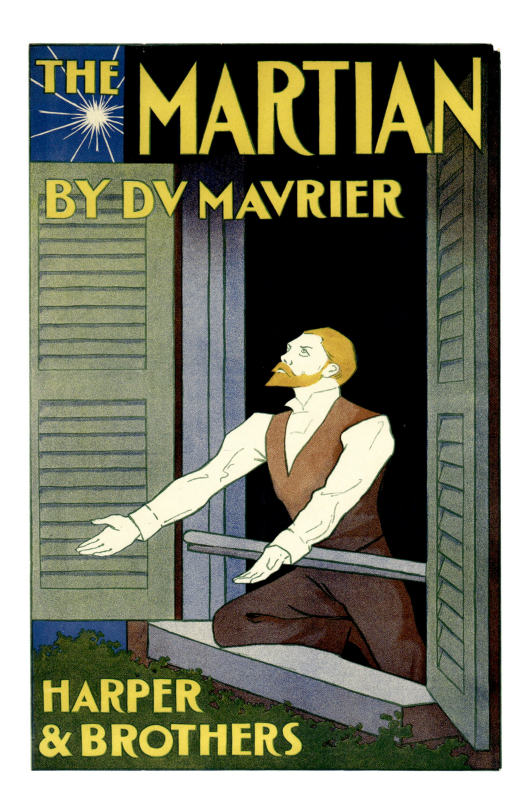

EDWARD PENFIELD | *The Martian by Du Maurier*, 1897

99 | e. pickert | *The New York Times, February 9, 1895*

100 | EDWARD HENRY POTTHAST | *The Century, July,* 1896

101 | MAURICE BRAZIL PRENDERGAST | *On the Point by Nathan Haskell Dole*, 1895

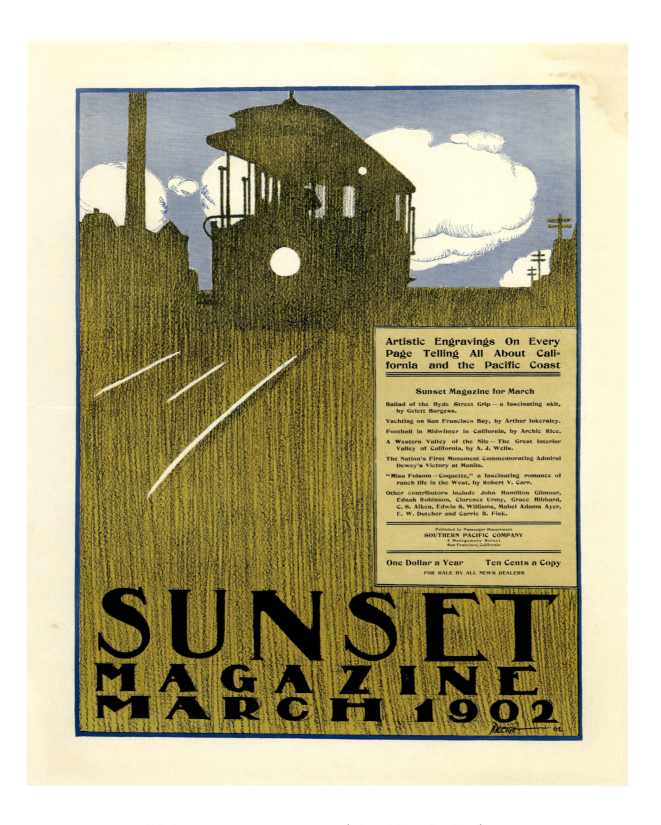

Sunset Magazine, March, 1902

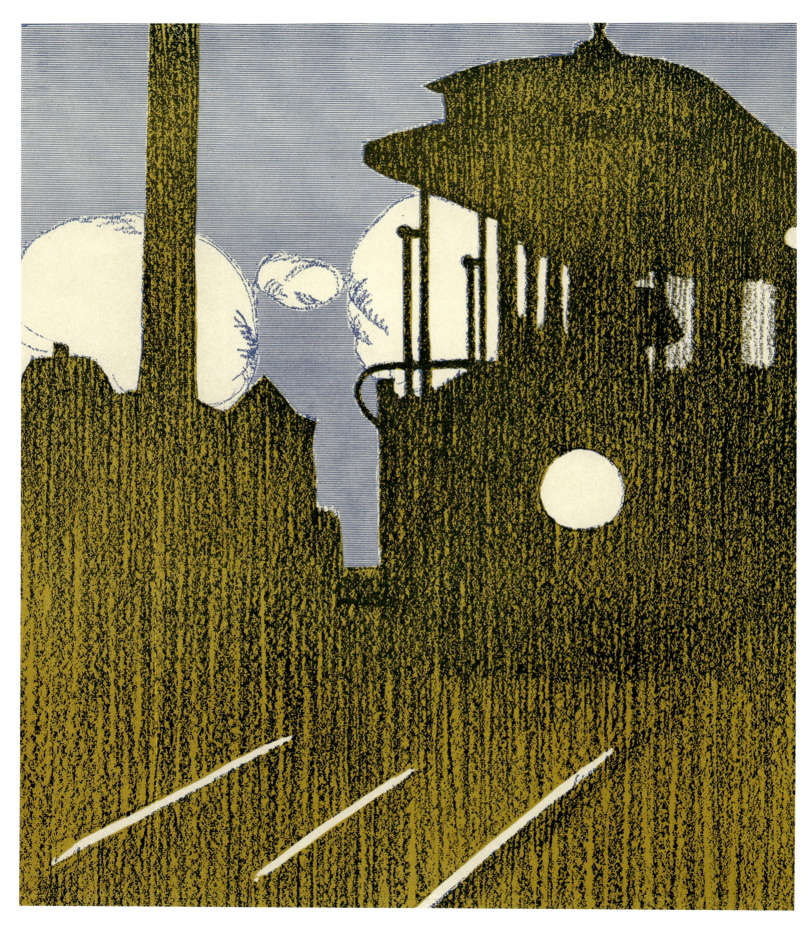

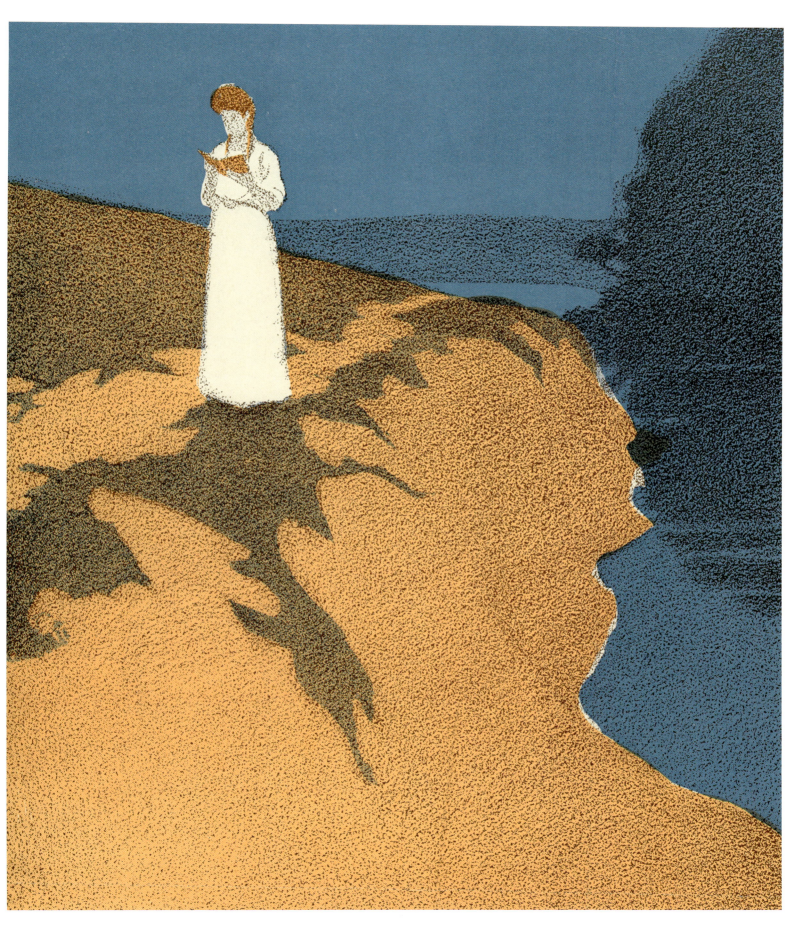

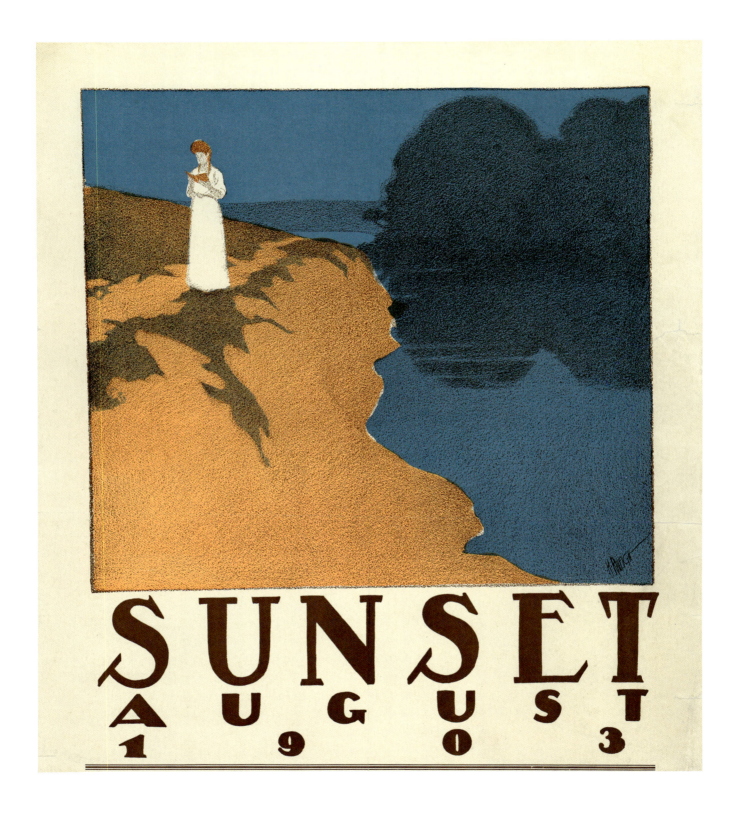

103 | HENRY PATRICK RALEIGH | *Sunset Magazine, August,* 1903

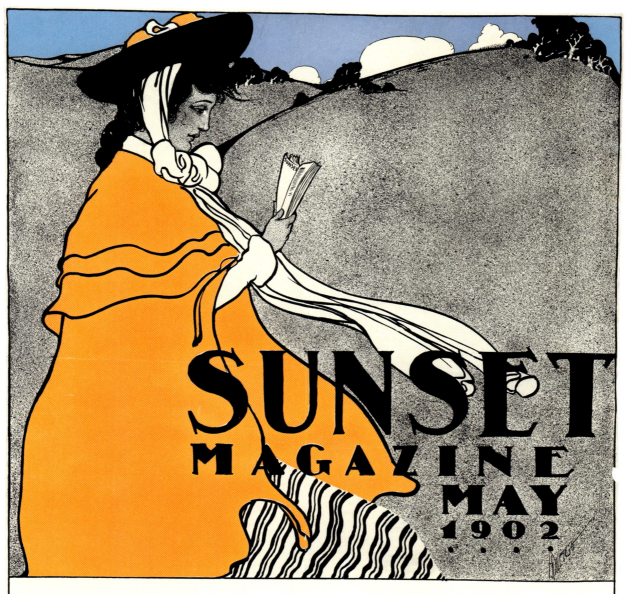

## SUNSET FOR MAY CONTAINS

A Weird, War Story by Gelett Burgess, author of "Vivette," and former editor of "The Lark."

Timely Hints for Summer Campers, by Katherine A. Chandler.

Picturesque Description, with Illustrations of California's Fruitful Santa Clara Valley, by H. L. Wells.

Horses of California—Oakwood Park—Seventh Paper, by Joseph Cairn Simpson, the Famous Turf Writer.

Ten 'Cross-Continent Meteors, Telling of the New Overland Limited, Electric Lighted Trains.

Crater Lake by Night and Day—A Study of Oregon's Natural Wonder, by Caspar W. Hodgson.

Articles Concerning the San Joaquin Valley, California, by Colvin B. Brown, Wm. S. Rice and James A. Barr.

Latest Portrait Studies of Maxine Elliott and Maude Fealy, Dramatic Stars. Reviews of New Books.

ELABORATELY ILLUSTRATED—All About California and the West. For Sale by all Newsdealers. Ten Cents a Copy—One Dollar a Year.

Published Monthly by Passenger Department SOUTHERN PACIFIC COMPANY, 4 Montgomery Street, San Francisco, California

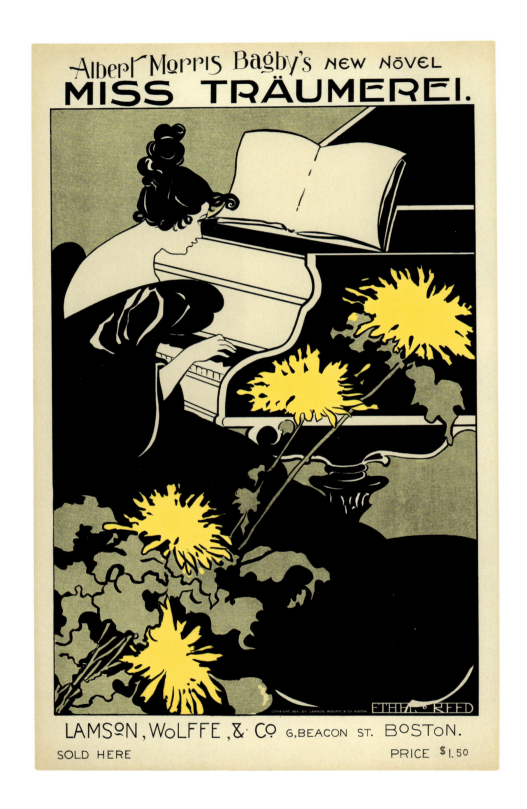

105 | ETHEL REED | *Albert Morris Bagby's New Novel, Miss Träumerei, 1895*

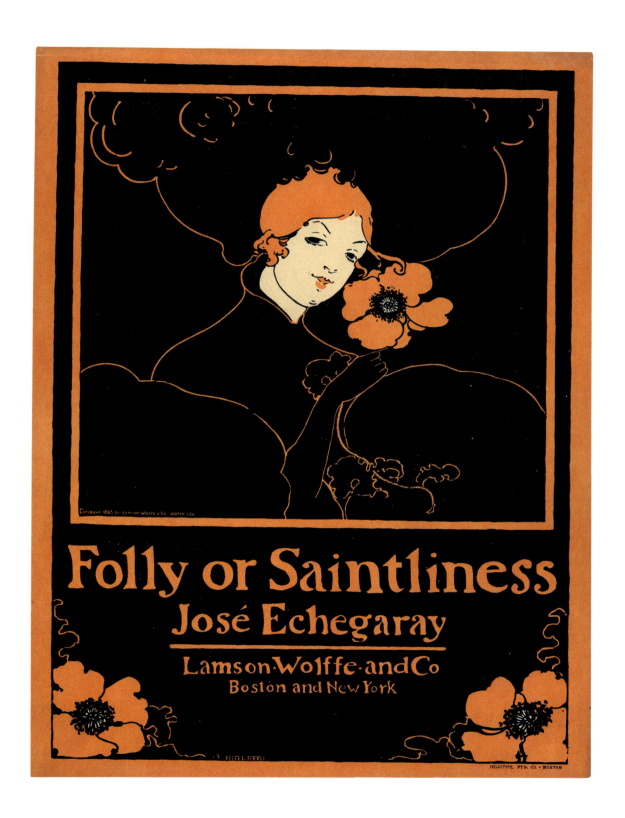

106 | ETHEL REED | *Folly or Saintliness by José Echegaray, 1895*

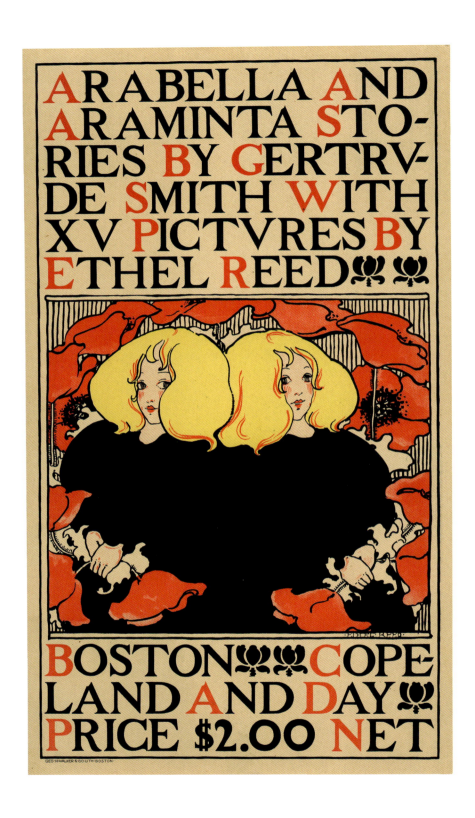

107 | ETHEL REED | *Arabella and Araminta Stories by Gertrude Smith with XV Pictures by Ethel Reed, 1895*

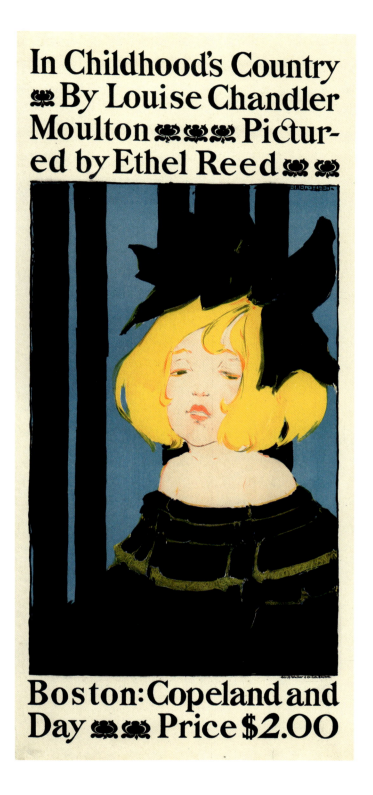

*In Childhood's Country by Louise Chandler Moulton, Pictured by Ethel Reed*, 1896

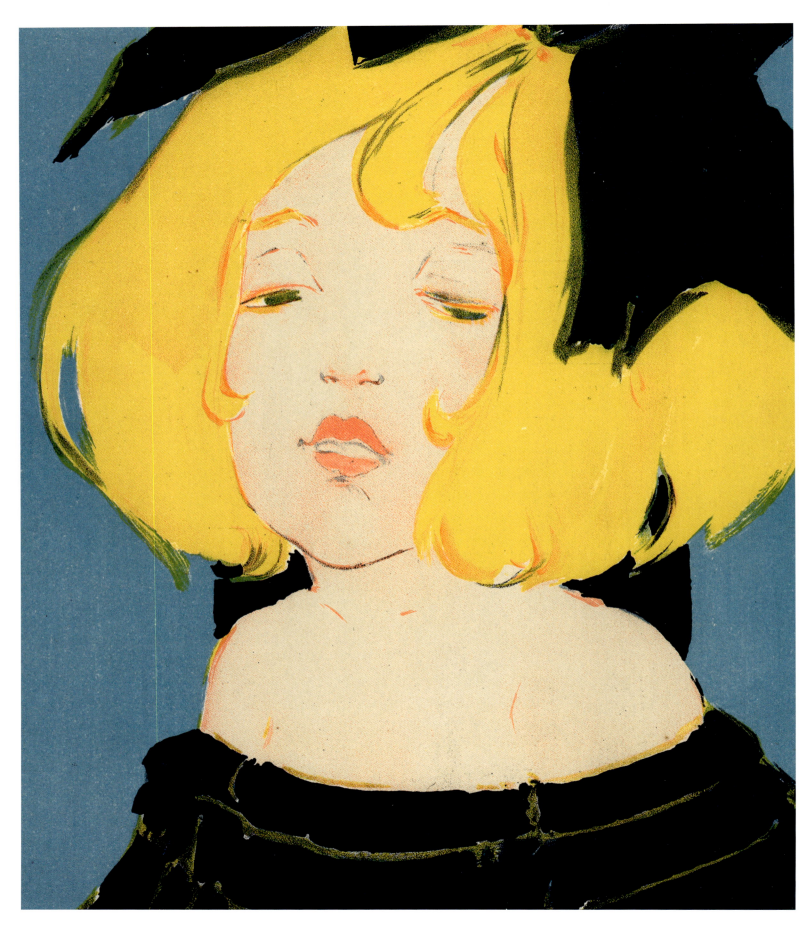

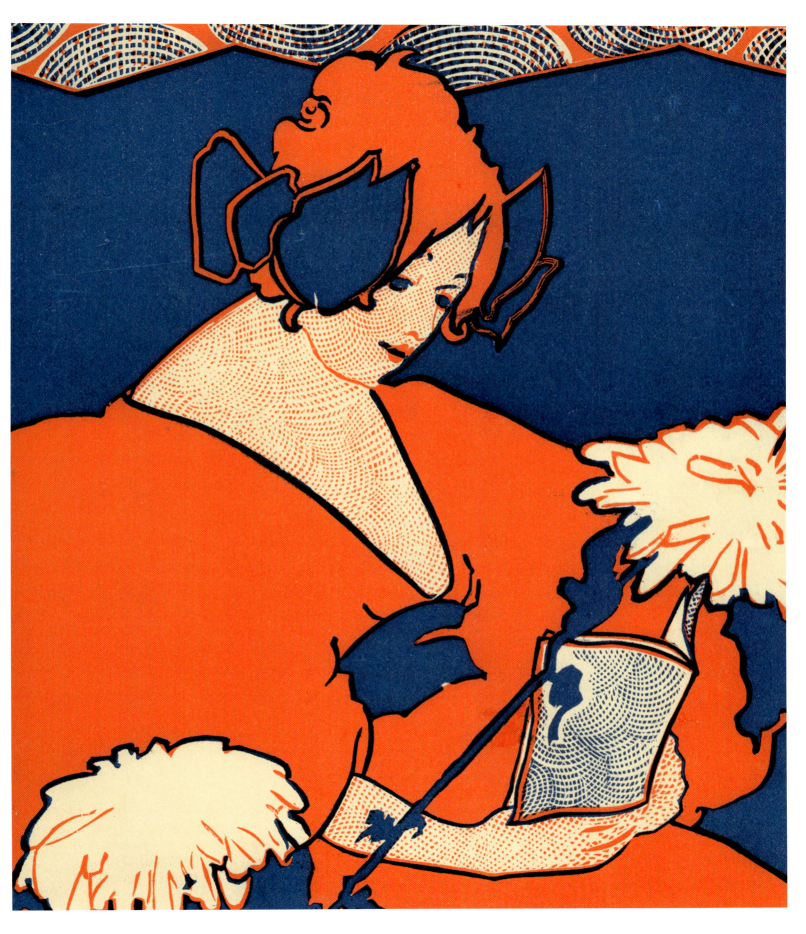

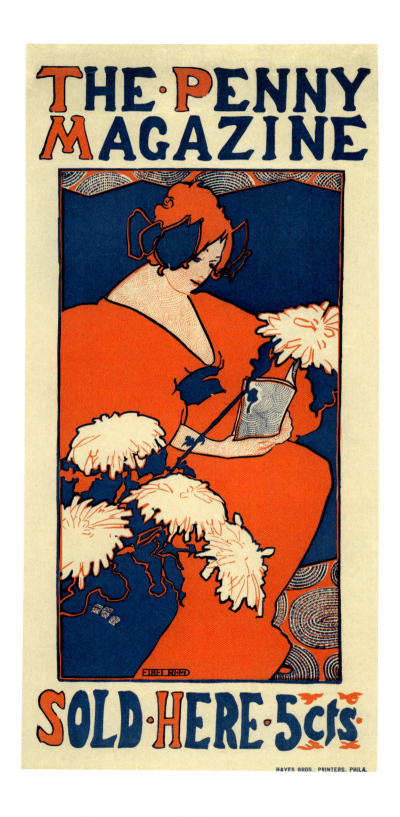

109 | ETHEL REED | *The Penny Magazine*, ca. 1896

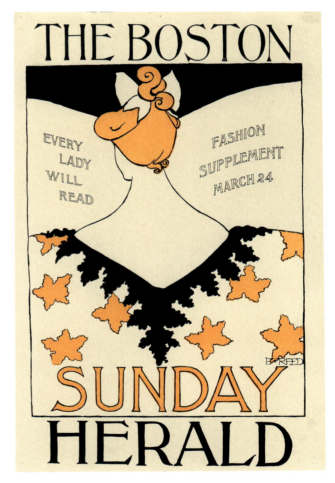

110 | ETHEL REED | *A Virginia Cousin and Bar Harbor Tales by Mrs. Burton Harrison*, 1895

111 | ETHEL REED | *The Boston Sunday Herald, March 24*, 1895

ETHEL REED | *Behind the Arras by Bliss Carman*, 1895

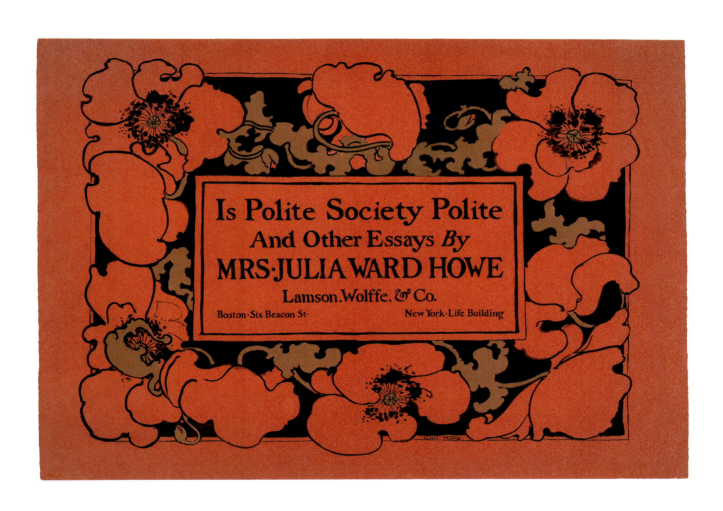

113 | ETHEL REED | *Is Polite Society Polite and Other Essays by Mrs. Julia Ward Howe*, 1895

114 | LOUIS JOHN RHEAD | *The Century Magazine, Midsummer Holiday Number, 1894*

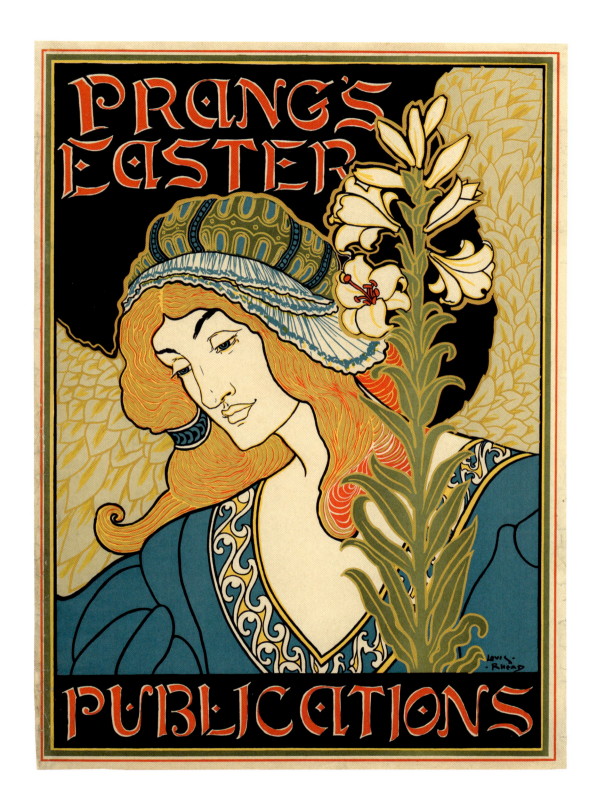

115 | LOUIS JOHN RHEAD | *Prang's Easter Publications*, 1895

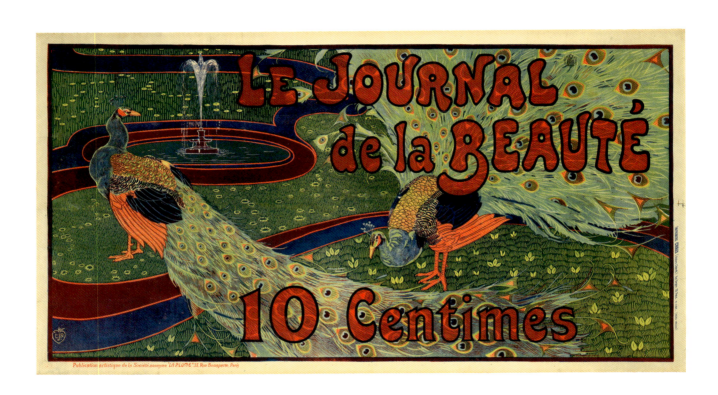

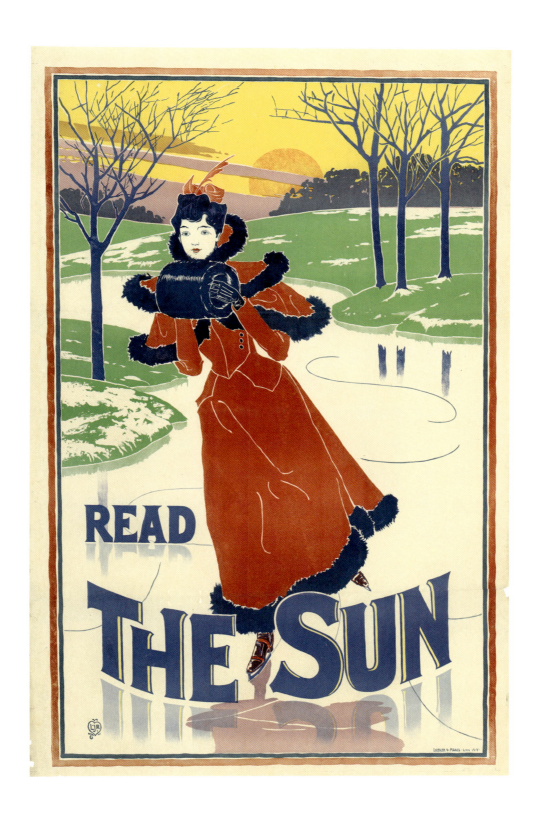

117 | LOUIS JOHN RHEAD | *The Sun*, 1895

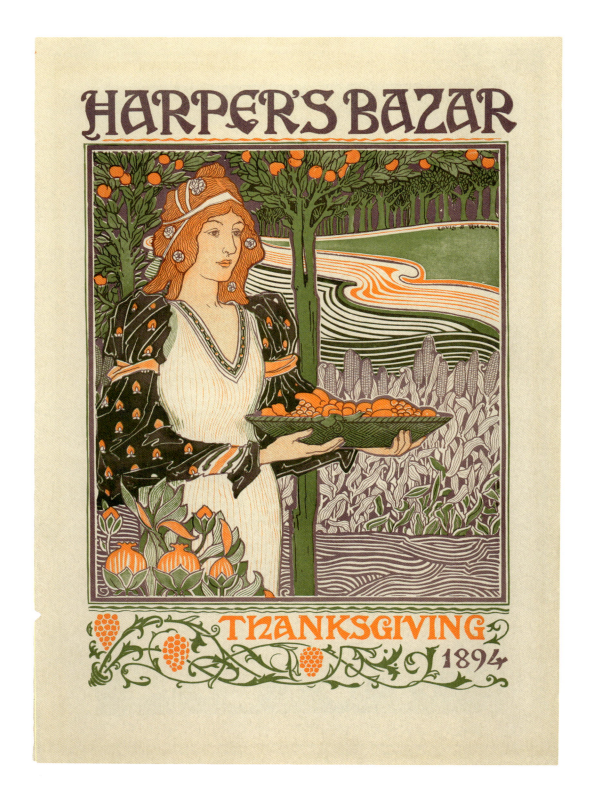

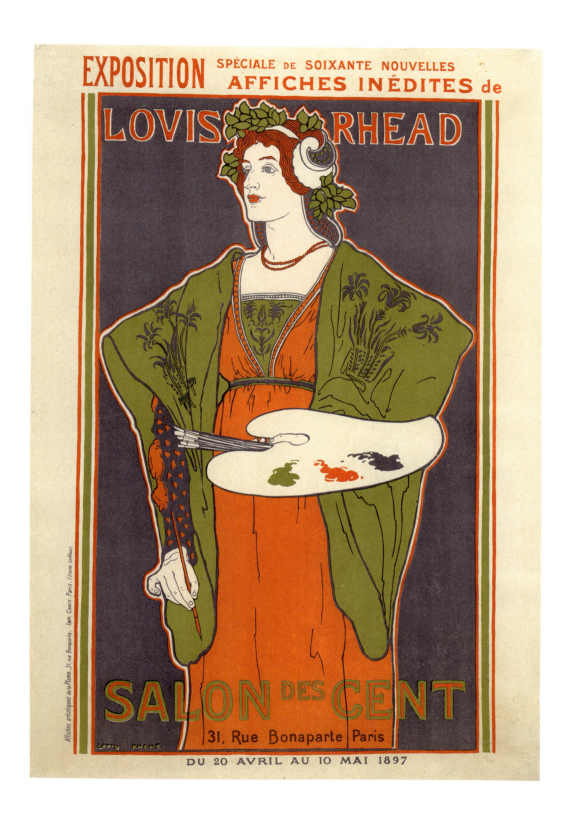

119 | LOUIS JOHN RHEAD | *Exposition, Salon des Cent*, 1897

120 | LOUIS JOHN RHEAD | *Poster Calendar 1897: Cover*, 1896

121 | louis john rhead | *Poster Calendar 1897: January, February, March*, 1896

122 | louis john rhead | *Poster Calendar 1897: April, May, June*, 1896

123 | LOUIS JOHN RHEAD | *Poster Calendar 1897: July, August, September, 1896*

124 | LOUIS JOHN RHEAD | *Poster Calendar 1897: October, November, December, 1896*

125 | louis john rhead | *The Weekly Dispatch*, 1895

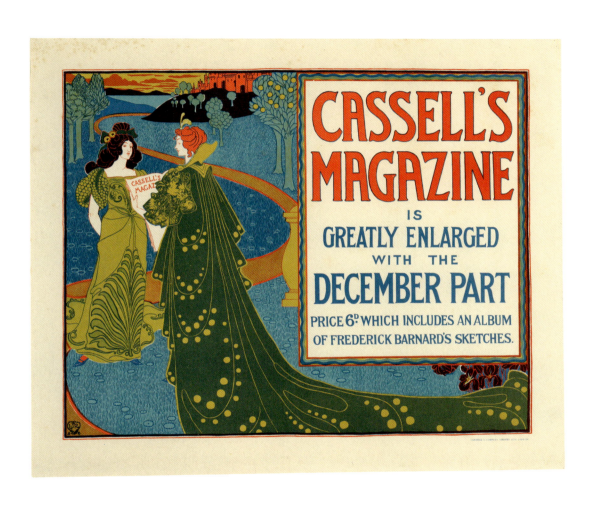

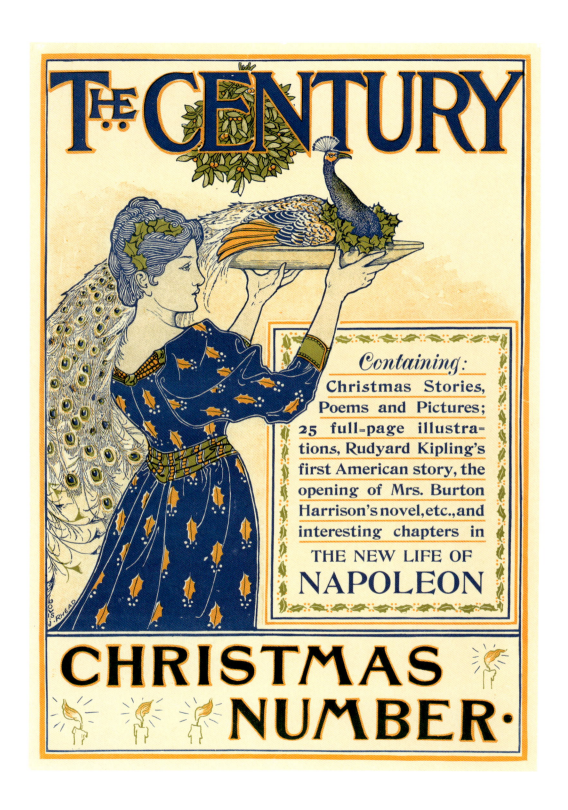

127 | LOUIS JOHN RHEAD | *The Century, December, Christmas Number,* 1894

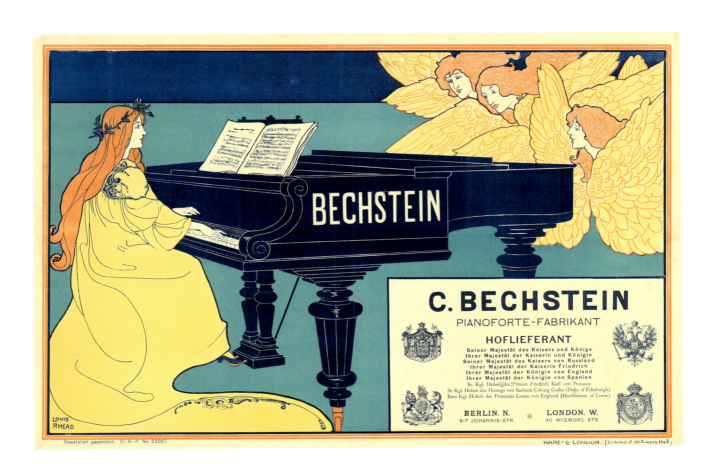

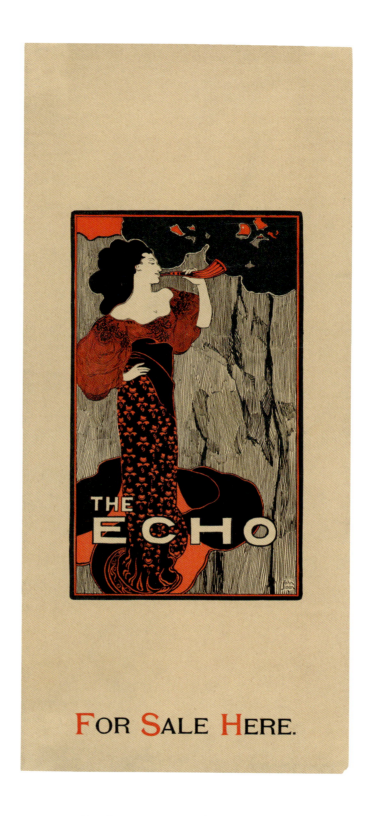

129 | john sloan | *The Echo*, 1895

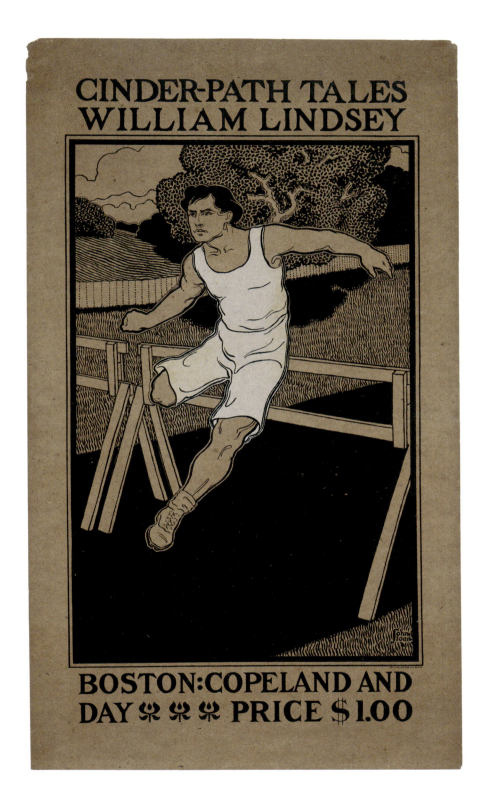

130 | JOHN SLOAN | *Cinder-Path Tales by William Lindsey, 1896*

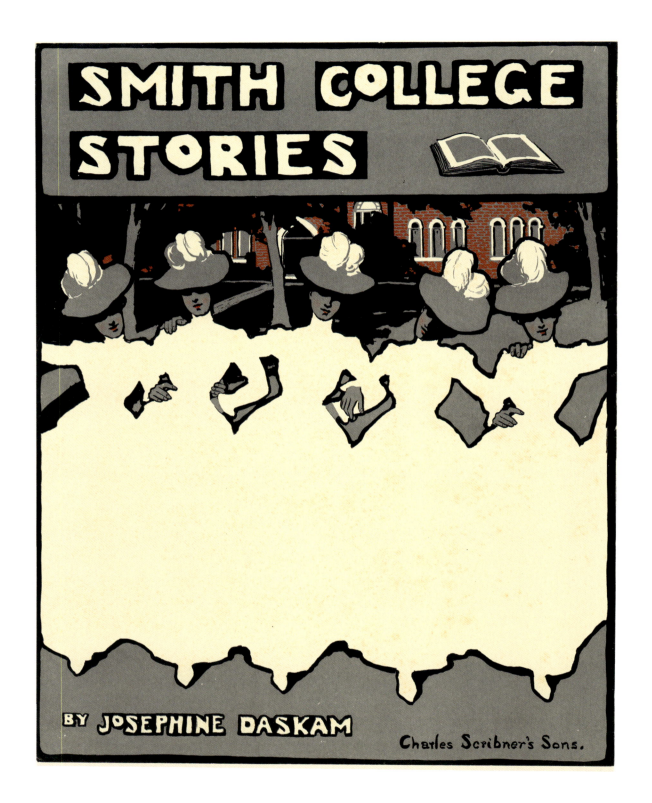

joseph lindon smith | *Handbook of the New Public Library*, 1895

133 | w. | *The Century, March, 1898*

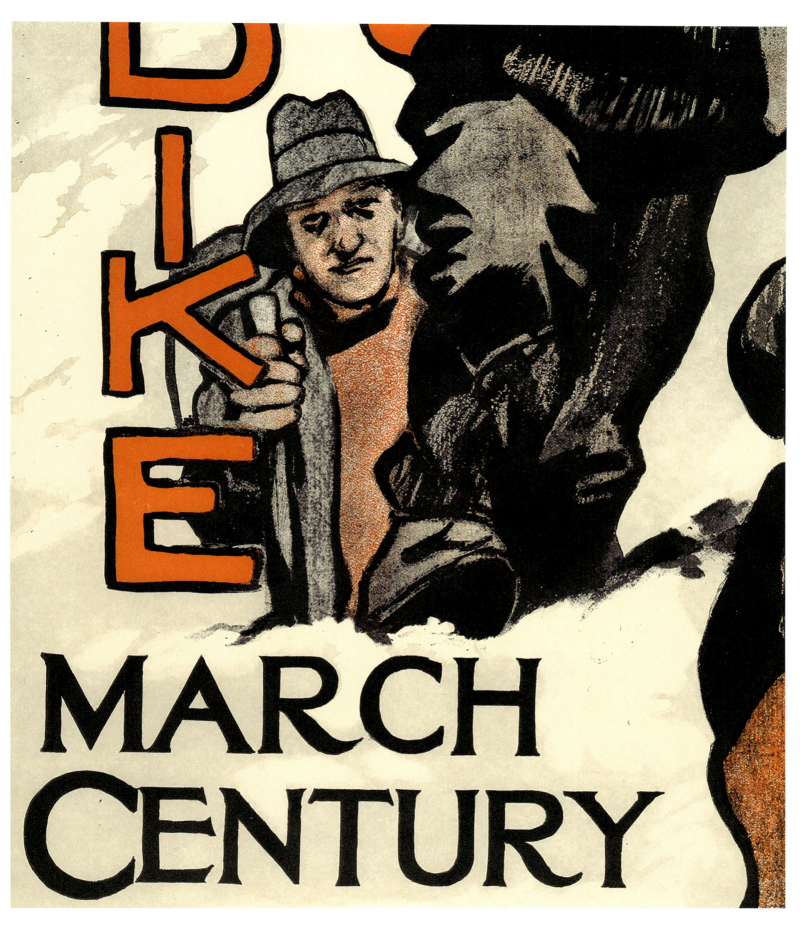

*Mrs. Cliff's Yacht* by Frank R. Stockton, 1896

135 | CHARLES HERBERT WOODBURY | *The Century, July,* 1895

# LIST OF PLATES

Reproduced in this book is a selection of the more than five hundred works in the Leonard A. Lauder Collection of American Posters, acquired by The Metropolitan Museum of Art beginning in 1984. Most date to the 1890s, though a few were made within the first few years of the twentieth century. Designed by the leading poster artists of the day, the majority of the posters were commissioned by publishing firms to advertise journals, magazines, and books intended for a mainstream audience, while some promote "little magazines"—publications distinguished by their experimental content and small circulation. Also included are advertisements for products associated with common leisure activities, such as bicycles and musical instruments, as well as yearly poster calendars. Taken together, the selection evinces both the diversity of styles and the commonality of themes that undergird poster production in the United States at the turn of the twentieth century.

The full Leonard A. Lauder Collection of American Posters may be accessed on The Met's website.

1 | ELISHA BROWN BIRD
(American, Dorchester, MA 1867–1943 Philadelphia, PA)
*The Captured Cunarder by William H. Rideing*, 1896
Lithograph, 23 1/16 x 12 1/2 in. (58.6 x 31.7 cm)
Leonard A. Lauder Collection of American Posters, Gift of Leonard A. Lauder, 1984 (1984.1202.2)

2 | ELISHA BROWN BIRD
(American, Dorchester, MA 1867–1943 Philadelphia, PA)
*The Red Letter*, 1896
Lithograph, 25 7/8 x 17 15/16 in. (65.8 x 45.5 cm)
Leonard A. Lauder Collection of American Posters, Gift of Leonard A. Lauder, 1984 (1984.1202.3)

3 | ELISHA BROWN BIRD
(American, Dorchester, MA 1867–1943 Philadelphia, PA)
*The Poster, March [Miss Art and Miss Litho]*, 1896
Lithograph, 19 1/16 x 12 5/8 in. (48.4 x 32.1 cm)
Leonard A. Lauder Collection of American Posters, Gift of Leonard A. Lauder, 1984 (1984.1202.5)

4 | WILL H. BRADLEY
(American, Boston, MA 1868–1962 La Mesa, CA)
*The Chap-Book [The Twins]*, 1894
Relief print, 20 x 14 in. (50.8 x 35.6 cm)
Leonard A. Lauder Collection of American Posters, Gift of Leonard A. Lauder, 1984 (1984.1202.8)

5 | WILL H. BRADLEY
(American, Boston, MA 1868–1962 La Mesa, CA)
*The Chap-Book, Thanksgiving Number*, 1895
Lithograph, 20 13/16 x 13 7/8 in. (52.8 x 35.2 cm)
Leonard A. Lauder Collection of American Posters, Gift of Leonard A. Lauder, 1984 (1984.1202.7)

6 | WILL H. BRADLEY
(American, Boston, MA 1868–1962 La Mesa, CA)
*When Hearts Are Trumps by Tom Hall*, 1894
Relief print, 17 1/8 x 14 3/16 in. (43.5 x 36 cm)
Leonard A. Lauder Collection of American Posters, Gift of Leonard A. Lauder, 1984 (1984.1202.6)

7 | WILL H. BRADLEY
(American, Boston, MA 1868–1962 La Mesa, CA)
*The Chap-Book [The Pipes]*, 1895
Lithograph, 21 3/8 x 14 15/16 in. (54.3 x 38 cm)
Leonard A. Lauder Collection of American Posters, Gift of Leonard A. Lauder, 1984 (1984.1202.10)

8 | WILL H. BRADLEY
(American, Boston, MA 1868–1962 La Mesa, CA)
*The Echo*, 1895
Relief print, 22 1/2 x 14 in. (57.1 x 35.5 cm)
Leonard A. Lauder Collection of American Posters, Gift of Leonard A. Lauder, 1984 (1984.1202.11)

9 | WILL H. BRADLEY
(American, Boston, MA 1868–1962 La Mesa, CA)
*Bradley: His Book [The Kiss]*, 1896
Relief print, 41 3/4 x 28 13/16 in. (106.1 x 73.2 cm)
Leonard A. Lauder Collection of American Posters, Gift of Leonard A. Lauder, 1984 (1984.1202.16)

10 | WILL H. BRADLEY
(American, Boston, MA 1868–1962 La Mesa, CA)
*The Modern Poster, Charles Scribner's Sons, New York*, 1895
Relief print, 19 13/16 x 12 7/16 in. (50.3 x 31.6 cm)
Purchase, Leonard A. Lauder Gift, 1990 (1990.1016.1)

11 | WILL H. BRADLEY
(American, Boston, MA 1868–1962 La Mesa, CA)
*Bradley: His Book [Beauty and the Beast]*, 1896
Relief print, 19 1/4 x 10 1/16 in. (48.9 x 25.6 cm)

Leonard A. Lauder Collection of American Posters, Gift of Leonard A. Lauder, 1984 (1984.1202.18)

12 | WILL H. BRADLEY
(American, Boston, MA 1868–1962 La Mesa, CA)
*Victor Bicycles, Overman Wheel Company*, 1896
Lithograph, 27 x 40 ¾ in. (68.6 x 103.5 cm)
Leonard A. Lauder Collection of American Posters, Gift of Leonard A. Lauder, 1986 (1986.1207)

13 | GEORGE REITER BRILL
(American, Pittsburgh, PA 1867–1918 Florida)
*Tribune*, late 19th century
Relief print, 21 15/16 x 15 9/16 in. (55.7 x 39.5 cm)
Purchase, Leonard A. Lauder Gift, 2002 (2002.223.1)

14 | GEORGE REITER BRILL
(American, Pittsburgh, PA 1867–1918 Florida)
*Philadelphia Sunday Press, June 9*, 1895
Relief print, 21 15/16 x 15 11/16 in. (55.7 x 39.8 cm)
Purchase, Leonard A. Lauder Gift, 1990 (1990.1100.3)

15 | GEORGE REITER BRILL
(American, Pittsburgh, PA 1867–1918 Florida)
*Philadelphia Sunday Press, February 23*, 1896
Relief print, 20 ¼ x 13 in. (51.4 x 33 cm)
Purchase, The Lauder Foundation, Leonard and Judy Lauder Fund Gift, 2015 (2015.470)

16 | WILLIAM L. CARQUEVILLE
(American, Chicago 1871–1946)
*Lippincott's, April*, 1895
Lithograph, 19 x 12 7/16 in. (48.2 x 31.6 cm)
Leonard A. Lauder Collection of American Posters, Gift of Leonard A. Lauder, 1984 (1984.1202.27)

17 | WILLIAM L. CARQUEVILLE
(American, Chicago 1871–1946)
*Lippincott's, May*, 1895
Lithograph, 18 13/16 x 12 ¼ in. (47.8 x 31.1 cm)

Leonard A. Lauder Collection of American Posters, Gift of Leonard A. Lauder, 1984 (1984.1202.28)

18 | WILLIAM L. CARQUEVILLE
(American, Chicago 1871–1946)
*Lippincott's, August*, 1895
Lithograph, 18 13/16 x 12 5/16 in. (47.8 x 31.2 cm)
Leonard A. Lauder Collection of American Posters, Gift of Leonard A. Lauder, 1984 (1984.1202.30)

19 | WILLIAM L. CARQUEVILLE
(American, Chicago 1871–1946)
*International, November*, 1896
Lithograph, 20 ¼ x 13 15/16 in. (51.4 x 35.4 cm)
Purchase, The Lauder Foundation, Evelyn H. and Leonard A. Lauder Fund Gift, 1986 (1986.1005.3)

20 | HOWARD CHANDLER CHRISTY
(American, Ohio 1873–1952 New York)
*The Bookman, September*, 1890s
Relief print, 12 13/16 x 20 1/16 in. (32.5 x 51 cm)
Purchase, Leonard A. Lauder Gift, 1988 (1988.1068.2)

21 | CHARLES ARTHUR COX
(American, born England, Liverpool 1829–1901 Boulder, CO)
*Bearings*, 1896
Relief print, 18 ⅛ x 13 3/16 in. (46 x 33.5 cm)
Leonard A. Lauder Collection of American Posters, Gift of Leonard A. Lauder, 1984 (1984.1202.34)

22 | CHARLES ARTHUR COX
(American, born England, Liverpool 1829–1901 Boulder, CO)
*Bearings*, ca. 1895
Relief print, 17 15/16 x 12 ⅝ in. (45.6 x 32 cm)
Purchase, The Lauder Foundation, Evelyn H. and Leonard A. Lauder Fund Gift, 1998 (1998.162.2)

23 | LAFAYETTE MAYNARD DIXON
(American, Fresno, CA 1875–1946 Tucson, AZ)
*Overland Monthly, June*, 1895
Relief print, 15 x 11 in. (38.1 x 28 cm)
Purchase, Leonard A. Lauder Gift, 2015 (2015.211)

24 | LAFAYETTE MAYNARD DIXON
(American, Fresno, CA 1875–1946 Tucson, AZ)
*Overland Monthly, July*, 1895
Relief print, 19 11/16 x 14 ¾ in. (50 x 37.5 cm)
Purchase, Leonard A. Lauder Gift, 1989 (1989.1108.1)

25 | LAFAYETTE MAYNARD DIXON
(American, Fresno, CA 1875–1946 Tucson, AZ)
*Sunset Magazine, October*, 1902
Relief print, 23 x 19 in. (58.4 x 48.3 cm)
Purchase, Leonard A. Lauder Gift, 2015 (2015.212)

26 | LAFAYETTE MAYNARD DIXON
(American, Fresno, CA 1875–1946 Tucson, AZ)
*Sunset Magazine, September*, 1904
Relief print, 26 x 17 in. (66 x 43.2 cm)
Purchase, Leonard A. Lauder Gift, 2015 (2015.214)

27 | LAFAYETTE MAYNARD DIXON
(American, Fresno, CA 1875–1946 Tucson, AZ)
*Sunset Magazine, November*, 1904
Relief print, 26 x 17 in. (66 x 43.2 cm)
Purchase, Leonard A. Lauder Gift, 2015 (2015.213)

28 | ARTHUR WESLEY DOW
(American, Ipswich, MA 1857–1922 New York)
*Modern Art, Edited by J. M. Bowles, Published by L. Prang and Company*, 1895
Lithograph, 20 1/16 x 15 ⅜ in. (51 x 39.1 cm)
Leonard A. Lauder Collection of American Posters, Gift of Leonard A. Lauder, 1984 (1984.1202.35)

29 | HENRY BREVOORT EDDY
(American, New York 1872–1935 Rye, NY)
*New York Journal*, 1900
Lithograph, 15 x 20 in. (38.1 x 50.8 cm)
Purchase, Leonard A. Lauder Gift, 2015 (2015.205)

30 | F. GILBERT EDGE
(American, active New York 19th–20th century)
*The Sunday World, October 4*, 1896
Letterpress, 16 9/16 x 12 1/16 in. (42.1 x 30.7 cm)
Purchase, Leonard A. Lauder Gift, 2003 (2003.190.9)

**31** | F. GILBERT EDGE
(American, active New York 19th–20th century)
*The Sunday World, June 7*, 1896
Letterpress, 18 7/16 x 12 1/16 in. (46.9 x 30.7 cm)
Purchase, Leonard A. Lauder Gift, 2003 (2003.190.16)

**32** | GEORGE WHARTON EDWARDS
(American, Fair Haven, CT 1869–1950 Greenwich, CT)
*The Century, March*, 1895
Lithograph, 16 5/16 x 12 1/8 in. (41.5 x 30.8 cm)
Purchase, Leonard A. Lauder Gift, 1990 (1990.1100.25)

**33** | GEORGE WHARTON EDWARDS
(American, Fair Haven, CT 1869–1950 Greenwich, CT)
*The Bookman, May*, 1897
Relief print, 16 7/16 x 11 11/16 in. (41.7 x 29.7 cm)
Purchase, Leonard A. Lauder Gift, 1994 (1994.443.6)

**34** | WILLIAM JAMES GLACKENS
(American, Philadelphia, PA 1870–1938 Westport, CT)
*Lippincott's, August*, 1894
Lithograph and relief print, 17 3/8 x 12 9/16 in. (44.2 x 31.9 cm)
Leonard A. Lauder Collection of American Posters, Gift of Leonard A. Lauder, 1984 (1984.1202.38)

**35** | JOSEPH J. GOULD JR.
(American, 1880–1935)
*Lippincott's, June*, 1896
Relief print, 16 9/16 x 11 7/8 in. (42 x 30.1 cm)
Leonard A. Lauder Collection of American Posters, Gift of Leonard A. Lauder, 1984 (1984.1202.42)

**36** | JOSEPH J. GOULD JR.
(American, 1880–1935)
*Lippincott's, July*, 1896
Lithograph, 18 11/16 x 14 1/2 in. (47.5 x 36.9 cm)
Leonard A. Lauder Collection of American Posters, Gift of Leonard A. Lauder, 1984 (1984.1202.43)

**37** | JOSEPH J. GOULD JR.
(American, 1880–1935)
*Lippincott's, November*, 1896
Lithograph, 16 9/16 x 13 1/8 in. (42 x 33.3 cm)
Leonard A. Lauder Collection of American Posters, Gift of Leonard A. Lauder, 1984 (1984.1202.46)

**38** | JOSEPH J. GOULD JR.
(American, 1880–1935)
*Lippincott's, December*, 1896
Lithograph, 15 9/16 x 12 15/16 in. (39.6 x 32.8 cm)
Leonard A. Lauder Collection of American Posters, Gift of Leonard A. Lauder, 1984 (1984.1202.47)

**39** | JOSEPH J. GOULD JR.
(American, 1880–1935)
*Lippincott's, February*, 1896
Relief print, 16 15/16 x 12 1/2 in. (43.1 x 31.8 cm)
Purchase, Leonard A. Lauder Gift, 1988 (1988.1068.5)

**40** | JOSEPH J. GOULD JR.
(American, 1880–1935)
*Lippincott's, August*, 1896
Lithograph, 19 5/16 x 14 3/16 in. (49.1 x 36 cm)
Purchase, Leonard A. Lauder Gift, 1988 (1988.1068.6)

**41** | JOSEPH J. GOULD JR.
(American, 1880–1935)
*Lippincott's, April*, 1897
Lithograph, 16 3/16 x 13 1/8 in. (41.1 x 33.4 cm)
Purchase, Leonard A. Lauder Gift, 1988 (1988.1068.7)

**42** | JOSEPH J. GOULD JR.
(American, 1880–1935)
*Lippincott's, January*, 1896
Lithograph, 17 3/16 x 14 7/16 in. (43.6 x 36.6 cm)
Purchase, The Lauder Foundation, Evelyn H. and Leonard A. Lauder Fund Gift, 1997 (1997.12)

**43** | ERNEST HASKELL
(American, Woodstock, CT 1876–1925 West Point, ME)
*Truth*, 1896
Lithograph and relief print, 21 1/16 x 14 7/8 in. (53.5 x 37.8 cm)
Purchase, Leonard A. Lauder Gift, 1995 (1995.491.97)

**44** | ERNEST HASKELL
(American, Woodstock, CT 1876–1925 West Point, ME)
*The New York Sunday Journal*, 1896
Lithograph and relief print, 21 x 15 3/16 in. (53.4 x 38.5 cm)
Purchase, Leonard A. Lauder Gift, 1991 (1991.1236.11)

**45** | ERNEST HASKELL
(American, Woodstock, CT 1876–1925 West Point, ME)
*The New York Sunday Journal, April 12*, 1896
Lithograph, 21 x 14 1/8 in. (53.3 x 35.8 cm)
Purchase, Leonard A. Lauder Gift, 1991 (1991.1236.12)

**46** | FRANK HAZENPLUG
(American, 1873/74–1931)
*The Chap-Book*, 1895
Relief print, 16 1/8 x 10 7/8 in. (41 x 27.6 cm)
Leonard A. Lauder Collection of American Posters, Gift of Leonard A. Lauder, 1984 (1984.1202.53)

**47** | FRANK HAZENPLUG
(American, 1873/74–1931)
*The Chap-Book*, 1896
Lithograph, 20 5/8 x 14 3/16 in. (52.4 x 36.1 cm)
Leonard A. Lauder Collection of American Posters, Gift of Leonard A. Lauder, 1984 (1984.1202.52)

**48** | FRANK HAZENPLUG
(American, 1873/74–1931)
*The Chap-Book*, 1896
Lithograph, 21 3/16 x 14 1/8 in. (53.8 x 35.8 cm)
Leonard A. Lauder Collection of American Posters, Gift of Leonard A. Lauder, 1984 (1984.1202.54)

**49** | FRANK HAZENPLUG
(American, 1873/74–1931)
*Galloping Dick by H. B. Marriott Watson*, 1896
Lithograph, 21 1/16 x 14 1/8 in. (53.5 x 35.8 cm)
Leonard A. Lauder Collection of American Posters, Gift of Leonard A. Lauder, 1984 (1984.1202.56)

**50** | FRANK HAZENPLUG
(American, 1873/74–1931)
*The Emerson and Fisher Company, Carriage Builders, Cincinnati, Ohio, USA*, 1896
Lithograph, 19 13/16 x 14 1/16 in. (50.3 x 35.7 cm)
Leonard A. Lauder Collection of American Posters, Gift of Leonard A. Lauder, 1984 (1984.1202.55)

**51** | FRANK HAZENPLUG
(American, 1873/74–1931)
*Living Posters*, 1895
Lithograph, 20 3/4 x 28 1/4 in. (52.7 x 71.8 cm)
Purchase, Leonard A. Lauder Gift, 2002 (2002.223.14)

**52** | H. M. LAWRENCE
(American, active 1890s)
*The Century, October*, 1895
Relief print, 18 3/4 x 11 13/16 in. (47.7 x 30 cm)
Leonard A. Lauder Collection of American Posters, Gift of Leonard A. Lauder, 1984 (1984.1202.57)

**53** | JOSEPH CHRISTIAN LEYENDECKER
(American, born Germany, Montabaur 1874–1951 New Rochelle, NY)
*The Century, August, Midsummer Holiday Number*, 1896
Lithograph, 21 5/16 x 15 7/8 in. (54.1 x 40.4 cm)
Leonard A. Lauder Collection of American Posters, Gift of Leonard A. Lauder, 1984 (1984.1202.59)

**54** | JOSEPH CHRISTIAN LEYENDECKER
(American, born Germany, Montabaur 1874–1951 New Rochelle, NY)
*The Chap-Book*, 1897
Lithograph, 21 15/16 x 15 11/16 in. (55.7 x 39.8 cm)
Purchase, The Lauder Foundation, Evelyn H. and Leonard A. Lauder Fund Gift, 1989 (1989.1032.3)

**55** | JOSEPH CHRISTIAN LEYENDECKER
(American, born Germany, Montabaur 1874–1951 New Rochelle, NY)
*Self Culture, October*, 1897
Relief print, 15 x 11 15/16 in. (38.1 x 30.3 cm)
Purchase, Leonard A. Lauder Gift, 1988 (1988.1120.11)

**56** | A. W. B. LINCOLN
(American, active 1890s)
*Yale Yarns*, 1895
Relief print, 15 1/2 x 15 1/2 in. (39.4 x 39.3 cm)
Purchase, Leonard A. Lauder Gift, 1990 (1990.1100.17)

**57** | WILLIAM HICOK LOW
(American, Albany, NY 1853–1932 New York)
*Scribner's, July, Fiction Number*, 1896
Lithograph, 21 11/16 x 13 7/8 in. (55.1 x 35.3 cm)
Purchase, Leonard A. Lauder Gift, 1988 (1988.1068.9)

**58** | FLORENCE LUNDBORG
(American, San Francisco, CA 1871–1949 New York)
*The Lark, November*, 1896
Woodcut, 21 5/16 x 14 7/16 in. (54.1 x 36.6 cm)
Leonard A. Lauder Collection of American Posters, Gift of Leonard A. Lauder, 1984 (1984.1202.60)

**59** | FLORENCE LUNDBORG
(American, San Francisco, CA 1871–1949 New York)
*The Lark, November*, 1895
Woodcut, 16 3/8 x 9 7/8 in. (41.6 x 25.1 cm)
Leonard A. Lauder Collection of American Posters, Gift of Leonard A. Lauder, 1984 (1984.1202.61)

**60** | FLORENCE LUNDBORG
(American, San Francisco, CA 1871–1949 New York)
*The Lark, February*, 1897
Woodcut, 24 5/16 x 12 15/16 in. (61.8 x 32.9 cm)
Leonard A. Lauder Collection of American Posters, Gift of Leonard A. Lauder, 1984 (1984.1202.65)

**61** | FLORENCE LUNDBORG
(American, San Francisco, CA 1871–1949 New York)
*The Lark, August*, 1896
Woodcut, 16 1/16 x 12 15/16 in. (40.8 x 32.9 cm)
Leonard A. Lauder Collection of American Posters, Gift of Leonard A. Lauder, 1984 (1984.1202.64)

**62** | O. C. MALCOLM
(American, active late 19th–early 20th century)
*Outing, Special Bicycle Number, June*, ca. 1895
Lithograph, 17 7/8 x 12 5/8 in. (45.4 x 32.1 cm)
Purchase, The Lauder Foundation, Evelyn H. and Leonard A. Lauder Fund Gift, 1998 (1998.162.3)

**63** | BLANCHE MCMANUS MANSFIELD
(American, East Feliciana, LA 1870–1929)
*The True Mother Goose with Notes and Pictures by Blanche McManus*, 1895
Relief print, 21 1/4 x 14 5/16 in. (53.9 x 36.4 cm)
Leonard A. Lauder Collection of American Posters, Gift of Leonard A. Lauder, 1984 (1984.1202.66)

**64** | BLANCHE MCMANUS MANSFIELD
(American, East Feliciana, LA 1870–1929)
*Captains Courageous, Rudyard Kipling's American Novel*, 1897
Relief print, 17 11/16 x 12 5/8 in. (45 x 32.1 cm)
Leonard A. Lauder Collection of American Posters, Gift of Leonard A. Lauder, 1984 (1984.1202.67)

**65** | H. W. MCVICKAR
(American, Irvington, NY 1860–1905 Southampton, NY)
*The Evolution of Woman by H. W. McVickar*, ca. 1896
Relief print, 17 13/16 x 12 in. (45.2 x 30.5 cm)
Purchase, The Lauder Foundation, Evelyn H. and Leonard A. Lauder Fund Gift, 1997 (1997.79.14)

**66** | A. K. MOE
(American, active late 19th century)
*Harvard Lampoon [Crew]*, 1895
Lithograph, 12 5/8 x 8 1/2 in. (32 x 21.6 cm)
Purchase, Leonard A. Lauder Gift, 1990 (1990.1100.12)

**67** | A. K. MOE
(American, active late 19th century)
*Harvard Lampoon [Pegasus]*, 1895
Lithograph, 13 x 8 15/16 in. (33 x 22.7 cm)
Purchase, Leonard A. Lauder Gift, 1990 (1990.1100.14)

**68** | ALICE CORDELIA MORSE
(American, Hammondsville, OH 1863–1961 New York )
*Kate Carnegie by Ian Maclaren*, 1896
Lithograph, 17 1/2 x 12 1/16 in. (44.5 x 30.6 cm)
Purchase, Leonard A. Lauder Gift, 1988 (1988.1120.13)

**69** | E. NADALL
(American, active ca. 1895)
*The Road Rights of Wheelmen, Callaghan and Company, Chicago*, 1895
Lithograph, 20 x 14 in. (50.8 x 35.5 cm)
Purchase, The Lauder Foundation, Leonard and Judy Lauder Fund Gift, 2019 (2019.96)

**70** | FRANK ARTHUR NANKIVELL
(American, born Australia, Maldon, Victoria 1869–1959 Florham Park, NJ)
*The Echo*, 1895
Relief print, 21 x 14 in. (53.3 x 35.6 cm)
Purchase, Leonard A. Lauder Gift, 2002 (2002.223.8)

**71** | VIOLET OAKLEY
(American, Jersey City, NJ 1874–1961 Philadelphia, PA)
*A Puritan's Wife by Max Pemberton*, 1896
Relief print, 19 x 12 1/2 in. (48.3 x 31.7 cm)
Purchase, The Lauder Foundation, Evelyn H. and Leonard A. Lauder Fund Gift, 1989 (1989.1032.7)

**72** | RICHARD FELTON OUTCAULT
(American, Lancaster, OH 1863–1928 Flushing, NY)
*The Sunday World, February 9*, 1896
Relief print, 18 7/16 x 11 3/16 in. (46.9 x 28.4 cm)
Purchase, Leonard A. Lauder Gift, 2003 (2003.190.3)

**73** | MAXFIELD PARRISH
(American, Philadelphia, PA 1870–1966 Plainfield, NH)
*Scribner's, August, Fiction Number*, 1897
Lithograph, 19 13/16 x 14 3/8 in. (50.3 x 36.5 cm)
Leonard A. Lauder Collection of American Posters, Gift of Leonard A. Lauder, 1984 (1984.1202.69)

**74** | MAXFIELD PARRISH
(American, Philadelphia, PA 1870–1966 Plainfield, NH)
*Scribner's, December, Christmas Special*, 1897
Lithograph, 21 9/16 x 13 7/8 in. (54.8 x 35.2 cm)
Leonard A. Lauder Collection of American Posters, Gift of Leonard A. Lauder, 1984 (1984.1202.70)

**75** | MAXFIELD PARRISH
(American, Philadelphia, PA 1870–1966 Plainfield, NH)
*The Century, August, Midsummer Holiday Number*, 1897
Lithograph, 19 7/8 x 13 9/16 in. (50.5 x 34.5 cm)
Leonard A. Lauder Collection of American Posters, Gift of Leonard A. Lauder, 1984 (1984.1202.71)

**76** | EDWARD PENFIELD
(American, Brooklyn, NY 1866–1925 Beacon, NY)
*Harper's, January*, 1895
Lithograph, 18 x 12 13/16 in. (45.7 x 32.6 cm)
Leonard A. Lauder Collection of American Posters, Gift of Leonard A. Lauder, 1984 (1984.1202.77)

**77** | EDWARD PENFIELD
(American, Brooklyn, NY 1866–1925 Beacon, NY)
*Harper's, March*, 1895
Lithograph, 19 1/4 x 13 13/16 in. (48.9 x 35.1 cm)
Leonard A. Lauder Collection of American Posters, Gift of Leonard A. Lauder, 1984 (1984.1202.79)

**78** | EDWARD PENFIELD
(American, Brooklyn, NY 1866–1925 Beacon, NY)
*Harper's, April*, 1894
Lithograph, 17 13/16 x 13 1/16 in. (45.3 x 33.1 cm)
Purchase, Leonard A. Lauder Gift, 1990 (1990.1105.1)

**79** | EDWARD PENFIELD
(American, Brooklyn, NY 1866–1925 Beacon, NY)
*Harper's, July*, 1894
Lithograph, 18 1/16 x 12 5/8 in. (45.8 x 32 cm)
Leonard A. Lauder Collection of American Posters, Gift of Leonard A. Lauder, 1984 (1984.1202.75)

**80** | EDWARD PENFIELD
(American, Brooklyn, NY 1866–1925 Beacon, NY)
*Harper's, May*, 1896
Lithograph, 17 3/4 x 11 7/8 in. (45.1 x 30.2 cm)
Leonard A. Lauder Collection of American Posters, Gift of Leonard A. Lauder, 1984 (1984.1202.88)

**81** | EDWARD PENFIELD
(American, Brooklyn, NY 1866–1925 Beacon, NY)
*Harper's, November*, 1895
Lithograph, 16 5/16 x 11 3/4 in. (41.4 x 29.8 cm)
Leonard A. Lauder Collection of American Posters, Gift of Leonard A. Lauder, 1984 (1984.1202.84)

**82** | EDWARD PENFIELD
(American, Brooklyn, NY 1866–1925 Beacon, NY)
*Harper's, March*, 1897
Lithograph, 14 x 19 in. (35.5 x 48.2 cm)
Leonard A. Lauder Collection of American Posters, Gift of Leonard A. Lauder, 1984 (1984.1202.97)

**83** | EDWARD PENFIELD
(American, Brooklyn, NY 1866–1925 Beacon, NY)
*Harper's, February*, 1897
Lithograph, 19 x 14 in. (48.3 x 35.5 cm)
Leonard A. Lauder Collection of American Posters, Gift of Leonard A. Lauder, 1984 (1984.1202.96)

**84** | EDWARD PENFIELD
(American, Brooklyn, NY 1866–1925 Beacon, NY)
*Harper's, June*, 1897
Lithograph, 14 5/16 x 18 11/16 in. (36.4 x 47.5 cm)
Leonard A. Lauder Collection of American Posters, Gift of Leonard A. Lauder, 1984 (1984.1202.100)

**85** | EDWARD PENFIELD
(American, Brooklyn, NY 1866–1925 Beacon, NY)
*Harper's, July*, 1897
Lithograph, 14 x 19 3/16 in. (35.6 x 48.7 cm)

Leonard A. Lauder Collection of American Posters, Gift of Leonard A. Lauder, 1984 (1984.1202.101)

86 | EDWARD PENFIELD
(American, Brooklyn, NY 1866–1925 Beacon, NY)
*Orient Cycles: Lead the Leaders*, ca. 1895
Lithograph, 42 1/16 x 28 1/8 in. (106.8 x 71.4 cm)
Leonard A. Lauder Collection of American Posters, Gift of Leonard A. Lauder, 1941 (1984.1202.121)

87 | EDWARD PENFIELD
(American, Brooklyn, NY 1866–1925 Beacon, NY)
*Ride a Stearns and Be Content*, 1896
Lithograph, 55 3/4 x 42 5/16 in. (141.6 x 107.5 cm)
Leonard A. Lauder Collection of American Posters, Gift of Leonard A. Lauder, 1984 (1984.1202.124)

88 | EDWARD PENFIELD
(American, Brooklyn, NY 1866–1925 Beacon, NY)
*Poster Calendar 1897: Cover*, 1896
Lithograph and relief print, 17 3/8 x 12 1/16 in. (44.1 x 30.6 cm)
Leonard A. Lauder Collection of American Posters, Gift of Leonard A. Lauder, 1984 (1984.1202.123[1])

89 | EDWARD PENFIELD
(American, Brooklyn, NY 1866–1925 Beacon, NY)
Proof for *Poster Calendar 1897: January, February, March*, 1896
Lithograph and relief print, 14 x 10 3/16 in. (35.5 x 25.8 cm)
Leonard A. Lauder Collection of American Posters, Gift of Leonard A. Lauder, 1984 (1984.1202.123[3])

90 | EDWARD PENFIELD
(American, Brooklyn, NY 1866–1925 Beacon, NY)
*Poster Calendar 1897: January, February, March*, 1896
Lithograph and relief print, 14 x 10 3/16 in. (35.6 x 25.8 cm)
Leonard A. Lauder Collection of American Posters, Gift of Leonard A. Lauder, 1984 (1984.1202.123[2])

91 | EDWARD PENFIELD
(American, Brooklyn, NY 1866–1925 Beacon, NY)
Proof for *Poster Calendar 1897: April, May, June*, 1896
Lithograph and relief print, 14 x 10 3/16 in. (35.6 x 25.8 cm)
Leonard A. Lauder Collection of American Posters, Gift of Leonard A. Lauder, 1984 (1984.1202.123[5])

92 | EDWARD PENFIELD
(American, Brooklyn, NY 1866–1925 Beacon, NY)
*Poster Calendar 1897: April, May, June*, 1896
Lithograph and relief print, 14 x 10 3/16 in. (35.5 x 25.8 cm)
Leonard A. Lauder Collection of American Posters, Gift of Leonard A. Lauder, 1984 (1984.1202.123[4])

93 | EDWARD PENFIELD
(American, Brooklyn, NY 1866–1925 Beacon, NY)
Proof for *Poster Calendar 1897: July, August, September*, 1896
Lithograph and relief print, 17 5/16 x 12 in. (44 x 30.5 cm)
Leonard A. Lauder Collection of American Posters, Gift of Leonard A. Lauder, 1984 (1984.1202.123[7])

94 | EDWARD PENFIELD
(American, Brooklyn, NY 1866–1925 Beacon, NY)
*Poster Calendar 1897: July, August, September*, 1896
Lithograph and relief print, 17 5/16 x 12 in. (44 x 30.5 cm)
Leonard A. Lauder Collection of American Posters, Gift of Leonard A. Lauder, 1984 (1984.1202.123[6])

95 | EDWARD PENFIELD
(American, Brooklyn, NY 1866–1925 Beacon, NY)
Proof for *Poster Calendar 1897: October, November, December*, 1896
Lithograph and relief print, 17 5/16 x 12 in. (44 x 30.5 cm)
Leonard A. Lauder Collection of American Posters, Gift of Leonard A. Lauder, 1984 (1984.1202.123[9])

96 | EDWARD PENFIELD
(American, Brooklyn, NY 1866–1925 Beacon, NY)
*Poster Calendar 1897: October, November, December*, 1896
Lithograph and relief print, 17 5/16 x 12 in. (44 x 30.5 cm)
Leonard A. Lauder Collection of American Posters, Gift of Leonard A. Lauder, 1984 (1984.1202.123[8])

97 | EDWARD PENFIELD
(American, Brooklyn, NY 1866–1925 Beacon, NY)
*English Society by George du Maurier*, 1897
Lithograph, 19 13/16 x 12 1/2 in. (50.3 x 31.7 cm)
Purchase, The Lauder Foundation, Evelyn H. and Leonard A. Lauder Fund Gift, 1986 (1986.1005.9)

98 | EDWARD PENFIELD
(American, Brooklyn, NY 1866–1925 Beacon, NY)
*The Martian by Du Maurier*, 1897
Lithograph and relief print, 20 1/2 x 12 7/8 in. (52 x 32.7 cm)
Leonard A. Lauder Collection of American Posters, Gift of Leonard A. Lauder, 1984 (1984.1202.119)

99 | E. PICKERT
(American, active late 19th century)
*The New York Times, February 9*, 1895
Lithograph and relief print, 30 1/4 x 19 15/16 in. (76.8 x 50.7 cm)
Leonard A. Lauder Collection of American Posters, Gift of Leonard A. Lauder, 1984 (1984.1202.125)

100 | EDWARD HENRY POTTHAST
(American, Cincinnati, OH 1857–1927 New York)
*The Century, July*, 1896
Lithograph, 20 7/8 x 15 1/16 in. (53.1 x 38.2 cm)
Leonard A. Lauder Collection of American Posters, Gift of Leonard A. Lauder, 1984 (1984.1202.126)

101 | MAURICE BRAZIL PRENDERGAST
(American, born Canada, St. John's, Newfoundland 1858–1924 New York)
*On the Point by Nathan Haskell Dole*, 1895
Relief print, 16 7/16 x 11 1/4 in. (41.8 x 28.6 cm)
Purchase, The Lauder Foundation, Evelyn H. and Leonard A. Lauder Fund Gift, 1986 (1986.1005.12)

**102** | HENRY PATRICK RALEIGH
(American, Portland, OR 1880–
1944 New York)
*Sunset Magazine, March,* 1902
Relief print, 24 x 19 in. (61 x 48.3 cm)
Purchase, Leonard A. Lauder Gift, 2015
(2015.216)

**103** | HENRY PATRICK RALEIGH
(American, Portland, OR 1880–
1944 New York)
*Sunset Magazine, August,* 1903
Relief print, 22 x 19 in. (55.9 x 48.3 cm)
Purchase, Leonard A. Lauder Gift, 2015
(2015.218)

**104** | HENRY PATRICK RALEIGH
(American, Portland, OR 1880–
1944 New York)
*Sunset Magazine, May,* 1902
Lithograph and relief print,
26 1/4 x 21 1/2 in. (66.7 x 54.6 cm)
Purchase, Leonard A. Lauder Gift, 2015
(2015.217)

**105** | ETHEL REED
(American, Newburyport, MA 1874–
1912 London)
*Albert Morris Bagby's New Novel, Miss Träumerei,* 1895
Lithograph, 21 15/16 x 13 9/16 in.
(55.8 x 34.5 cm)
Leonard A. Lauder Collection of
American Posters, Gift of Leonard
A. Lauder, 1984 (1984.1202.129)

**106** | ETHEL REED
(American, Newburyport, MA 1874–
1912 London)
*Folly or Saintliness by José Echegaray,* 1895
Relief print, 20 1/8 x 15 1/16 in.
(51.1 x 38.2 cm)
Leonard A. Lauder Collection of
American Posters, Gift of Leonard
A. Lauder, 1984 (1984.1202.132)

**107** | ETHEL REED
(American, Newburyport, MA 1874–
1912 London)
*Arabella and Araminta Stories by Gertrude Smith with XV Pictures by Ethel Reed,* 1895
Lithograph, 27 1/8 x 15 7/16 in.
(68.9 x 39.2 cm)
Leonard A. Lauder Collection of
American Posters, Gift of Leonard
A. Lauder, 1984 (1984.1202.128)

**108** | ETHEL REED
(American, Newburyport, MA 1874–
1912 London)
*In Childhood's Country by Louise Chandler Moulton, Pictured by Ethel Reed,* 1896
Lithograph, 25 1/16 x 11 3/8 in.
(63.7 x 28.9 cm)
Leonard A. Lauder Collection of
American Posters, Gift of Leonard
A. Lauder, 1984 (1984.1202.137)

**109** | ETHEL REED
(American, Newburyport, MA 1874–
1912 London)
*The Penny Magazine,* ca. 1896
Lithograph, 21 9/16 x 10 1/4 in. (54.7 x 26 cm)
Purchase, Leonard A. Lauder Gift, 1999
(1999.402)

**110** | ETHEL REED
(American, Newburyport, MA 1874–
1912 London)
*A Virginia Cousin and Bar Harbor Tales by Mrs. Burton Harrison,* 1895
Lithograph, 24 3/4 x 17 1/8 in.
(62.8 x 43.5 cm)
Leonard A. Lauder Collection of
American Posters, Gift of Leonard
A. Lauder, 1984 (1984.1202.133)

**111** | ETHEL REED
(American, Newburyport, MA 1874–
1912 London)
*The Boston Sunday Herald, March 24,* 1895
Relief print, 18 15/16 x 12 3/8 in.
(48.1 x 31.4 cm)
Leonard A. Lauder Collection of
American Posters, Gift of Leonard
A. Lauder, 1984 (1984.1202.135)

**112** | ETHEL REED
(American, Newburyport, MA 1874–
1912 London)
*Behind the Arras by Bliss Carman,* 1895
Lithograph, 27 7/8 x 19 7/16 in.
(70.8 x 49.4 cm)
Leonard A. Lauder Collection of
American Posters, Gift of Leonard
A. Lauder, 1984 (1984.1202.130)

**113** | ETHEL REED
(American, Newburyport, MA 1874–
1912 London)
*Is Polite Society Polite and Other Essays by Mrs. Julia Ward Howe,* 1895
Lithograph, 17 1/2 x 25 1/16 in.
(44.5 x 63.6 cm)
Purchase, The Lauder Foundation,
Evelyn H. and Leonard A. Lauder Fund
Gift, 1986 (1986.1005.14)

**114** | LOUIS JOHN RHEAD
(American, born England, Etruria 1857–
1926 Amityville, NY)
*The Century Magazine, Midsummer Holiday Number,* 1894
Lithograph, 14 7/16 x 19 5/8 in.
(36.7 x 49.9 cm)
Purchase, The Lauder Foundation,
Evelyn H. and Leonard A. Lauder Fund
Gift, 1985 (1985.1129.4)

**115** | LOUIS JOHN RHEAD
(American, born England, Etruria 1857–
1926 Amityville, NY)
*Prang's Easter Publications,* 1895
Lithograph, 23 7/8 x 16 15/16 in.
(60.6 x 43.1 cm)
Leonard A. Lauder Collection of
American Posters, Gift of Leonard
A. Lauder, 1984 (1984.1202.146)

**116** | LOUIS JOHN RHEAD
(American, born England, Etruria 1857–
1926 Amityville, NY)
*Le Journal de la Beauté,* 1897
Lithograph, 33 3/16 x 60 3/4 in.
(84.3 x 154.3 cm)
Leonard A. Lauder Collection of
American Posters, Gift of Leonard
A. Lauder, 1984 (1984.1202.145)

**117** | LOUIS JOHN RHEAD
(American, born England, Etruria 1857–
1926 Amityville, NY)
*The Sun,* 1895
Lithograph, 48 13/16 x 31 1/4 in.
(124 x 79.3 cm)
Leonard A. Lauder Collection of
American Posters, Gift of Leonard
A. Lauder, 1984 (1984.1202.143)

**118** | LOUIS JOHN RHEAD
(American, born England, Etruria 1857–
1926 Amityville, NY)
*Harper's Bazar, November, Thanksgiving,* 1894
Lithograph and relief print,
16 1/16 x 11 1/4 in. (40.8 x 28.6 cm)
Leonard A. Lauder Collection of
American Posters, Gift of Leonard
A. Lauder, 1984 (1984.1202.149)

119 | LOUIS JOHN RHEAD
(American, born England, Etruria 1857–
1926 Amityville, NY)
*Exposition, Salon des Cent*, 1897
Lithograph, 23 7/8 x 16 in. (60.6 x 40.7 cm)
Purchase, The Lauder Foundation,
Evelyn H. and Leonard A. Lauder Fund
Gift, 1985 (1985.1051.3)

120 | LOUIS JOHN RHEAD
(American, born England, Etruria 1857–
1926 Amityville, NY)
*Poster Calendar 1897: Cover*, 1896
Lithograph, 19 3/16 x 13 3/4 in. (48.8 x 35 cm)
Purchase, The Lauder Foundation,
Evelyn H. and Leonard A. Lauder Fund
Gift, 1986 (1986.1005.17[1])

121 | LOUIS JOHN RHEAD
(American, born England, Etruria 1857–
1926 Amityville, NY)
*Poster Calendar 1897: January, February, March*, 1896
Lithograph, 19 3/16 x 13 3/4 in. (48.8 x 35 cm)
Purchase, The Lauder Foundation,
Evelyn H. and Leonard A. Lauder Fund
Gift, 1986 (1986.1005.17[2])

122 | LOUIS JOHN RHEAD
(American, born England, Etruria 1857–
1926 Amityville, NY)
*Poster Calendar 1897: April, May, June*, 1896
Lithograph, 19 3/16 x 13 3/4 in. (48.8 x 35 cm)
Purchase, The Lauder Foundation,
Evelyn H. and Leonard A. Lauder Fund
Gift, 1986 (1986.1005.17[3])

123 | LOUIS JOHN RHEAD
(American, born England, Etruria 1857–
1926 Amityville, NY)
*Poster Calendar 1897: July, August, September*, 1896
Lithograph, 19 3/16 x 13 3/4 in. (48.8 x 35 cm)
Purchase, The Lauder Foundation,
Evelyn H. and Leonard A. Lauder Fund
Gift, 1986 (1986.1005.17[4])

124 | LOUIS JOHN RHEAD
(American, born England, Etruria 1857–
1926 Amityville, NY)
*Poster Calendar 1897: October, November, December*, 1896
Lithograph, 19 3/16 x 13 3/4 in. (48.8 x 35 cm)
Purchase, The Lauder Foundation,
Evelyn H. and Leonard A. Lauder Fund
Gift, 1986 (1986.1005.17[5])

125 | LOUIS JOHN RHEAD
(American, born England, Etruria 1857–
1926 Amityville, NY)
*The Weekly Dispatch*, 1895
Lithograph, 38 x 55 3/4 in. (96.5 x 141.6 cm)
Purchase, The Lauder Foundation,
Evelyn H. and Leonard A. Lauder Fund
Gift, 2015 (2015.466)

126 | LOUIS JOHN RHEAD
(American, born England, Etruria 1857–
1926 Amityville, NY)
*Cassell's Magazine, December*, 1896
Lithograph, 12 5/8 x 15 in. (32.1 x 38.1 cm)
Purchase, The Lauder Foundation,
Evelyn H. and Leonard A. Lauder Fund
Gift, 1985 (1985.1132.1)

127 | LOUIS JOHN RHEAD
(American, born England, Etruria 1857–
1926 Amityville, NY)
*The Century, December, Christmas Number*, 1894
Lithograph and relief print, 13 x 19 3/16 in. (33 x 48.7 cm)
Purchase, The Lauder Foundation,
Leonard and Judy Lauder Fund Gift, 2017 (2017.151)

128 | LOUIS JOHN RHEAD
(American, born England, Etruria 1857–
1926 Amityville, NY)
*C. Bechstein Pianos*, ca. 1896
Lithograph and relief print,
29 7/8 x 19 3/4 in. (75.9 x 50.2 cm)
Purchase, The Lauder Foundation,
Leonard and Judy Lauder Fund Gift, 2022 (2022.8)

129 | JOHN SLOAN
(American, Lock Haven, PA 1871–
1951 Hanover, NH)
*The Echo*, 1895
Relief print, 18 3/8 x 8 1/16 in. (46.7 x 20.5 cm)
Purchase, The Lauder Foundation,
Evelyn H. and Leonard A. Lauder Fund
Gift, 1985 (1985.1129.2)

130 | JOHN SLOAN
(American, Lock Haven, PA 1871–
1951 Hanover, NH)
*Cinder-Path Tales by William Lindsey*, 1896
Lithograph, 23 3/4 x 13 5/8 in. (60.3 x 34.6 cm)
Purchase, The Lauder Foundation,
Evelyn H. and Leonard A. Lauder Fund
Gift, 1985 (1985.1129.1)

131 | JESSIE WILLCOX SMITH
(American, Philadelphia, PA 1863–
1935 Philadelphia, PA)
*Smith College Stories by Josephine Daskam*, 1900
Lithograph and relief print,
12 3/4 x 9 15/16 in. (32.4 x 25.2 cm)
Purchase, The Lauder Foundation,
Evelyn H. and Leonard A. Lauder Fund
Gift, 1985 (1985.1132.2)

132 | JOSEPH LINDON SMITH
(American, Pawtucket, RI 1863–
1950 Dublin, NH)
*Handbook of the New Public Library*, 1895
Lithograph, 15 3/8 x 21 1/4 in. (39 x 54 cm)
Purchase, Leonard A. Lauder Gift, 1990 (1990.1100.6)

133 | W.
(American, active late 19th century)
*The Century, March*, 1898
Relief print, 19 x 13 3/16 in. (48.3 x 33.5 cm)
Purchase, Leonard A. Lauder Gift, 1988 (1988.1068.16)

134 | E. B. WELLS
(American, active late 19th century)
*Mrs. Cliff's Yacht by Frank R. Stockton*, 1896
Relief print, 18 1/2 x 12 3/8 in. (47 x 31.5 cm)
Leonard A. Lauder Collection of American Posters, Gift of Leonard A. Lauder, 1984 (1984.1202.153)

135 | CHARLES HERBERT WOODBURY
(American, Lynn, MA 1864–1940 Jamaica Plain, MA)
*The Century, July*, 1895
Lithograph, 19 x 13 3/8 in. (48.3 x 34 cm)
Leonard A. Lauder Collection of American Posters, Gift of Leonard A. Lauder, 1984 (1984.1202.156)

# NOTES

**Preface**

This text was adapted and updated from Leonard A. Lauder, "Introduction," in *American Art Posters of the 1890s in The Metropolitan Museum of Art, including the Leonard A. Lauder Collection*, ed. David W. Kiehl (New York: The Metropolitan Museum of Art, 1987).

1. Edward Penfield, "Introduction," in Percival Pollard, *Posters in Miniature* (New York: R. H. Russell and Son, 1896).

**The Literary Poster: A Beacon of Modernity**

1. Popularized through literature, theater, illustration, and the press, the term "New Woman" emerged in late nineteenth-century Europe and the United States to describe a middle- or upper-class woman who was independent and well educated. See Martha H. Patterson, ed., *The American New Woman Revisited: A Reader, 1894–1930* (New Brunswick, NJ: Rutgers University Press, 2008).
2. For a history on the development of the Gibson Girl character, see Lynn D. Gordon, "The Gibson Girl Goes to College: Popular Culture and Women's Higher Education in the Progressive Era, 1890–1920," *American Quarterly* 39, no. 2 (Summer 1987): 211.
3. David W. Kiehl, "American Art Posters of the 1890s," in *American Art Posters of the 1890s in The Metropolitan Museum of Art, including the Leonard A. Lauder Collection*, ed. David W. Kiehl (New York: The Metropolitan Museum of Art, 1987), 13.
4. Edward Penfield continued to design a placard in his signature style for each monthly issue of *Harper's* through July 1899. Kiehl, "American Art Posters," 11.
5. Herbert Stone, "Mr. Penfield's Posters," *The Chap-Book*, October 1, 1894, 248, quoted in Martin S. Lindsay, "The Complete *Harper's* Posters, 1893–1899: Harper's Posters for 1893," *Edward Penfield: Master of Graphic Design*, accessed July 28, 2023, https://edwardpenfield.com/catalogue/the-complete-harpers-posters/1893/.
6. Mabel Key, "The Passing of the Poster," *Brush and Pencil* 4, no. 1 (April 1899): 15.
7. Kiehl, "American Art Posters," 13–14; Neil Harris, "American Poster Collecting: A Fitful History," *American Art* 12, no. 1 (Spring 1998): 13. Prior to the emergence of the literary poster, artists rarely held the copyright for their designs.
8. Nancy Finlay, "American Posters and Publishing in the 1890s," in *American Art Posters of the 1890s in The Metropolitan Museum of Art, including the Leonard A. Lauder Collection*, ed. David W. Kiehl (New York: The Metropolitan Museum of Art, 1987), 50; and Michele H. Bogart, *Artists, Advertising, and the Borders of Art* (Chicago and London: University of Chicago Press, 1995), 85.
9. Anonymous article in *The Publishers' Weekly*, February 3, 1894, quoted in Roberta Wong, "Will Bradley and the Poster," *The Metropolitan Museum of Art Bulletin* 30, no. 6 (June–July 1972): 294.
10. Some scholars have suggested that American circus posters may have influenced Chéret. See Harris, "American Poster Collecting," 13.
11. Kiehl, "American Art Posters," 12–13; and Harris, "American Poster Collecting," 13.
12. Gabriel P. Weisberg emphasizes that literary posters were intended for a relatively small audience who were "members of the affluent middle class — essentially the readers of magazines of the period," writing that "to see the poster renaissance of the 1890s as a way to reach the masses is to miss the point entirely." Gabriel P. Weisberg, "Graphic Art in America: The Artistic and Civic Poster in the United States Reconsidered," *Journal of Decorative and Propaganda Arts* 16 (Summer 1990): 112.
13. Kiehl, "American Art Posters," 13.
14. Julia Siemon, "A Poetics of Portraiture and the Legacy of Dante and Petrarch," in *The Medici: Portraits and Politics, 1512–1570*, ed. Keith Christiansen and Carlo Falciani (New York: The Metropolitan Museum of Art, 2021), 161–63. In the catalogue entry for Bronzino's *Portrait of a Young Man* (176–79), Andrea Bayer notes that the painting's underdrawing reveals changes to the positioning of the sitter's hands and the book: "At first the book was shown fully open with the spine facing the viewer and the sitter's hands along its upper edge. Bronzino redrew hand and book so that the sitter seems to mark a specific page or passage in it, or as if he is interrupted while reading," 179.
15. Quoted in Kiehl, "American Art Posters," 15.
16. Kiehl, "American Art Posters," 14.
17. "Little magazine" refers to a type of magazine popular in the 1890s

that was distinguished for its small format and number of pages and its experimental content. For more on the history of the "little magazine," see Kirsten MacLeod, *American Little Magazines of the Fin de Siècle: Art, Protest, and Cultural Transformation* (Toronto: University of Toronto Press, 2018).
18. Roberta Wong, *Will H. Bradley: American Artist and Craftsman (1868–1962)* (New York: The Metropolitan Museum of Art, 1972), n.p.
19. Wong, "Will Bradley and the Poster," 294.
20. Wong, "Will Bradley and the Poster," 298.
21. Key, "Passing of the Poster," 12.

**By Women, for Women: American Art Posters of the 1890s**

1. *The Poster* was published monthly between June 1898 and December 1900. For more on its history, see John Hewitt, "'The Poster' and the Poster in England in the 1890s," *Victorian Periodicals Review* 35, no. 1 (Spring 2002): 37–62.
2. S. C. de Soissons, "Ethel Reed and Her Art," *The Poster: An Illustrated Monthly Chronicle* 1, no. 5 (November 1898): 199.
3. De Soissons, "Ethel Reed and Her Art," 200, 202.
4. "Woman About Town," *Washington Post*, January 26, 1896, 17; and J[ames] M[acArthur], "A Chat with Miss Ethel Reed," *The Bookman* 2, no. 4 (December 1895): 279.
5. Reed also modeled for photographer F. Holland Day, who took at least six photographs of the artist in his Boston studio in 1895. William S. Peterson, *The Beautiful Poster Lady: A Life of Ethel Reed* (New Castle, DE: Oak Knoll Press, 2013), 15–17, 20.
6. "Woman About Town," 17.
7. M[acArthur], "Chat with Miss Ethel Reed," 278.
8. "The Work of Miss Ethel Reed," *The International Studio* 10, no. 50 (1897): 230.
9. Kirsten Swinth, *Painting Professionals: Women Artists and the Development of Modern American Art, 1870–1930* (Chapel Hill: University of North Carolina Press, 2001), 131–32.
10. Michele H. Bogart, *Artists, Advertising, and the Borders of Art* (Chicago: University of Chicago Press, 1995), 16, 18–20, 30–31.
11. Bogart, *Artists, Advertising, and the Borders of Art*, 30.
12. For further discussion of the exclusion of women from the canon of American graphic design, see Martha Scotford, "Is There a Canon of Graphic Design History?" *AIGA Journal* 9, no. 2 (1991): 37–44, reprinted in Marie Finamore and Steven Heller, eds., *Design Culture: An Anthology of Writing from the AIGA Journal of Graphic Design* (New York: Allworth Press, 1997), 218–27; Martha Scotford, "Messy History vs. Neat History: Toward an Expanded View of Women in Graphic Design," *Visible Language* 28, no. 4 (Fall 1994): 367–87; Ellen Mazur Thomson, "Alms for Oblivion: The History of Women in Early American Graphic Design," *Design Issues* 10, no. 2 (Summer 1994): 27–48; Ellen Mazur Thomson, *The Origins of Graphic Design in America, 1870–1920* (New Haven: Yale University Press, 1997), 133–59; and Briar Levit, ed., *Baseline Shift: Untold Stories of Women in Graphic Design History* (New York: Princeton Architectural Press, 2021).
13. Erica Hirshler, *A Studio of Her Own: Women Artists in Boston, 1870–1940* (Boston: MFA Publications, 2001), 70.
14. "Ethel Reed, Artist," *Bradley: His Book* 1, no. 3 (July 1896): 74.
15. Martha H. Kennedy, *Drawn to Purpose: American Women Illustrators and Cartoonists* (Jackson: University Press of Mississippi in association with the Library of Congress, 2018), 4–5.
16. Nina de Angeli Walls, "Educating Women for Art and Commerce: The Philadelphia School of Design, 1848–1932," *History of Education Quarterly* 34, no. 3 (Autumn 1994): 330–31.
17. Helena Wright, *With Pen and Graver: Women Graphic Artists before 1900* (Washington, DC: National Museum of American History, Smithsonian Institution, 1995), 6–9.
18. "Woman's Position in Art," *The Crayon* 8, no. 2 (February 1861): 28.
19. Laura R. Prieto, *At Home in the Studio: The Professionalization of Women Artists in America* (Cambridge, MA: Harvard University Press, 2001), 8.
20. Swinth, *Painting Professionals*, 3.
21. For an in-depth analysis of this issue, see Anthea Callen, "Sexual Division of Labor in the Arts and Crafts Movement," *Woman's Art Journal* 5, no. 2 (Autumn 1984–Winter 1985): 1–6.
22. Walter Smith, *The Masterpieces of the Centennial International Exhibition Illustrated*, vol. 2, *Industrial Arts* (Philadelphia: Gebbie and Barrie, 1877), 95–96, quoted in Thomson, "Alms for Oblivion," 44.
23. Alice C. Morse, "Women Illustrators," in *Art and Handicraft in the Woman's Building of the World's Columbian Exposition, Chicago, 1893*, ed. Maud Howe Elliott (Paris: Boussod, Valadon and Company, 1893), 68–79 (quotation, 68). Morse is believed to have also designed the book's cover, as she chaired the Sub-Committee on Book-Covers, Wood Engraving, and Illustration of the Board of Women Managers and organized an exhibition of her book covers for the Woman's Building at the exposition. Mindell Dubansky, *The Proper Decoration of Book Covers: The Life and Work of Alice C. Morse* (New York: Grolier Club, 2008), 88–89.
24. Morse, "Women Illustrators," 73.
25. David W. Kiehl, "American Art Posters," in *American Art Posters of the 1890s in The Metropolitan Museum of Art, including the Leonard A. Lauder Collection*, ed. David W. Kiehl (New York: The Metropolitan Museum of Art, 1987), 11–14.
26. Bogart, *Artists, Advertising, and the Borders of Art*, 5.
27. On the relationship between publishers and the art poster, see Nancy Finlay, "American Posters and Publishing in the 1890s," in *American Art*

*Posters of the 1890s in The Metropolitan Museum of Art, including the Leonard A. Lauder Collection*, ed. David W. Kiehl (New York: The Metropolitan Museum of Art, 1987), 45–55.

28. For a full list of all known book covers designed by or attributed to Morse, see Dubansky, *Proper Decoration of Book Covers*, 47–89.
29. *Kate Carnegie* is one of two known posters Morse created for Dodd, Mead and Company; the other is George Gissing's *The Paying Guest*, published in 1895. Dubansky, *Proper Decoration of Book Covers*, 91.
30. Finlay, "American Posters and Publishing in the 1890s," 46–48.
31. I thank Gene Mackay for his assistance in properly identifying the fishing equipment in this work.
32. In 1901 A. Wessels published another edition of McManus Mansfield's *True Mother Goose* with a new cover design based on the composition of the poster and endpapers designed by McManus Mansfield.
33. Illustrator Maxfield Parrish designed a poster advertising the exhibition, an example of which is in the collection of The Metropolitan Museum of Art (41.12.218).
34. "Ethel Reed, Artist," 76.
35. For example: William L. Carqueville, *Lippincott's, June*, 1895. The Metropolitan Museum of Art, New York, Leonard A. Lauder Collection of American Posters, Gift of Leonard A. Lauder, 1984 (1984.1202.29).
36. Bogart, *Artists, Advertising, and the Borders of Art*, 23–25.
37. Ethel Reed, *The House of the Trees and Other Poems by Ethelwyn Wetherald*, 1895. The Metropolitan Museum of Art, New York, Purchase, The Lauder Foundation, Evelyn H. and Leonard A. Lauder Fund Gift, 1986 (1986.1005.13).
38. Ethel Reed, *The Best Guide to Boston*, 1895. The Metropolitan Museum of Art, New York, Leonard A. Lauder Collection of American Posters, Gift of Leonard A. Lauder, 1984 (1984.1202.136).
39. One hundred copies of Carman's eighteen-stanza poem were printed by Wayside Press, owned by illustrator Will H. Bradley. Bliss Carman, *The Girl in the Poster: For a Design by Miss Ethel Reed* (Springfield, MA: Wayside Press, 1897), 5–6.
40. M[acArthur], "Chat with Miss Ethel Reed," 278.
41. Ethel Reed, *Fairy Tales*, 1895. The Metropolitan Museum of Art, New York, Leonard A. Lauder Collection of American Posters, Gift of Leonard A. Lauder, 1984 (1984.1202.131).
42. Peterson, *Beautiful Poster Lady*, 27, 31.
43. See Jennifer A. Greenhill, "Poster Pyrotechnics: Advertising Psychology and the Foundations of Modern Marketing," in this volume.
44. "Ethel Reed, Artist," 75; and "Work of Miss Ethel Reed," 235.
45. Ethel Reed quoted in M[acArthur], "Chat with Miss Ethel Reed," 280.
46. W. J. Henderson, "Holiday Books for Young People with Illustrations," *The Book Buyer: A Review and Record of Current Literature* 12 (December 1895): 716.
47. Nancy Finlay, *Artists of the Book in Boston, 1890–1910* (Cambridge, MA: Houghton Library, Harvard University, 1985), 27.
48. Finlay notes that the frieze of poppies in Reed's poster for *The Boston Sunday Herald* (fig. 7) may have been inspired by Sarah Wyman Whitman's cover design for Celia Thaxter's *An Island Garden* (Boston and New York: Houghton Mifflin Company, 1894). Finlay, *Artists of the Book in Boston*, 21.
49. Hirshler, *Studio of Her Own*, 71.
50. "Work of Miss Ethel Reed," 236.
51. Finlay, *Artists of the Book in Boston*, 44–45.
52. Ethel Reed, *The Quest of the Golden Girl*, 1897. The Metropolitan Museum of Art, New York, Purchase, The Lauder Foundation, Evelyn H. and Leonard A. Lauder Fund Gift, 1989 (1989.1032.8); "Work of Miss Ethel Reed," 236.
53. Beardsley was fired as art editor of *The Yellow Book* following the trial and conviction of Oscar Wilde, even though the two men were not close friends or associates and Wilde had not published in the journal. Wilde had a yellow clothbound book under his arm at the time of his arrest for sodomy. Although the book turned out to be a copy of Pierre Louÿs's *Aphrodite*, the press mistakenly reported it was *The Yellow Book*, thus connecting Beardsley's decadence to Wilde's homosexuality and leading the publisher John Lane to sever all ties with the illustrator. David Colvin, *Aubrey Beardsley: A Slave to Beauty* (London: Orion Media, 1998), 54–64.
54. Peterson, *Beautiful Poster Lady*, 58, 60.
55. "The Decadent's Progress, The Yellow Book. A Quarterly. Vol. XII," *The Chap-Book* 6, no. 9 (March 15, 1897): 370.
56. Jessica Todd Smith, "Ethel Reed: The Girl in the Poster" (master's thesis, Harvard University, 1991), 103–11.
57. For more information on the history and influence of little magazines in the United States, see Melinda Knight, "Little Magazines and the Emergence of Modernism in the 'Fin de Siècle,'" *American Periodicals* 6 (1996): 29–45.
58. Marvin R. Nathan, "San Francisco's Fin de Siècle Bohemian Renaissance," *California History* 61, no. 3 (Fall 1982): 202–3.
59. "Notes," *The Chap-Book* 7, no. 7 (August 15, 1897): 227.
60. Finlay, "American Posters and Publishing in the 1890s," 50–54.
61. Mabel Key, "The Passing of the Poster," *Brush and Pencil* 4, no. 1 (April 1899): 12.
62. Key did include a reproduction of Blanche Ostertag's *Calendar Poster*, but the artist and her work are not discussed in the article.
63. Herbert Cecil Duce, *Poster Advertising* (Chicago: Blakely Printing Company, 1912), 129.
64. For more on the life and work of Violet Oakley, see Bailey Van Hook, *Violet Oakley: An Artist's Life* (Newark, DE: University of Delaware Press, 2016); and Patricia Likos Ricci, *A Grand Vision: Violet Oakley and the American Renaissance* (Philadelphia: Woodmere Art Museum, 2017).

65. Josephine Dodge Daskam, *Smith College Stories* (New York: Charles Scribner's Sons, 1900), preface.
66. For more on the intersection of women's suffrage and the arts, see Kate Clarke Lemay, ed., *Votes for Women! A Portrait of Persistence* (Princeton, NJ: Princeton University Press, 2019); and National Endowment for the Arts, *Creativity and Persistence: Art That Fueled the Fight for Women's Suffrage* (Washington, DC: National Endowment for the Arts, 2020), https://www.arts.gov/sites/default/files/Creativity-and-Persistence-0820.pdf.
67. Lemay, *Votes for Women!*, 186.

**Poster Pyrotechnics: Advertising Psychology and the Foundations of Modern Marketing**

This essay draws on ongoing research, some of which has been published previously. Section III is adapted from my article "Flip, Linger, Glide: Coles Phillips and the Movements of Magazine Pictures," *Art History* 40, no. 3 (June 2017): 582–611. A portion of the last paragraph of section IV appeared in my essay "Selling Structures: The Periodical Page and the Art of Suggestive Advertising c. 1900," in *Visuelles Design: Die Journalseite als gestaltete Fläche / Visual Design: The Periodical Page as a Designed Surface*, proceedings of a conference organized by Forschergruppe 2288 "Journalliteratur," Marburg, Germany, November 23–25, 2017 (Hannover: Wehrhahn, 2019), 427–50. The second paragraph of section V is adapted from my essay "Maxfield Parrish's Creative Machinery for Transportation," in Monica Jovanovich and Melissa Renn, eds., *Corporate Patronage of Art and Architecture in the United States, Late 19th Century to the Present* (New York: Bloomsbury, 2019), 39–62. Some of the material addressed in this essay will appear in my book in progress, *Commercial Imagination: Psychotechnics of American Advertising ca. 1900* (working title).

1. W. S. Rogers, "The Modern Poster: Its Essentials and Significance," *Journal of the Royal Society of Arts* 62, no. 3192 (January 23, 1914): 188, containing the lecture "What Is a Poster?" followed by questions and comments; W. S. Rogers, *A Book of the Poster: Illustrated with Examples of the Work of the Principal Poster Artists of the World* (London: Greening and Company, 1901).
2. Rogers, "The Modern Poster: Its Essentials and Significance," 192.
3. T. Russell, "Experimental Science Applied to Advertising," *Advertising* 13 (October 1903): 12–16; 13 (November 1903): 92–94; 13 (December 1903): 168; (January 1904): 234–36. For responses, see R. M. Lucy, "The Best Critical Article," and E. H. Day, "The Best Suggestive Letter," 13 (February 1904): 324–36; T. Russell, "The Results of Our Investigations Tabulated and Commented Upon," 13 (April 1904): 462–68.
4. Walter Dill Scott, "The Psychology of Advertising," twelve-part series in *The Advertising World*: "The Feelings and Emotions," 5 (December 1903): 23–27; "Beauty of Symmetry and Proportion," 5 (January 1904): 113–19; "Sympathy," 5 (February 1904): 181–85, 88; "Sympathy for Joy versus Sympathy for Sorrow," 5 (March 1904): 245–50; "Deliberation," 5 (April 1904): 308–12; "The Survival of the Fittest," 5 (May 1904): 372–75; "The Habit of Reading Advertisements," 6 (June 1904): 17–21; "The Mortality Rate of Advertisers," 6 (July 1904): 96–102; "Summation of Stimuli," 6 (September 1904): 232–38; "Reflex and Instinctive Actions," 6 (October 1904): 298–304; "Some Instincts Which Affect Advertising," 6 (November 1904): 376–84; and "A Helpful Classification of Instincts," 7 (January 1905): 148–54. For the *Globe* commentary, see "En Passant; Many a True Word Is Spoken in Jest," 5 (April 1904): 303–4. See also the series announcement, "En Passant: Our Second Birthday," 5 (December 1903): 17–18.
5. Ruth Iskin makes this distinction in *The Poster: Art, Advertising, Design, and Collecting, 1860s–1900s* (Hanover, NH: Dartmouth College Press, 2014).
6. Michele H. Bogart, *Artists, Advertising, and the Borders of Art* (Chicago: University of Chicago Press, 1995), 85.
7. Mabel Key, "The Passing of the Poster," *Brush and Pencil* 4, no. 1 (April 1899): 19.
8. Charles Matlack Price, *Posters: A Critical Study of the Development of Poster Design in Continental Europe, England and America* (New York: George W. Bricka, 1913), 4.
9. Price, *Posters*, 373.
10. Price, *Posters*, 5.
11. Price, *Posters*, 4, 9.
12. Price, *Posters*, 4.
13. Price, *Posters*, 8.
14. Price, *Posters*, 7.
15. Price, *Posters*, 9 (emphasis in original).
16. The authoritative source on the works exhibited at the Armory show, which opened in February 1913, is Marilyn Satin Kushner and Kimberly Orcutt, eds., *The Armory Show at 100: Modernism and Revolution* (New York: New-York Historical Society, 2013).
17. Price, *Posters*, 13–14.
18. Price, *Posters*, 13–14.
19. Walter Dill Scott, "The Psychology of Advertising," *Atlantic Monthly* 93, no. 555 (January 1904): 34.
20. Herbert W. Hess, *Productive Advertising* (Philadelphia and London: J. B. Lippincott Company, 1915), 134.
21. Price, *Posters*, 3.
22. In the mid-1890s Harlow Gale sought to understand "the mental processes which go on in the minds of customers from the time they see the advertisement until they have purchased the article advertised." See John Eighmey and Sela Sar, "Harlow Gale and the Origins of the Psychology of Advertising," *Journal of Advertising* 36, no. 4 (Winter 2007): 150.
23. Walter Dill Scott, *The Psychology of Advertising: A Simple Exposition of the Principles of Psychology in Their*

*Relation to Successful Advertising*, rev. ed. (Boston: Small, Maynard and Company, 1917 [1908]), 220–21.

24. Scott, *Psychology of Advertising*, 220–21. Scott noted his own susceptibility in earlier writings. See "The Habit of Reading Advertisements," 20–21.
25. Will B. Wilder, "Hypnotism in Advertising," *Fame* 1 (September 1892): 196–97.
26. See Mark Crispin Miller, "Introduction," in Vance Packard, *The Hidden Persuaders* (1957; New York: Ig Publishing, 2007), 9–27, for an excellent summary of Packard's work and its reception.
27. Price, *Posters*, 3.
28. Price, *Posters*, 210.
29. Price, *Posters*, 210.
30. Price, *Posters*, 311.
31. Will Bradley, *Will Bradley: His Chap-Book: An Account, in the Words of the Dean of American Typographers, of His Graphic Arts Adventures: As Boy Printer in Ishpeming; Art Student in Chicago; Designer, Printer and Publisher at the Wayside Press; the Years as Art Director in Periodical Publishing, and the Interludes of Stage, Cinema and Authorship* (New York: The Typophiles, 1955), 75.
32. Hess, *Productive Advertising*, 112.
33. Bradley, *Will Bradley: His Chap-Book*, 75.
34. Max Eastman, "What Is the Matter with Magazine Art?" in *Journalism versus Art* (New York: Alfred A. Knopf, 1916), 46 (first published in *The Masses* 6, no. 4 [January 1915]: 12–16).
35. Eastman, "What Is the Matter with Magazine Art?," 46.
36. Eastman, "What Is the Matter with Magazine Art?," 49.
37. Robert Herrick, "By-Products of a Novelist: Youth's Fervor in *The Masses*," *Chicago Tribune*, February 22, 1914, quoted in Rebecca Zurier, *Art for the Masses: A Radical Magazine and Its Graphics, 1911–1917* (Philadelphia: Temple University Press, 1988), 43.
38. Eastman, "What Is the Matter with Magazine Art?," 25, 33.
39. Eastman, "What Is the Matter with Magazine Art?," 34. Phillips's work was a topic of conversation in the popular press right at the time Eastman wrote his essay; Phillips appeared frequently in the trade literature and had recently published two collectible volumes of his work: *A Gallery of Girls* (New York: The Century Company, 1911), and *A Young Man's Fancy* (New York: Bobbs-Merrill, 1912).
40. "Coles Phillips Girls: Introducing You to a Form of Art Which Its Creator Styles the 'Fadeaway,' That Has Made Him One of the Foremost Delineators of American Beauties," *San Francisco Chronicle*, December 31, 1911.
41. Bradley's cover designs for *Inland Printer* are listed (among many other contributions to the journal) in Anthony Bambace, *Will H. Bradley: His Work. A Bibliographical Guide* (New Castle, DE: Oak Knoll Press, 1995), 132–39.
42. Frank Weitenkampf, *American Graphic Art* (New York: American Graphic Art, 1912), 337–38.
43. On Bradley's work for *Collier's*, see Bradley, *Will Bradley: His Chap-Book*, 69–75.
44. [George French], "Good Designs Applied to the Whole Paper: A Fine Example Furnished by Will Bradley on the Easter *Collier's* — Notes About Other Matters of Advertising Interest," *Profitable Advertising* 17, no. 12 (May 1908): 1258.
45. George French to C. S. Hallowell at *Collier's Weekly*, April 10, 1908, box 4, folder labeled "Collier's Magazine. Copies of various letters to Will Bradley, 1907–8," Will Bradley Collection, The Huntington Library, Art Museum and Botanical Gardens (hereafter "HL").
46. French, "Good Designs Applied to the Whole Paper," 1258. French was a respected authority on printing, graphic art, and advertising. See his first book, *Printing in Relation to Graphic Art* (Cleveland: Imperial Press, 1903).
47. See American Type Founders Company, *Specimens of Printing Types* (New York: American Type Founders, 1897).
48. L. C. McChesney, manager, advertising department, National Photograph Company, to B. Mathewson, April 9, 1908, box 4, folder labeled "Collier's Magazine. Copies of various letters to Will Bradley, 1907–8," Will Bradley Collection, HL.
49. J. L. S. Williams and Clara Elsene Peck, "O Lead Me to the Little Hills," with verses by Wallace Irwin, *Collier's: The National Weekly* 41, no. 3 (April 11, 1908): 8–9.
50. Bradley, *Will Bradley: His Chap-Book*, 71.
51. See Bambace, *Will H. Bradley*, section D.
52. See Walter Dill Scott, "Association of Ideas: First of a Series of Twelve Papers on Psychological Topics by Walter Dill Scott, Director of the Psychological Laboratory of the Northwestern University," *Mahin's Magazine* 1, no. 1 (April 1902): 10–13.
53. Charles Hiatt, *Picture Posters: A Short History of the Illustrated Placard, with Many Reproductions of the Most Artistic Examples in All Countries* (New York: Macmillan, 1896), 298.
54. Iskin, *The Poster*, 233.
55. Will Bradley, "The Use of Borders and Ornament," *The American Chap-Book* 1 (November 1904): 8.
56. Bradley, "The Use of Borders and Ornament," 12.
57. See *A Booklet of Designs* (New York: Will Bradley's Art Service for Advertisers, ca. 1914), n.p. [30]; "Tickle Your Type and Make It Smile," advertising leaflet (New York: Will Bradley's Art Service for Advertisers, ca. 1912), Gordon A. Pfeiffer Collection, University of Delaware Library, Wilmington.
58. John La Farge to Charles Scribner's Sons, January 19, 1910, Maxfield Parrish Papers (ML-62), box 2, folder 28, Rauner Special Collections Library, Dartmouth College (hereafter "DCL").
59. See Sylvia Yount, *Maxfield Parrish, 1870–1966* (New York: Harry N. Abrams in association with the

Pennsylvania Academy of the Fine Arts, 1999), 46–49.

60. "Parrish Turns to Nature," *Art Digest* (July 1, 1931): 16. See also "Turns from Girl on Rock to 'Pictorial Window' Art," *San Diego Union*, May 3, 1931.

61. Jackson Lears, *Fables of Abundance: A Cultural History of Advertising in America* (New York: Basic Books, 1994), 215; and Karl Marx, *Capital: A Critique of Political Economy* (1867; London: Penguin, 1990), 1:164.

62. "Buy Products Not Advertised on Our Roadsides," postcard with "Design contributed by Maxfield Parrish," Vermont Association for Billboard Restriction. Maxfield Parrish Papers, box 7, folder 41, DCL.

63. Bogart, *Artists, Advertising, and the Borders of Art*, 113.

64. *Outdoor Advertising — The Modern Marketing Force. A Manual for Business Men and Others Interested in the Fundamentals of Outdoor Advertising* (Chicago: Outdoor Advertising Association of America, 1928), 35–40, bibliography on 40.

65. George French, *The Art and Science of Advertising* (Boston: Sherman, French and Company, 1909), 52.

**A Complex Art: Techniques for a New Poster Aesthetic**

1. Study and analysis of the posters entailed a combination of visual examination, examination with magnification, and microscopy. The marks made by printing were assessed in the context of the inks, paper, condition, and former conservation interventions, all of which can alter the appearance of the print as well as provide valuable information about the techniques of manufacture and the use of the object. Extensive research used contemporary printing manuals, known examples of processes, other comparative materials, and descriptions of the posters from printmakers and publishers at the time of their making and over their histories.

2. The process of preparing a lithographic printing surface has several more steps to ensure good images. For a video demonstration of the steps, see "What Is Printmaking? Lithograph," The Metropolitan Museum of Art website, accessed August 1, 2023, https://www.metmuseum.org/about-the-met/collection-areas/drawings-and-prints/materials-and-techniques/printmaking/lithograph.

3. Peter C. Marzio, *The Democratic Art: Chromolithography, 1840–1900: Pictures for a 19th-Century America* (Fort Worth, TX: Amon Carter Museum of Western Art, 1979), 15.

4. "Identification: Planographic," *Graphics Atlas*, accessed August 1, 2023, http://www.graphicsatlas.org/identification/?process_id=57.

5. David Cumming, *Handbook of Lithography: A Practical Treatise for All Who Are Interested in the Process*, 2nd ed. (London: Adam and Charles Black, n.d.), 10.

6. Bronze powder was commonly used in this period to simulate gold in prints, books, paintings, and drawings. The color on this poster may have darkened slightly over time, as contemporary descriptions describe the image as "a girl, with metallic gold hair." W. S. Rogers, *A Book of the Poster: Illustrated with Examples of the Work of the Principal Poster Artists of the World* (London: Greening and Company, 1901), 90. This print is an algraph, a lithograph printed from an aluminum matrix.

7. Louis Flader and J. S. Mertle, *Modern Photoengraving: A Practical Textbook on Latest American Procedures* (Chicago: Modern Photoengraving Publishers, 1948).

# SELECTED BIBLIOGRAPHY

Bambace, Anthony. *Will H. Bradley: His Work, A Bibliographical Guide.* New Castle, DE: Oak Knoll Press, 1995.

Bogart, Michele H. *Artists, Advertising, and the Borders of Art.* Chicago: University of Chicago Press, 1995.

Brandt, Frederick R. *Designed to Sell: Turn-of-the-Century American Posters in the Virginia Museum of Fine Arts.* Richmond: Virginia Museum of Fine Arts, 1994.

Cumming, David. *Handbook of Lithography: A Practical Treatise for All Who Are Interested in the Process.* 2nd ed. London: Adam and Charles Black, n.d.

Eighmey, John, and Sela Sar. "Harlow Gale and the Origins of the Psychology of Advertising." *Journal of Advertising* 36, no. 4 (Winter 2007): 147–58.

Flader, Louis. *Modern Photoengraving: A Practical Textbook on Latest American Procedures.* Chicago: Modern Photoengraving Publishers, 1948.

Greenhill, Jennifer A. "Maxfield Parrish's Creative Machinery for Transportation." In *Corporate Patronage of Art and Architecture in the United States, Late 19th Century to the Present,* edited by Monica Jovanovich and Melissa Renn, 39–62. New York: Bloomsbury, 2019.

———. "Selling Structures: The Periodical Page and the Art of Suggestive Advertising c. 1900." In *Visuelles Design: Die Journalseite als gestaltete Fläche / Visual Design: The Periodical Page as a Designed Surface,* edited by Anja Burghart, 427–50. Hannover: Wehrhahn, 2019.

Harris, Neil. "American Poster Collecting: A Fitful History." *American Art* 12, no. 1 (Spring 1998): 11–39.

Hoffman, Frederick J. *The Little Magazine: A History and a Bibliography.* Princeton, NJ: Princeton University Press, 1946.

Iskin, Ruth. *The Poster: Art, Advertising, Design, and Collecting, 1860s–1900s.* Hanover, NH: Dartmouth College Press, 2014.

Johnson, Diane Chalmers. *American Art Nouveau.* New York: Harry N. Abrams, 1979.

Kennedy, Martha H. *Drawn to Purpose: American Women Illustrators and Cartoonists.* Jackson: University Press of Mississippi in association with the Library of Congress, 2018.

Knight, Melinda. "Little Magazines and the Emergence of Modernism in the 'Fin de Siècle.'" *American Periodicals* 6 (1996): 29–45.

Kiehl, David W., ed. *American Art Posters of the 1890s in The Metropolitan Museum of Art, including the Leonard A. Lauder Collection.* New York: The Metropolitan Museum of Art, 1987.

Koch, Robert. *Will H. Bradley: American Artist in Print, A Collector's Guide.* New York and Manchester, VT: Hudson Hills Press, 2002.

Lears, Jackson. *Fables of Abundance: A Cultural History of Advertising in America.* New York: Basic Books, 1994.

Levit, Briar, ed. *Baseline Shift: Untold Stories of Women in Graphic Design History.* New York: Princeton Architectural Press, 2021.

MacLeod, Kirsten. *American Little Magazines of the Fin de Siècle: Art, Protest, and Cultural Transformation.* Toronto: University of Toronto Press, 2018.

Margolin, Victor. *American Poster Renaissance: The Great Age of Poster Design, 1890–1900.* Secaucus, NJ: Castle Books, 1975.

Marzio, Peter C. *The Democratic Art: Chromolithography, 1840–1900: Pictures for a 19th-Century America.* Fort Worth, TX: Amon Carter Museum of Western Art, 1979.

Meech, Julia, and Gabriel P. Weisberg. *Japonisme Comes to America: The Japanese Impact on the Graphic Arts, 1876–1925.* New York: Harry N. Abrams in association with the Jane Voorhees Zimmerli Art Museum, Rutgers University, 1990.

Patterson, Martha H. *The American New Woman Revisited: A Reader, 1894–1930.* New Brunswick, NJ: Rutgers University Press, 2008.

Peterson, William S. *The Beautiful Poster Lady: A Life of Ethel Reed.* New Castle, DE: Oak Knoll Press, 2013.

Saunders, Gill, and Margaret Timmers, eds. *The Poster: A Visual History.* London: V&A Publications, 2020.

Spangenberg, Kristin L., and Deborah Walk, eds. *The Amazing Circus Poster: The Strobridge Lithographing Company.* Cincinnati: Cincinnati Art Museum, 2011.

Swinth, Kirsten. *Painting Professionals: Women Artists and the Development of Modern American Art, 1870–1930.* Chapel Hill: University of North Carolina Press, 2001.

Thomson, Ellen Mazur. *The Origins of Graphic Design in America, 1870–1920.* New Haven: Yale University Press, 1997.

Timmers, Margaret, ed. *The Power of the Poster.* London: V&A Publications, 1998.

Weisberg, Gabriel P. "Graphic Art in America: The Artistic and Civic Poster in the United States Reconsidered." *Journal of Decorative and Propaganda Arts* 16 (Summer 1990): 104–13.

Wong, Roberta Waddell. *Will H. Bradley, American Artist and Craftsman (1868–1962).* New York: The Metropolitan Museum of Art, 1972.

Yount, Sylvia. *Maxfield Parrish, 1870–1966.* New York: Harry N. Abrams in association with the Pennsylvania Academy of the Fine Arts, 1999.

# INDEX

Page references in *italics* refer to illustrations.

advertising psychology, 47–51, 53–54, 62, 67
    outdoor advertising and, 68–69
Aesthetic movement, 29–30, 42, 61
algraphs, 72
American art-poster movement, 27–28, 30–32
*American Chap-Book* (figs. 27, 28), 64, 65, 65–66
American Type Founders, 65
Art Nouveau, 22, 32, 38, 45
Arts and Crafts movement, 29–30, 42

Bagby, Albert Morris, *Miss Träumerei*, Reed's designs for (pl. 105), 33–34, 53, 235
Baum, L. Frank, *Mother Goose in Prose*, 66
Beardsley, Aubrey, 38, 239n53
*Bearings*, Cox's posters for (pls. 21, 22), 230
Benday tints (figs. 38–41), 76–82, 77–79, 83
    Day's invention of, 76–78
bicycling, 15–16
billboards, 18, 67–69
    Outdoor Advertising Association of America's promotion of (fig. 31), 67–69, 68
    Vermont Association for Billboard Restriction's campaign against (fig. 30), 67, 68
Bird, Elisha Brown:
    *The Captured Cunarder by William H. Rideing* (pl. 1), 229
    *The Poster, March [Miss Art and Miss Litho]* (pl. 3), 229
    *The Red Letter* (pl. 2), 229
Bogart, Michele H., 26, 31, 34, 68
*Book Buyer, The*, 35
*Bookman, The*:
    Christy's poster for (pl. 20, fig. 47), 83, 83 (detail), 230
    Edwards's poster for (pl. 33), 231

*Boston Sunday Herald*:
    Reed's first poster design published by, on February 24, 1895 (fig. 7), 25, 27, 35, 239n48
    Reed's March 24, 1895, poster for (pl. 111), 33–34, 235
Boyé, Bertha Margaret, *Votes for Women* (fig. 18), 44, 45
Bradley, Will H., 20–23, 27, 40–41, 48–49, 55, 57, 58–66, 239n39
    *American Chap-Book* (figs. 27, 28), 64, 65, 65–66
    *Bradley: His Book [Beauty and the Beast]* (pl. 11), 229–30
    *Bradley: His Book [The Kiss]* (pl. 9), 229
    *The Chap-Book [The Blue Lady]*, 1894 (fig. 6), 22, 22
    *The Chap-Book [The Twins]*, 1894 (pl. 4), 229
    *The Chap-Book [The Pipes]*, 1895 (pl. 7), 40, 229
    *The Chap-Book*, September 1895 (fig. 26), 62–63, 63
    *The Chap-Book*, Thanksgiving Number, 1895 (pl. 5), 22–23, 229
    *Collier's: The National Weekly*, April 11, 1908 (figs. 24, 25), 59–61, 60
    *The Echo* (pl. 8), 229
    *The Modern Poster, Charles Scribner's Sons, New York* (pl. 10), 11, 76, 229
    *Victor Bicycles, Overman Wheel Company* (pl. 12), 230
    *When Hearts Are Trumps by Tom Hall* (pl. 6), 229
*Bradley: His Book* (pls. 9, 11), 21, 27–28, 33, 35, 229–30
    front and back covers of first issue of (fig. 23), 59, 59
Brill, George Reiter, 12
    *Philadelphia Sunday Press*, February 23, 1896 (pl. 15), 230
    *Philadelphia Sunday Press*, June 9, 1895 (pl. 14), 75, 230
    *Tribune* (pl. 13), 230

Bronzino (Agnolo di Cosimo di Mariano):
    *Portrait of a Young Man* (fig. 4), 20, 20, 237n14
*Brush and Pencil*, 23
Burgess, Frank Gelett, 39

Carman, Bliss:
    *Behind the Arras*, Reed's poster for (pl. 112), 34, 235
    "The Girl in the Poster: For a Design by Miss Ethel Reed," 34
Carqueville, William L.:
    *International, November*, 1896 (pl. 19, fig. 36), 76, 76 (detail), 230
    *Lippincott's, April*, 1895 (pl. 16), 230
    *Lippincott's, May*, 1895 (pl. 17), 230
    *Lippincott's, August*, 1895 (pl. 18), 230
*Century, The*, 42, 62
    contests sponsored by, 20, 67
    Edwards's poster for March 1895 issue of (pl. 32), 231
    Lawrence's poster for October 1895 issue of (pl. 52), 232
    Leyendecker's poster for August 1896 issue of (pl. 53), 75, 232
    Parrish's poster for August 1897 issue of (pl. 75), 67, 233
    Potthast's poster for July 1896 issue of (pl. 100), 234
    Rhead's poster for Midsummer Holiday 1894 issue of (pl. 114), 235
    Rhead's poster for December 1894 issue of (pl. 127), 236
    W.'s poster for March 1898 issue of (pl. 133), 236
    Wildhack's cover for May 1908 issue of (fig. 20), 51, 52
    Woodbury's poster for July 1895 issue of (pl. 135), 236
*Chap-Book, The*, 39
    Bradley's posters for (figs. 6, 26, pls. 4, 5, 7), 22, 22–23, 40, 62–63, 63, 229
    Hazenplug's posters for (pls. 46–48, fig. 37), 74, 76, 76 (detail), 231

Chéret, Jules, 18–19, 52, 237n10
    *Jardin de Paris* poster (fig. 3), 19, *19*
children's books, 30, 35–38, 42
    McManus Mansfield's *The True Mother Goose* (pl. 63), 32–33, 232, 239n32
    Reed's designs for (figs. 11–13, pls. 107, 108), 35–38, *36*, *37*, 235
Christy, Howard Chandler, *The Bookman, September,* 1890s (pl. 20, fig. 47), 83, *83* (detail), 230
circus posters (fig. 2), 11, 17, *17*, 18, 237n10
Cluett, Peabody and Company, advertisement for (fig. 25), 60, *61*
*Collier's: The National Weekly*, Bradley's designs for (figs. 24, 25), 59–61, *60*
Copeland and Day, 35, 38
Cox, Charles Arthur:
    *Bearings*, ca. 1895 (pl. 22), 230
    *Bearings*, 1896 (pl. 21), 230

Day, Benjamin, mechanical tints invented by, 76–78
    *see also* Benday tints
Day, F. Holland, 238n5
Dixon, Lafayette Maynard, 12
    *Overland Monthly, June,* 1895 (pl. 23), 230
    *Overland Monthly, July,* 1895 (pl. 24), 230
    *Sunset Magazine, October,* 1902 (pl. 25), 230
    *Sunset Magazine, September,* 1904 (pl. 26), 230
    *Sunset Magazine, November,* 1904 (pl. 27), 230
Dow, Arthur Wesley, *Modern Art, Edited by J. M. Bowles, Published by L. Prang and Company* (pl. 28), 230
Duce, Herbert Cecil, 41

Eastman, Max, 55–57, 241n39
Echegaray, José, *Folly or Saintliness*, Reed's poster for (pl. 106), 37, 235
*Echo, The*:
    Bradley's poster for (pl. 8), 229
    Nankivell's poster for (pl. 70), 233
    Sloan's poster for (pl. 129), 236
Eddy, Henry Brevoort, *New York Journal*, 1900 (pl. 29), 230
Edge, F. Gilbert:
    *The Sunday World, June 7,* 1896 (pl. 31), 78–79, 231
    *The Sunday World, October 4,* 1896 (pl. 30), 230

Edison's phonograph, advertisement for (fig. 24), 60, 61–62
Edwards, George Wharton:
    *The Bookman, May,* 1897 (pl. 33), 231
    *The Century, March,* 1895 (pl. 32), 231
etching, 82–83
    metal-plate relief (fig. 47), 82–83, *83*

Fisk Tires, Parrish's advertising campaign for (fig. 29), 66, *67*
*Fly Leaf, The*, 39
French, George, 59–61, 69

Gale, Harlow, 47–48
Glackens, William James, *Lippincott's, August,* 1894 (pl. 34), 231
*Good Housekeeping*, 55
    Phillips's cover design for (fig. 21), 56, *57*, 58
Gould, Joseph J., Jr., 15–17
    *Lippincott's, January,* 1896 (pl. 42), 231
    *Lippincott's, February,* 1896 (pl. 39), 231
    *Lippincott's, June,* 1896 (pl. 35), 231
    *Lippincott's, July,* 1896 (pl. 36), 15–17, 19, 231
    *Lippincott's, August,* 1896 (pl. 40), 231
    *Lippincott's, November,* 1896 (pl. 37), 231
    *Lippincott's, December,* 1896 (pl. 38, fig. 42–46), 80, *80–81* (details), 231
    *Lippincott's, April,* 1897 (pl. 41), 231
Green, Elizabeth Shippen, 42

*Harper's*, Penfield's posters for (pls. 76–85), 30–31, 237n4
    *see also* Penfield, Edward
*Harper's Bazar*, Rhead's poster for (pl. 118), 235
*Harvard Lampoon*, Moe's posters for (pls. 66, 67), 232
Haskell, Ernest:
    *The New York Sunday Journal,* 1896 (pl. 44), 231
    *The New York Sunday Journal, April 12,* 1896 (pl. 45), 231
    *Truth* (pl. 43, fig. 35), 52–53, *75*, *75* (detail), 231
Hayes, Charles J., *Engraving and Printing Methods* (fig. 38), 76–77, *77*
Hazenplug, Frank:
    *The Chap-Book,* 1895 (pl. 46), 74, 231
    *The Chap-Book,* 1896 (pl. 47, fig. 37), 76, *76* (detail), 231
    *The Chap-Book,* 1896 (pl. 48), 231

*The Emerson and Fisher Company, Carriage Builders, Cincinnati, Ohio, USA* (pl. 50), 232
*Galloping Dick by H. B. Marriott Watson* (pl. 49), 231
*Living Posters* (pl. 51), 232
Heiter, Michael M., frontispiece for *Outdoor Advertising — The Modern Marketing Force* (fig. 31), 68
Hirshler, Erica, 38
Hopper, Edward (fig. 22), 57, *57*
Howe, Mrs. Julia Ward, *Is Polite Society Polite and Other Essays*, Reed's poster for (pl. 113), 11, 37, 235

*Inland Printer*, 58, 62
*International*, Carqueville's poster for (pl. 19, fig. 36), 76, *76* (detail), 230
*International Studio, The*, 26, 35, 38
Iskin, Ruth, 63–64

Japanese wood-block prints, 15, 32, 74
Johnston, Frances Benjamin, *Miss Ethel Reed* (fig. 8), 25, *27*, 38

*Kate Carnegie* (Maclaren):
    McManus Mansfield's cover for (fig. 9), 32, *33*
    Morse's poster for (pl. 68), 12, 31–32, 233, 239n29
Key, Mabel, 41, 49
key block, 74, 82
Kipling, Rudyard, *Captains Courageous*:
    McManus Mansfield's cover design for (fig. 10), 32, *33*
    McManus Mansfield's poster for (pl. 64), 32, 232

La Farge, John, 66
Lane, John, 239n53
*Lark, The*, 39–41
    Lundborg's posters for (pls. 58–61), 39–41
Lawrence, H. M., *The Century, October,* 1895 (pl. 52), 232
Leyendecker, Frank Xavier, 49
Leyendecker, Joseph Christian, 41, 49
    *The Century, August, Midsummer Holiday Number,* 1896 (pl. 53), 75
    *The Chap-Book,* 1897 (pl. 54), 232
    *Self Culture, October,* 1897 (pl. 55, fig. 39), 78 (detail), *79*, 232
Lincoln, A. W. B., *Yale Yarns* (pl. 56), 232
*Lippincott's*, 19

Carqueville's posters for (pls. 16–18), 230
Glackens's poster for (pl. 34), 231
Gould's posters for (pls. 35–42, figs. 42–46), 15–17, 19, 80, 80–81 (details), 231
lithographic techniques, 18, 71–82
    Benday tints (figs. 38–41), 76–82, 77–79, 83
    metal-plate relief compared to (figs. 47, 48), 82–83, 83
little magazines, 39, 237–38n17
*Lotus, The*, 39
Low, William Hicok, *Scribner's, July, Fiction Number* (pl. 57), 232
Lundborg, Florence, 39–41
    cover design for Bertha H. Smith, *Yosemite Legends* (fig. 16), 40, 41
    *The Lark, November,* 1895 (pl. 59), 232
    *The Lark, August,* 1896 (pl. 61), 40, 232
    *The Lark, November,* 1896 (pl. 58), 232
    *The Lark, February,* 1897 (pl. 60), 232

MacArthur, James, 26, 34–35, 38
Maclaren, Ian, *Kate Carnegie*:
    McManus Mansfield's cover for (fig. 9), 32, 33
    Morse's poster for (pl. 68), 12, 31–32, 233, 239n29
Malcolm, O. C., *Outing, Special Bicycle Number* (pl. 62), 232
Marx, Karl, 67
McChesney, L. C., 61–62
McManus Mansfield, Blanche, 32–33
    *Captains Courageous, Rudyard Kipling's American Novel* (pl. 64), 32, 232
    cover design for Ian Maclaren, *Kate Carnegie* (fig. 9), 32, 33
    cover design for Rudyard Kipling, *Captains Courageous* (fig. 10), 32, 33
    *The True Mother Goose with Notes and Pictures by Blanche McManus* (pl. 63), 32–33, 232, 239n32
McVickar, H. W., *The Evolution of Woman by H. W. McVickar* (pl. 65), 232
metal-plate relief (fig. 47), 82–83, 83
*M'lle New York*, 39
Moe, A. K.:
    *Harvard Lampoon [Crew]* (pl. 66), 232
    *Harvard Lampoon [Pegasus]* (pl. 67), 232
*Moods*, 39
Moore, Guernsey, 61

Morse, Alice Cordelia, 30, 31–32, 41, 42, 238n23
    *Kate Carnegie by Ian Maclaren* (pl. 68), 12, 31–32, 233, 239n29
Mother Goose, 66
    McManus Mansfield's *The True Mother Goose* (pl. 63), 32–33, 232, 239n32
Moulton, Louise Chandler, *In Childhood's Country*, Reed's designs for (pl. 108), 38, 235

Nadall, E., *The Road Rights of Wheelmen, Callaghan and Company, Chicago* (pl. 69), 233
Nankivell, Frank Arthur, *The Echo* (pl. 70), 233
"New Woman," 15, 19, 34, 43, 237n1
*New York Journal, The*, Eddy's poster for (pl. 29), 230
*New York Sunday Journal, The*, Haskell's posters for (pls. 44, 45), 231

Oakley, Violet, 42
    *Plastic Club Special Exhibition of the Work of Jessie Willcox Smith, Elizabeth Shippen Green, Violet Oakley* (fig. 17), 42, 43
    *A Puritan's Wife by Max Pemberton* (pl. 71), 42, 233
Office of War Information (OWI), 11
Outcault, Richard Felton, *The Sunday World, February 9*, 1896 (pl. 72), 233
*Outdoor Advertising — The Modern Marketing Force* (fig. 31), 67–69, 68
*Overland Monthly*, Dixon's posters for (pls. 23, 24), 12, 230

Packard, Vance, *The Hidden Persuaders*, 54
Parrish, Maxfield, 20, 41, 49, 66–67, 239n33
    advertising campaign for Fisk Tires (fig. 29), 66, 67
    *The Century, August, Midsummer Holiday Number,* 1897 (pl. 75), 67, 233
    landscape by, featured in campaign against billboards (fig. 30), 67, 68
    *Scribner's, August, Fiction Number,* 1897 (fig. 22, pl. 73), 57, 57, 233
    *Scribner's, December, Christmas Special,* 1897 (pl. 74), 233
Penfield, Edward, 12, 17, 19, 21, 41, 48–49, 237n4
    *English Society by George du Maurier* (pl. 97), 234

*Harper's, April,* 1893 (fig. 1), 16, 17–18, 30, 233
*Harper's, April,* 1894 (pl. 78), 12, 20, 74, 233; study for (figs. 5, 32–34), 20, 21, 72–74, 73 (details)
*Harper's, July,* 1894 (pl. 79), 20, 233
*Harper's, January,* 1895 (pl. 76), 79, 233; photomicrographs of (figs. 41, 48), 79, 79, 83, 83
*Harper's, March,* 1895 (pl. 77), 233
*Harper's, November,* 1895 (pl. 81), 233
*Harper's, May,* 1896 (pl. 80), 233
*Harper's, February,* 1897 (pl. 83), 233
*Harper's, March,* 1897 (pl. 82), 233
*Harper's, June,* 1897 (pl. 84), 233
*Harper's, July,* 1897 (pl. 85), 233
*The Martian by Du Maurier* (pl. 98), 234
*Orient Cycles: Lead the Leaders* (pl. 86), 234
*Poster Calendar 1897: Cover,* 1896 (pl. 88), 234
*Poster Calendar 1897: January, February, March* (pl. 90), 234; proof for (pl. 89), 234
*Poster Calendar 1897: April, May, June* (pl. 92), 234; proof for (pl. 91), 234
*Poster Calendar 1897: July, August, September* (pl. 94), 234; proof for (pl. 93), 234
*Poster Calendar 1897: October, November, December* (pl. 96), 234; proof for (pl. 95), 234
*Ride a Stearns and Be Content* (pl. 87), 234
*Penny Magazine*, Reed's poster for (pl. 109, fig. 40), 34, 78 (detail), 79, 235
*Philadelphia Sunday Press*, Brill's posters for (pls. 14, 15), 12, 75, 230
Phillips, Cole (fig. 22), 57, 57–58, 241n39
    cover design for *Good Housekeeping* (fig. 21), 56, 57, 58
Pickert, E., *The New York Times, February 9,* 1895 (pl. 99), 234
Plastic Club, Philadelphia, 42
    Oakley's poster for exhibition at (fig. 17), 42, 43
Pope, Marion Manville, 19
poppy motifs, 35–37
Porter, Bruce, 39
*Poster, The*, 25, 238n1
    Bird's poster for (pl. 3), 229
Potthast, Edward Henry, *The Century, July,* 1896 (pl. 100), 234
Prang, Louis, 76

Prendergast, Maurice Brazil, *On the Point by Nathan Haskell Dole* (pl. 101), 234
Price, Charles Matlack, 49–51, 53, 54–55
printing process:
  literary posters' allusions to, 22–23
  *see also* lithographic techniques
*P. T. Barnum's Greatest Show on Earth and The Great London Circus* (fig. 2), 17, 17

Raleigh, Henry Patrick:
  *Sunset Magazine*, March, 1902 (pl. 102), 234–35
  *Sunset Magazine*, May, 1902 (pl. 104), 235
  *Sunset Magazine*, August, 1903 (pl. 103), 235
reading, depicted in literary posters, 19–20, 33–34
Red Rose Girls, 42–44
Reed, Ethel, 25–28, 33–39, 41, 48–49, 238n5
  *Albert Morris Bagby's New Novel, Miss Träumerei* (pl. 105), 33–34, 53, 235
  *Arabella and Araminta Stories by Gertrude Smith with XV Pictures by Ethel Reed* (pl. 107), 35–37, 235; cover design, endpapers, and interior illustrations for (figs. 11–13), 35, 36, 37
  *Behind the Arras by Bliss Carman* (pl. 112), 34, 235
  *The Best Guide to Boston*, 34
  *The Boston Sunday Herald*, February 24, 1895 (fig. 7), 25, 27, 35, 239n48
  *The Boston Sunday Herald*, March 24, 1895 (pl. 111), 33–34, 235
  *Fairy Tales*, 35, 38
  *Folly or Saintliness by José Echegaray* (pl. 106), 37, 235
  *The House of the Trees and Other Poems by Ethelwyn Wetherald*, 34
  *In Childhood's Country by Louise Chandler Moulton, Pictured by Ethel Reed* (pl. 108), 38, 235
  *Is Polite Society Polite and Other Essays by Mrs. Julia Ward Howe* (pl. 113), 11, 37, 235
  Johnston's cyanotype portrait of (fig. 8), 25, 27, 38
  *The Penny Magazine*, ca. 1896 (pl. 109, fig. 40), 34, 78 (detail), 79, 235
  *The Quest of the Golden Girl*, 38
  *A Virginia Cousin and Bar Harbor Tales by Mrs. Burton Harrison* (pl. 110), 235
  *The Yellow Book: An Illustrated Quarterly* (figs. 14, 15), 38–39, 39
Rhead, Louis John:
  *Cassell's Magazine*, December, 1896 (pl. 126), 236
  *C. Bechstein Pianos* (pl. 128), 12, 236
  *The Century Magazine*, Midsummer Holiday Number, 1894 (pl. 114), 235
  *The Century*, December, Christmas Number, 1894 (pl. 127), 236
  *Exposition, Salon des Cent* (pl. 119), 235
  *Harper's Bazar*, November, Thanksgiving, 1894 (pl. 118), 235
  *Le Journal de la Beauté* (pl. 116), 235
  *Poster Calendar 1897: Cover* (pl. 120), 236
  *Poster Calendar 1897: January, February, March* (pl. 121), 236
  *Poster Calendar 1897: April, May, June* (pl. 122), 236
  *Poster Calendar 1897: July, August, September* (pl. 123), 236
  *Poster Calendar 1897: October, November, December* (pl. 124), 236
  *Prang's Easter Publications* (pl. 115), 235
  *The Sun* (pl. 117), 235
  *The Weekly Dispatch* (pl. 125), 236
Rogers, W. S., 47, 48

San Francisco College Equal Suffrage League, 45
Sartain, Emily, 42
Scott, Walter Dill, 47–48, 54, 62, 69
*Scribner's* magazine:
  Low's poster for (pl. 57), 232
  Parrish's posters for (fig. 22, pls. 73, 74), 57, 57, 233
  Wildhack's poster for (fig. 19), 50–51, 51
Senefelder, Alois, 71
Siemon, Julia, 20
Sloan, John:
  *Cinder-Path Tales by William Lindsey* (pl. 130), 236
  *The Echo* (pl. 129), 236
Smith, Gertrude, *Arabella and Araminta Stories*, Reed's designs for (figs. 11–13, pl. 107), 35, 36, 37
Smith, Jessie Willcox, 42–44
  *Smith College Stories by Josephine Daskam* (pl. 131), 42–43, 236
Smith, Joseph Lindon, *Handbook of the New Public Library* (pl. 132), 236
Smith, Walter, 30
Soissons, S. C. de, 25
Stephens, Alice Barber, 42
*Sunday World, The*:
  Edge's posters for (pls. 30, 31), 78–79, 230–31
  Outcault's poster for (pl. 72), 233
*Sunset Magazine*:
  Dixon's posters for (pls. 25–27), 12, 230
  Raleigh's posters for (pls. 102–4), 12, 234–35

*Truth*, Haskell's poster for (pl. 43, fig. 35), 52–53, 75, 75 (detail), 231

Vermont Association for Billboard Restriction, postcard issued by (fig. 30), 67, 68

W., *The Century*, March, 1898 (pl. 133), 236
Weitenkampf, Frank, 58–59
Wells, E. B., *Mrs. Cliff's Yacht by Frank R. Stockton* (pl. 134), 236
Whitman, Sarah Wyman, 239n48
Wilde, Oscar, 239n53
Wildhack, Robert J., 53, 58
  *The Century*, May, 1908 (fig. 20), 51, 52
  *Scribner's*, September, 1906 (fig. 19), 50–51, 51
women's suffrage, 44–45
  Boyé's *Votes for Women* poster and (fig. 18), 44, 45
Wong, Roberta, 21
Woodbury, Charles Herbert:
  *The Century*, July, 1895 (pl. 135), 236
World's Columbian Exposition (Chicago, 1893), 30
Wundt, Wilhelm, 47–48

*Yellow Book: An Illustrated Quarterly, The*, 38, 239n53
  Reed's designs for (figs. 14, 15), 38–39, 39

zincographs, 72

This catalogue is published in conjunction with *The Art of the Literary Poster: Works from the Leonard A. Lauder Collection*, on view at The Metropolitan Museum of Art, New York, from March 7 through June 11, 2024.

This publication has been made possible by a generous grant from Leonard A. Lauder.

**Published by The Metropolitan Museum of Art, New York**
Mark Polizzotti, Publisher and Editor in Chief
Peter Antony, Associate Publisher for Production
Michael Sittenfeld, Associate Publisher for Editorial

Edited by Elisa Urbanelli
Production by Paul Booth
Designed by Susan Marsh
Bibliographic editing by Jessica Skwire Routhier
Image acquisitions and permissions by Jenn Sherman

Photographs of works in The Met collection are by Love Ablan, Imaging Department, The Metropolitan Museum of Art, unless otherwise noted. Image © The Metropolitan Museum of Art: figs. 4, 6, 16, 26; Image © The Metropolitan Museum of Art; photo by Teri Aderman: fig. 9; Image © The Metropolitan Museum of Art; photo by Rachel Mustalish: figs. 39, 41, 43–48

Additional credits: Courtesy of Arthur and Elizabeth Schlesinger Library on the History of Women in America, Radcliffe Institute for Advanced Study, Harvard University: fig. 18; © Cincinnati Art Museum / Bridgeman Images: fig. 2; Courtesy Dartmouth College Library: fig. 30; Courtesy of Jennifer Greenhill: figs. 23–25, 27–29, 31; Courtesy of Helen Farr Sloan Library & Archives, Delaware Art Museum: figs. 11–15; Courtesy of Houghton Library, Harvard University: fig. 10; Courtesy of Library of Congress: figs. 7, 8; Courtesy of New York Public Library: fig. 19; Shawshots / Alamy Stock Photo: fig. 3; Courtesy of Sterling Memorial Library, Yale University: fig. 21; Courtesy of Swann Auction Galleries: fig. 1; Digital image © Whitney Museum of American Art / Licensed by Scala / Art Resource, NY: fig. 22; Courtesy of Woodmere Art Museum, Philadelphia, PA: fig. 17

Typeset in Arno Pro and Bradley Chicopee Pro by Matt Mayerchak
Printed on Condat Matte Perigord 150 gsm
Separations by Verona Libri, Verona, Italy
Printed and bound by Verona Libri, Verona, Italy

JACKET, FRONT: Edward Penfield, *Harper's, February*, 1897 (detail, pl. 83)

JACKET, BACK: Charles Arthur Cox, *Bearings*, 1896 (detail, pl. 21)

DETAILS, p. 2: Elisha Brown Bird, *The Captured Cunarder by William H. Rideing*, 1896 (pl. 1); p. 4: Henry Patrick Raleigh, *Sunset Magazine, May*, 1902 (pl. 104); p. 6: Ethel Reed, *Albert Morris Bagby's New Novel, Miss Träumerei*, 1895 (pl. 105); p. 8: Louis John Rhead, *Le Journal de la Beauté*, 1897 (pl. 116); p. 12: Will H. Bradley, *The Modern Poster, Charles Scribner's Sons, New York*, 1895 (pl. 10); p. 13: Lafayette Maynard Dixon, *Overland Monthly, July*, 1895 (pl. 24); p. 14: Joseph J. Gould Jr., *Lippincott's, July*, 1896 (pl. 36); p. 24: Ethel Reed, *Folly or Saintliness by José Echegaray*, 1895 (pl. 106); p. 46: Will H. Bradley, *The Chap-Book [The Pipes]*, 1895 (pl. 7); p. 70: Edward Penfield, *Poster Calendar 1897: Cover*, 1896 (pl. 88); p. 84: Blanche McManus Mansfield, *The True Mother Goose with Notes and Pictures by Blanche McManus*, 1895 (pl. 63); p. 228: Frank Hazenplug, *Living Posters*, 1895 (pl. 51)

The Metropolitan Museum of Art endeavors to respect copyright in a manner consistent with its nonprofit educational mission. If you believe any material has been included in this publication improperly, please contact the Publications and Editorial Department.

Copyright © 2024 by The Metropolitan Museum of Art, New York

FIRST PRINTING

All rights reserved. No part of this publication may be reproduced or transmitted in any form or by any means, electronic or mechanical, including photocopying, recording, or any information storage and retrieval system, without permission in writing from the publishers.

The Metropolitan Museum of Art
1000 Fifth Avenue
New York, New York 10028
metmuseum.org

Distributed by
Yale University Press,
New Haven and London
yalebooks.com/art
yalebooks.co.uk

Cataloguing-in-Publication Data is available from the Library of Congress.

ISBN 978-1-58839-774-4